Chris Stein/Negative

Me, Blondie, and the Advent of Punk

Chris Stein

Contributions by
Deborah Harry, Glenn O'Brien, and Shepard Fairey

RIZZOLI
NEW YORK

New York · Paris · London · Milan

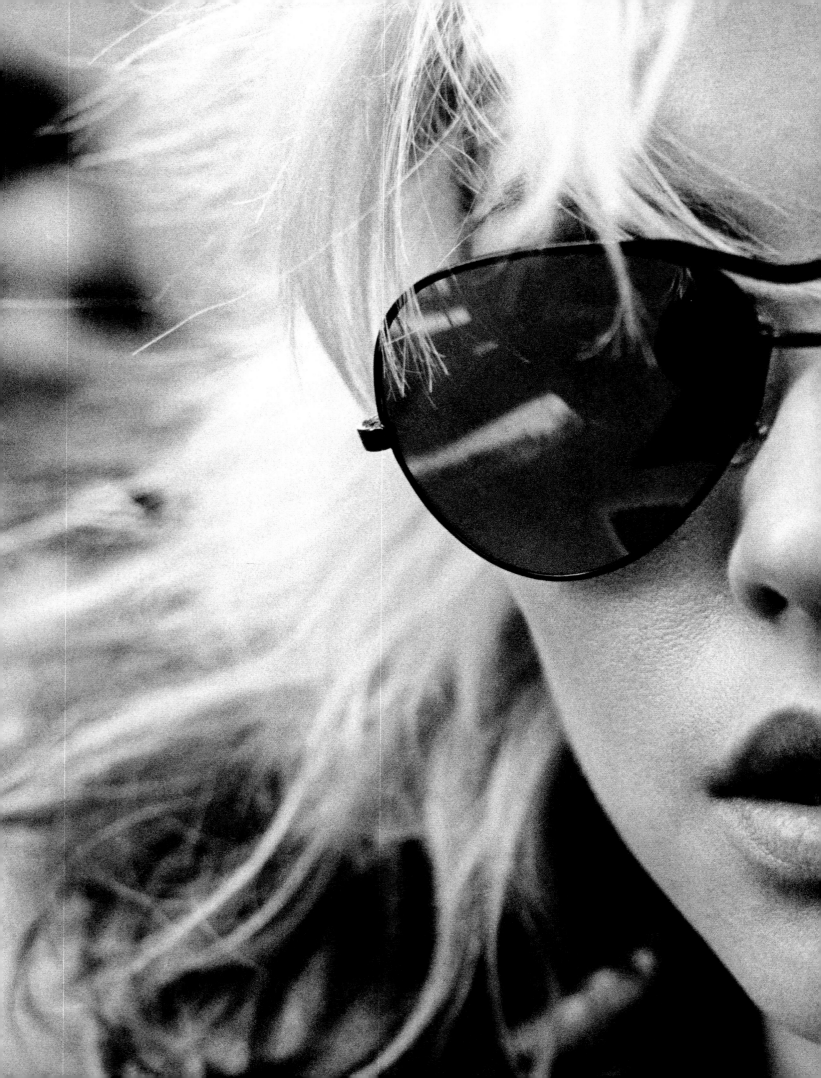

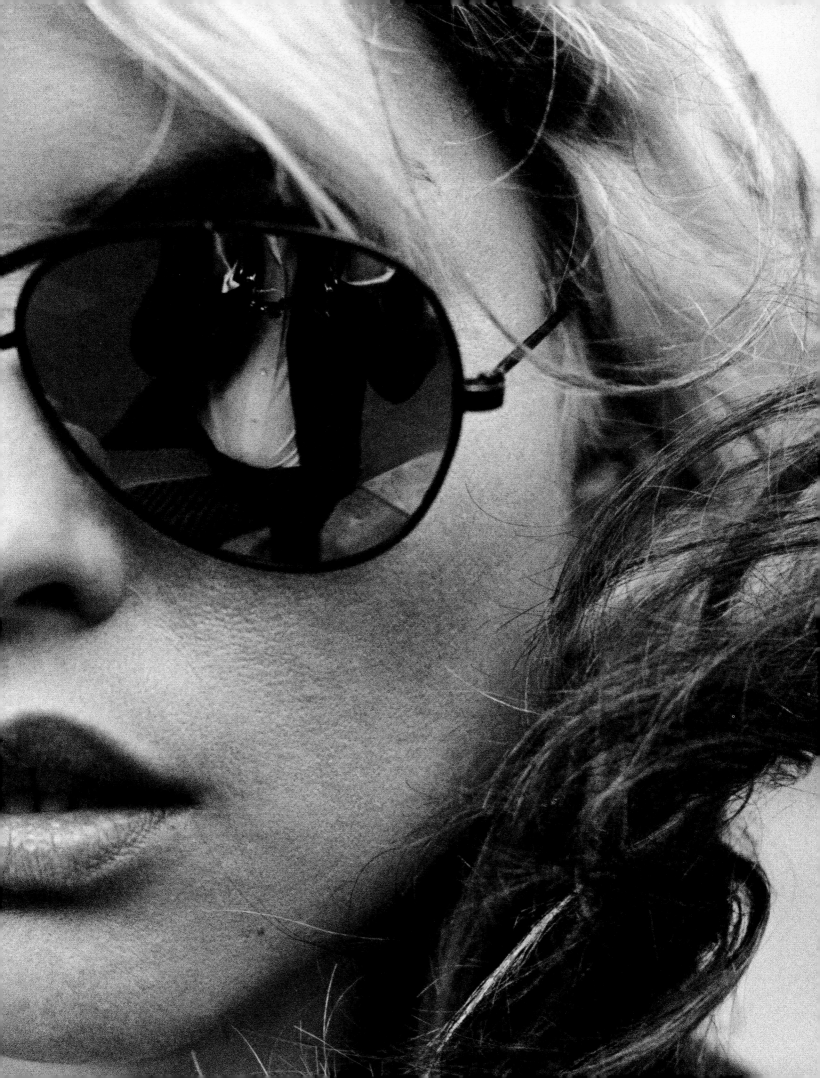

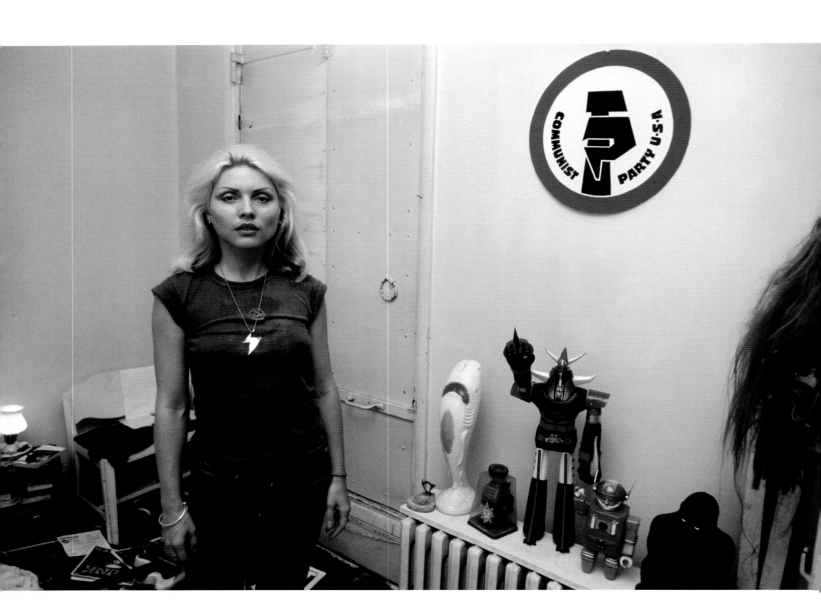

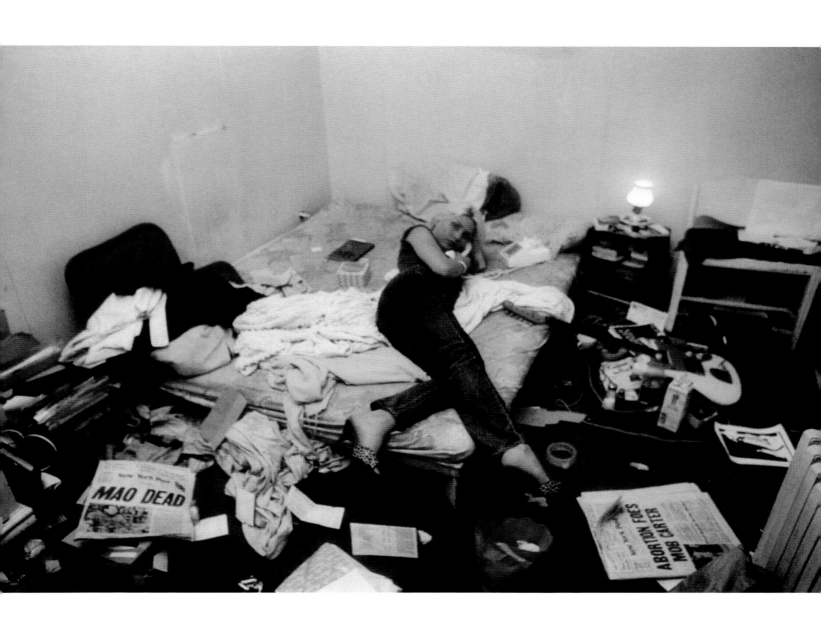

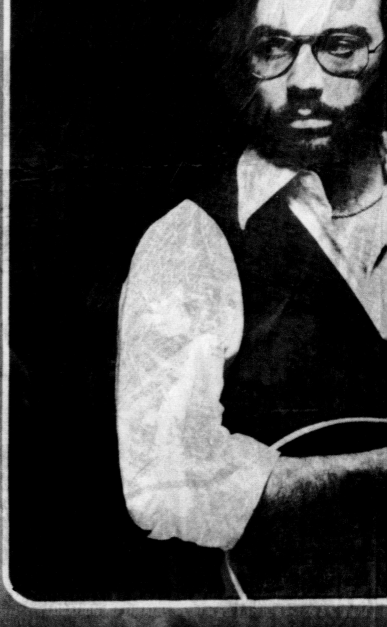

COVER Debbie and Anya Phillips
in a hotel room during the Sleaze
Convention, 1976. [More info about
this photo, **PAGE 85**.]

BACK COVER Assorted images from
the interior.

OPENING IMAGES (PAGES 2–3) Debbie in
sunglasses, late seventies, **(PAGES 4–5)**
in our Bowery loft, and **(PAGES 6–7)** in
Paris in front of a poster for Blondie, 1978.

Published in 2014 by
Rizzoli International Publications, Inc.
300 Park Avenue South
New York, New York 10010
www.rizzoliusa.com

Pages 180 – 181 Courtesy of the H.R. Giger Museum

Edited by Leah Whisler
Designed by Shepard Fairey / Studio Number One
in concert with UnderConsideration, LLC

2015 2016 2017 2018 / 10 9 8 7 6 5 4 3

Printed in China

ISBN 13: 978-0-8478-4363-3

Distributed by Random House

Library of Congress Catalog Control Number: 2014933736

Chris Stein/Negative

Me, Blondie, and the
Advent of Punk

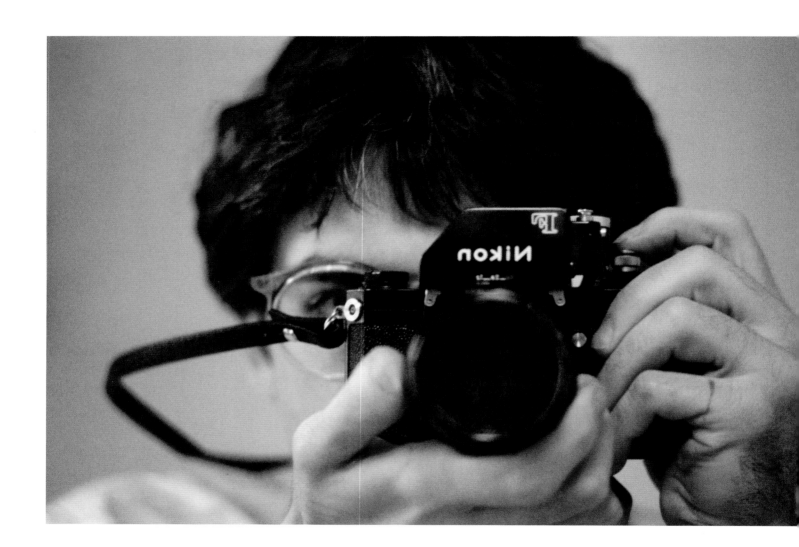

An early "selfie," Nikon F, c. 1976–77.

Introduction
Rock and Roll Retrograde
Chris Stein

I see the same Jean Cocteau quote around a lot, that "film will only become art when its materials are as inexpensive as pencil and paper." With some adjustments to context and price range, we may now, with the Internet, have gotten to the "when" that he refers to.

Of late, I really like looking at Instagram. One hundred fifty million–plus people taking and putting up more than sixteen billion images makes an environment that's somewhat like the one Cocteau spoke of. Instagram is filled with boring snapshots of pets and food as well as brilliant images and bits of art by people who are aware of what they are pressing on their "public." But every now and then I will come upon an image that is fantastic in its innocence, some little illuminated square that makes me really wonder if the person who took it knows how good it is. We are in a culture of frantic recording; at our concerts, we are faced with a sea of hands wielding cell phone cameras. Photography is of the masses.

When I was growing up in Brooklyn, photography was distant and mysterious, as were many other things that were simply "there" but undefined. Music was in a similar place, and I don't know if I gave its workings much thought. I clearly remember being surprised that my first guitar produced more notes than those made by its six strings. I guess the mechanics of life are just taken for granted by kids. I played with a little Kodak camera. I took it on a ghost ride in Coney Island and managed to get pictures of a big, evil *papier-mâché* caterpillar creature and some mean-looking pirates. This was a great success for me. Around this time (age eight to ten), I came upon a picture in a book or magazine of a nighttime, snow-lined street illuminated by an old-fashioned streetlamp. This image had enough seductive power over me that I still recall it all these years later. I "got" the idea of photography as time travel, of moments frozen and stilled, of windows into the past.

At age eighteen or so, I met a fellow Brooklyn kid, Dennis McGuire, who was a terrific photographer. I later found out that he had apprenticed for Diane Arbus. He, along with another close friend, Joey Freeman, hung around the periphery of the early Warhol Factory. I have to credit Dennis as a major influence; he almost single-handedly got me into carrying around a camera and taking pictures that I thought would become something beyond the images themselves.

I pretty much missed the sixties with my early attempts at picture-taking; I wasn't packing a camera full-time yet. My first year at the School of Visual Arts (SVA) in New York was 1966–67. I left for a few years to be a hippie, then came back in the early seventies. I was a fine arts major, but this was at the height of early conceptual art, which I found sort of dry, so I drifted into photography.

The pirate photo I took on the Coney Island ghost ride.

SVA was a hipster breeding ground and I started seeing flyers for something called the New York Dolls on the lobby bulletin boards. I think initially I thought it was a drag act, but I eventually came upon a *Village Voice* review that identified them as a rock band, comparing the singer to Mick Jagger. I went to see them at the Mercer Arts Center. Opening for the Dolls was a band called the Magic Tramps. Long story, but I fell in with them and their lead singer, Eric Emerson. I helped them move equipment (roadie) and took photos of them. I got them a job playing at the SVA Christmas party in 1972. (Oddly, one summer night before I met them at Mercer I was staggering around the hot Bowery streets with some friends and we stumbled into CBGB and saw the Magic Tramps playing . . . this was very early on . . . and a bit of foreshadowing.)

The New York music and art scene was small and incestuous; everyone was related. Eric had one of many falling-outs with one of many girlfriends and moved into my apartment on First and 1st. My friendship with Eric led to my attending the first show of the girl group the Stillettoes, which was founded by Elda Gentile, a girl he had a child with and which featured a then-unknown Deborah Harry. The rest is, as they say, history.

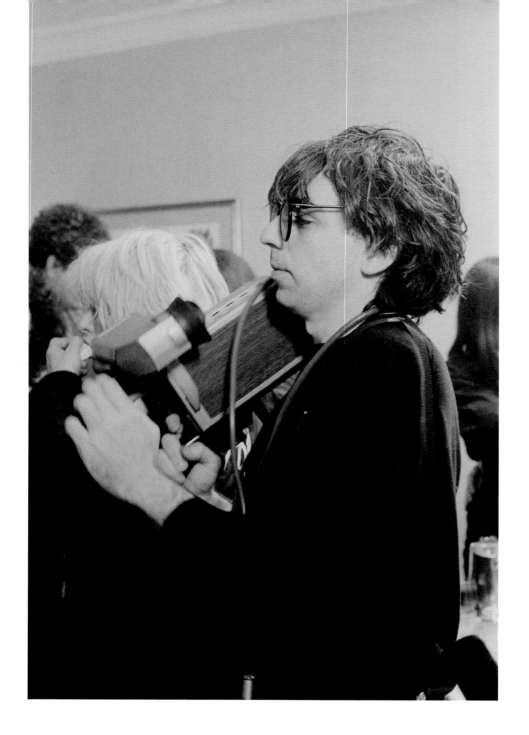

ABOVE This was shot at a party in London, c. 1978–79, I dragged this old-school video rig around for a few years. It was the first Panasonic portable VHS unit with a huge camera—all consumer stuff, the phrase "prosumer" didn't exist. The whole thing was uncomfortably large. I hauled it all around the world and, when we got back to the States, I found out there was a much smaller unit (about half the size) being sold. The batteries of this thing were the size of maybe six Flip cameras and probably didn't last for an hour. Back at the School of Visual Arts, I had used the first reel-to-reel Sony portable videotape units which were even more temperamental. I used the Sony to shoot *Hollywood Spit*, a very early public-access cable show I shot with Joey Freeman, old friend and Warhol apprentice.

OPPOSITE A strip from *Hollywood Spit* and all the characters that made up our cast.

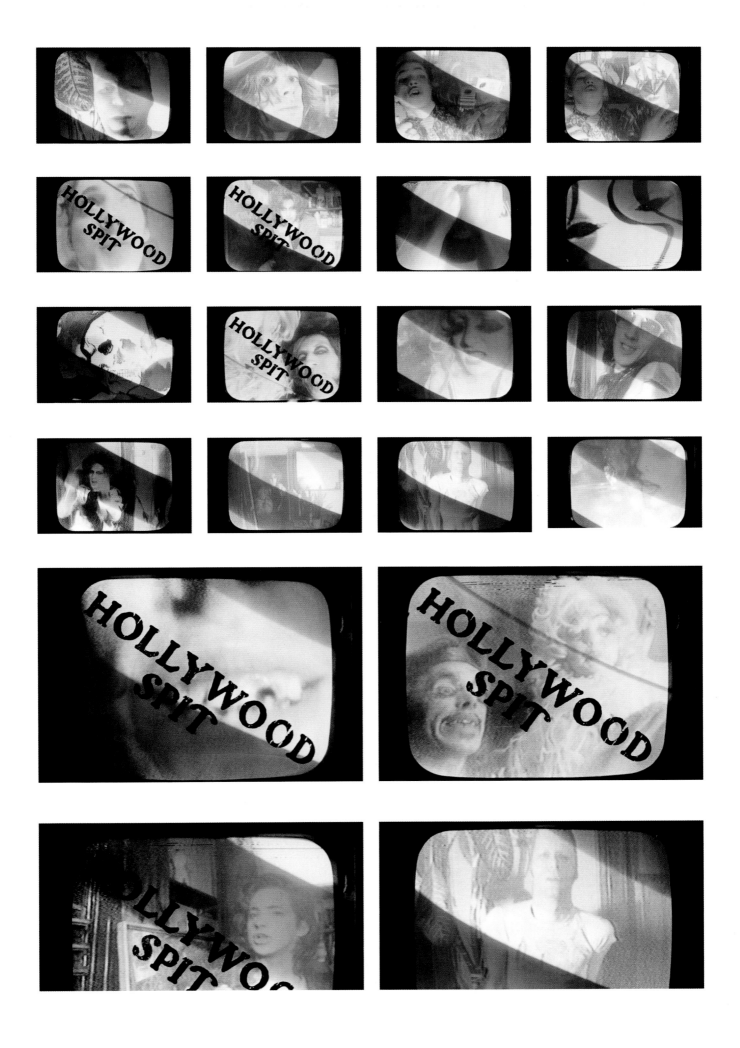

I'm constantly asked to verbally describe "the days back then." It's as if the sixties didn't exist, such is the rabid interest in the seventies and the advent of punk, new music, etc. No matter how much regret I beat down about this or that missed thing, I never forget how lucky I am to have been part of these events, this time. It was the best and the worst. New York hadn't yet emerged into the light of full-blown, rampant consumerism. Today, in boutiques in New York, I see things for sale for thousands of dollars that emulate and reference stuff we bought in junk stores for next to nothing. Living space was cheap and no one talked about real estate. The moment is well defined by Scorsese's 1976 *Taxi Driver*— the heat of the streets, the fog, the violence, and the desolation; yet the hope in the midst of it all. By 1975, we were plunging ahead with the band and I was taking lots of pictures of everything around me.

Among these "things" was Debbie Harry, my longtime friend. I was always aware of her astonishing looks and the effect she had on people. She and I collaborated on photographic images of her. Some of these shots were out in the world in advance of the music we worked on. There was no viral marketing then; things moved slowly. The New York underground music scene was rife with visual content. There was a deliberate deconstruction of the art and fashion that had been popular, a backlash against the conservative forms that everyone was so bored with. In the sixties, the cultural revolution was conducted in the middle of a thriving economy. Now, things were sliding downhill. The great recession of the seventies, triggered by a doubling of oil prices, began around 1973. I'd always been a fan of decay and dissolution, and here we were surrounded by decline on all sides.

I often think that this theme of beauty amid rubble is what maintains. (I think of the Lenny Bruce monologue wherein he describes his perhaps grudging acceptance of pop music; how much he is moved by "Rose in Spanish Harlem.") My fellow denizens were glamorous; Richard Hell, Johnny Thunders, and others exuded as much visual charisma as Debbie herself. I was surrounded, too, by great, creative, driven photographers—Robert Mapplethorpe, David Godlis, Bob Gruen, Roberta Bayley—this was a moment for the advent of a new photography that was emerging alongside a new music.

I am always asked if I thought I would still be doing this thirty or forty years later. And I answer that I was very much "in the moment" back then, and back then, I don't think anyone else was giving much thought to the future either.

I think the pictures are successful. People seem to like them. Sometimes they become the objects that I am looking for, that is, something more than just the images. My photo heroes produce work that transcends the images on paper. Arbus's pictures of people and even objects are more than portraits; they describe the relationship of subject and object, her own psychology somehow imposed on both the person in the shot and the viewer. I love Brassai's milieu for more than just its time-travel glimpses. His pictures of graffiti, hookers, and people hanging out in bars exist as objects in the same way great sculptures take up emotional space.

Now, we've turned the corner into the future that we've been hearing about for the last hundred years. This future rains upon us in fragments that hint at its potential. Maybe we will never get there; maybe the future will always be slightly out of reach. Maybe my kids will be able to have their memories mined. But memory is subjective, and even if we can hook up to the machine and look at our thoughts, will that make the data any more real or credible? Photographs exist outside the feedback loop of our capricious thought processes. They ground the moment in some semblance of solidity.

Voyeur
Deborah Harry

I had no idea that Chris was a voyeur when I met him. How could I know? His mother told me when we met that his personality was fully intact as a tiny baby. This uniqueness, a voyeuristic infant, was just the beginning of getting to know Chris Stein. I found a definition of voyeur: "An obsessive observer of sordid or sensational subjects." An observer, who, in Chris's case, takes photos of the things that catch his eye.

I'm joking . . . a bit . . . because he does have a good eye and it's proven by the wonderful photos he's taken over the years. Sometimes, I would follow him and take a shot of the same thing that he had just shot to try to understand his vision and point of view. This was fun and interesting but it didn't really explain how he looked at the world and what inspired him to shoot a picture.

When you get to know another person, you talk about yourselves, your histories, schools, tastes, etc. Chris went to Quintano's School for Young Professionals after he was kicked out of Midwood High School in Brooklyn. We found out years later that Johnny Thunders went there, too, but not at the same time. After high school, Chris attended SVA (School of Visual Arts) in Manhattan, where he studied art and photography. Chris told me early on that he had always taken pictures, even before art school, and he showed me some of his work. Most always black-and-white, pre-digital with real film, shot full frame, rarely cropped, his pictures were printed with a rough-edged, irregular black border and they really said something to me. The subject matter was varied but the clarity was the same. The singularity of Chris's-eye view of the world comes through in every shot and the pictures are interesting. They lead you into situations that make you wish you had been there, too. Somehow, his photos almost convey a scent. You can almost smell the scene in the shot or feel the temperature of the room.

Looking at his photographs with intention is really like being there. When we first started touring around the world, shooting the sights was the most fun and we went to some pretty exotic places. We played in Bangkok in 1977 (I think) on the New Year's Eve, they finally lifted the 11:00 p.m. curfew of the Vietnam War era. The streets were shockingly different from anything either of us had ever seen before: an open sewage system, beggars with leprosy, and tiny babies on rope leashes also begging. The overwhelming heat mixed with the smells of humanity living without paved streets and plumbing was mind-blowing. Of course, Bangkok today is much different, but when I look at Chris's shots from that time, it's all there: those smells, the heat, the leap back in time . . . amazing.

Light and dark, contrasting moments in his New York City, the people of New York City, the city where he was born.

We started working together, Chris and I, in 1973. I sort of got used to seeing him with a camera, always taking pictures, so when he started shooting me, it wasn't much of a shock really. After all, we were in the same group, the Stillettoes, and Chris had a casual ease with a camera that belied how well he knew his f-stops. I never felt comfortable in front of a camera and never liked seeing photos of myself. Chris's sense of humor and easy, relaxed personality made me feel relaxed, too, and eventually, I started to like being shot by him, which has led to his photos of me being seen worldwide. There was an easy trust that I felt standing in front of his camera. I've watched him suggest to total strangers, without even actually speaking, that he'd like to take their pictures, and so I know he must have made them feel the same way. All of the experiences I had with Chris as his subject in those early days gave me a confidence that made it possible for me to do photo sessions with some of the world's most famous photographers. Because of our personal relationship, I think, Chris's pictures of me are the most real and unguarded and ultimately revealing.

Those days, and the nights at CBGB, were full of characters, and you will meet some of them in the following pages. I remember when we set up the enlarger in our apartment on West 17th Street. The kitchen was really large, and after developing the film, Chris would print then hang the photos under the skylight after a substantial amount of muttering and cursing. I'm sure some of the shots included in this book are from those same negatives. And I am sure you will enjoy seeing Chris's photos and reading his comments about them—along with all his stories about the scene and the characters that have filled the frames of his camera lens.

One of my favorite pictures that Chris has taken of me.

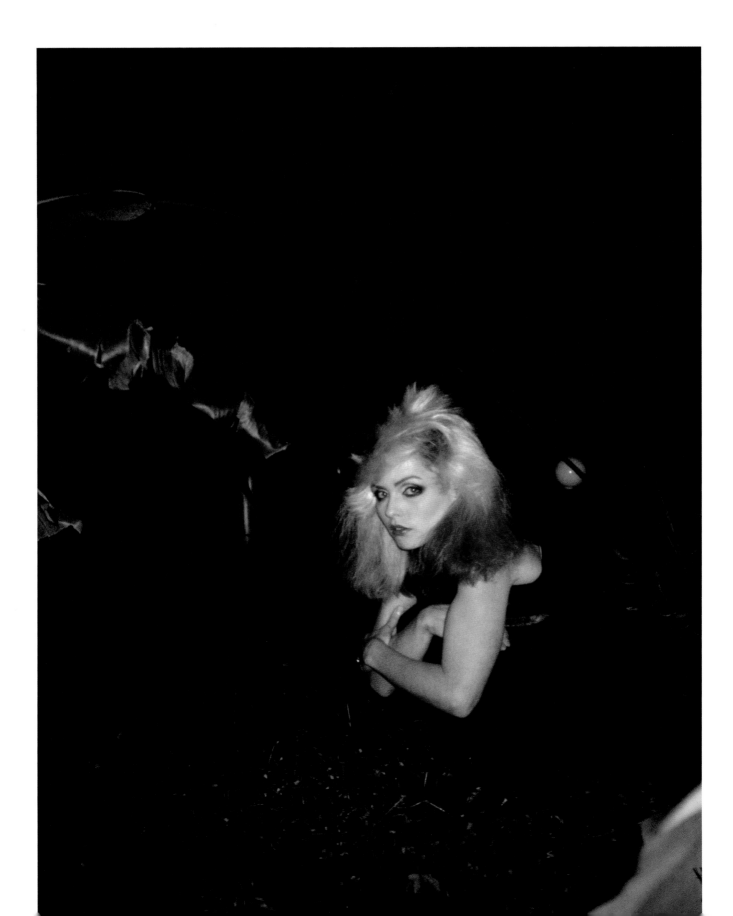

The Light Side of the Dark Side
Glenn O'Brien

Chris says, "It was the best of times; it was the worst of times." That was Dickens's *Tale of Two Cities*, but in the late twentieth century, New York was also at least two cities, one of which was downtown. For a little while, it was the center of the art and music universe.

I think it was the kind of best times that can only happen at the worst times. New York was poor and run-down and violent and scary and glamorous and fabulous all at once. New York was dirty in terms of actual filth and it was also dirty in terms of sheer prurience. The dirt kind of made us stand out.

New York was way more New York then. People came to New York because you could be yourself here. You could be an artist or musician or a ballerina or a drag queen. You could be a freak, a sexual outlaw, an artist, or a bum. It was OK. People were too busy being themselves that they didn't bother you about being you. A lot of people found this to be a very fertile and productive time. You could go to Max's Kansas City and see Bob Rauschenberg in the front and Johnny Thunders in the back, and that just seemed normal.

Chris wasn't the only renaissance punk. We all did everything. We were all musicians, songwriters, actors, filmmakers, painters, writers, producers, directors, comedians . . . drug addicts. Why not? We lived in squats, abandoned factories and warehouses, tenements in transition, even literal holes. There was no money, no jobs, but we had a lot of time to perfect our crafts. It's not like we had to work.

In poor, old, dangerous New York, the youth of downtown Manhattan did almost everything, often very well. Sometimes somebody did more than one thing very, very well. Paint and play guitar. Write and act. It's very New York, but at the same time kind of un-American. Two or three professions is almost as eyebrow raising as two or three passports. You must have something to hide. People like that tend to scare normal people, who aren't all that good at their one job.

So since Chris had a pretty good gig playing in Blondie and writing songs, some people, especially photographers, might have thought that his taking pictures was taking work away from a real photographer somewhere. Except that all the real photographers I knew thought Chris was really good. The photographers knew, but except for a picture published here and one in an exhibition there, most people didn't know Chris took all these great pictures. Sometimes renaissance ambidextrousness and the trans-disciplinary chops of multi-tasking artists are only realized and appreciated many years later. Fuck, huh? Anyway, here's the book so see for yourself.

I had a *New Yorker* cartoon in my desk drawer for years. Cocktail party conversation: "You're a writer? Oh, I write." Imagine a whole career of that! You're a photographer? Oh, I take pictures, too! *[Sneeze.]* But Chris really is a photographer.

OK, Chris Stein was also a great songwriter, a great guitarist (king of the E bow), a great cable TV star, an intrepid record producer. He was also a really great pothead—like a pagan rasta. He was also a scholar of non-scholarly things, like the history of magic in the twentieth century, beatnik history, and radical anthropology and cosmology theory, conspiracy theory, and various other outlier intellectual realms. He knew complex shit other people didn't know, when he saw a door, he went through it. Even if there wasn't a floor on the other side. He has always been a daring and intrepid cat.

That he has a great eye is evident here. He also found Debbie, which is also pretty good looking out. If Chris has his eyes open and he has a camera with him, he will find meaning in an otherwise inscrutable view. He will see what's really there.

He was always a natural photographer and he also had the advantage of getting to go places other people don't go. Being in a huge band means travel and all access and entrée to the exclusive and hidden worlds. He has a permanent, invisible backstage pass. Chris met people others don't meet. Because they wanted to meet him. He was famous but didn't care; he had that air about him, that made people want to find out what he knows. Not that he would let on, but he might just give you a hint.

Dude goes to Burning Man every year. Hung with Burroughs. He's friends with Iggy and the guy who designed the alien in *Alien*. He knows more about Nazis than the Mossad. He probably has some of Aleister Crowley's kitchen utensils.

Chris is an artist first. He was never in it for the money. Blondie has some money now, I guess, but he was in it for fun and glory. I remember when they had the number one single in the country and I lent him $50. For Chris, it's all knowledge and experience, beauty and irony.

Chris said this book might be called *Negative*. That's funny if you know him. Chris knows what dark matter and dark energy are. Chris has always been attracted to the light side of the dark side of the force. He understands chiaroscuro and negative space and negatives in photography and elsewhere. In Blondie, Chris wore the mantle of Debbie's boyfriend so lightly because he understands shadow. He was always good at lurking.

He knows what William Burroughs knew. The secret of invisibility is seeing the other person first. Chris was the kind of secret ringleader of punk rock. Occultists used to talk about the Secret Chiefs. In the art and music world, Chris is one of the secret chiefs. He will, of course, deny this. But the proof is here. Look at all the people he found and what he did with them. These are famous people in their pre-famous period. Chris shot them and processed them and the rest is history.

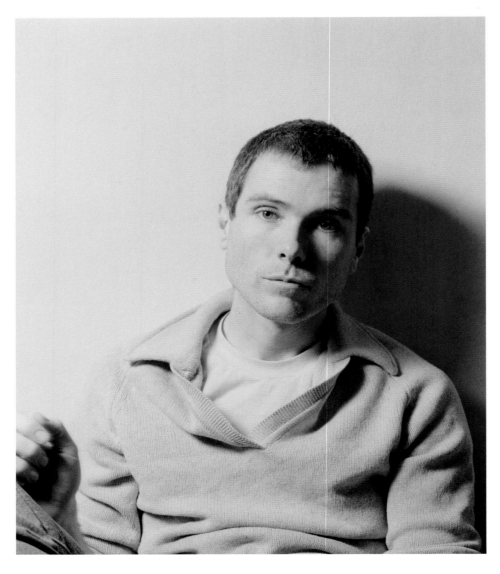

LEFT An early portrait of Glenn I took in our 58th Street apartment, early eighties. Glenn and I once bought the *High Times* magazine centerfold and smoked it. I must have run into him at first during his time with his band Konelrad (Control of Electronic Radiation, an emergency broadcast system established under Harry Truman in 1951). These days, Conelrad is a metal band from Pittsburgh which has nothing to do with Glenn's old band that played at CB's. Glenn's torso can be seen in underwear on the interior of the Rolling Stones' classic *Sticky Fingers* album that Andy Warhol did the graphics for. (The exterior shot of the jeans with zipper is supposed to be Joe Dallesandro.)

OPPOSITE Glenn and Victor Bockris on the set of *TV Party*, c. 1978–82, the "television show that's a cocktail party but could be a political party." It was the brainchild of my old buddy Glenn O'Brien. This was about six years after our *Hollywood Spit* days, and public-access TV in Manhattan had come a long way in spite of its still very limited reach. By this time there were a whole number of "shows" up and running— amongst them shows like *Robyn Byrd* and *Ugly George*, which were completely comprised of prurient content. *Robyn Byrd* was a kind of porn chat show with a devoted following. Ugly George walked the streets of Manhattan wearing a silver jumper while attempting to coerce girls into

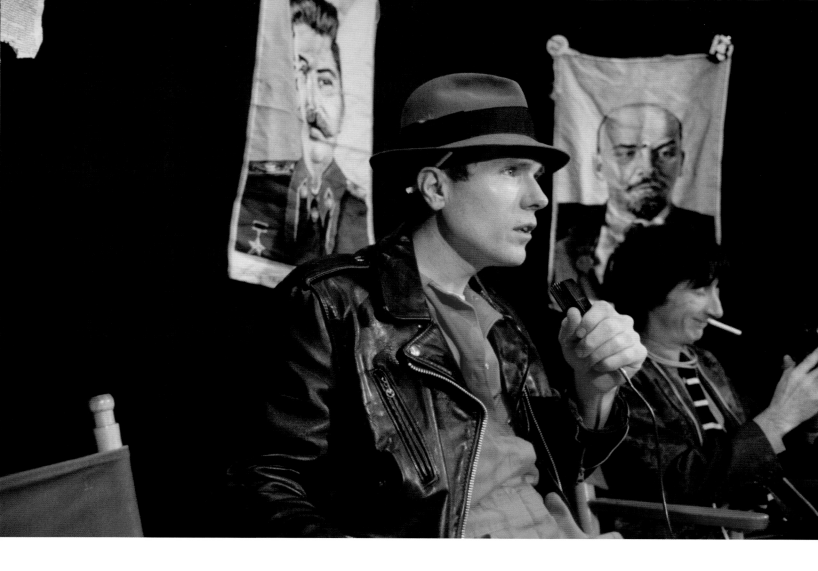

removing their clothing in "dimly lit hall-ways." It was odd, not too many people were actually watching this stuff but the public-access airwaves were filled with an assortment of colorful characters.

One night, Glenn wound up on a show that was hosted by Coca Crystal, an activist and feminist he knew from his days at *High Times* magazine. The show was called *If I Can't Dance You Can Keep Your Revolution*, a phrase from Emma Goldman, a feminist and anarchic writer from an earlier time. The following day, when he was riding on the subway, Glenn was approached by several people who had "seen him on TV" the night before. The rest is history. Glenn was the host, I was the co-host, Walter was "Doc Steding," the bandleader. Fab Five Freddy (Brathwaite) and Jean-Michel Basquiat were frequent camera opera-tors and cast members. Amos Poe was the director (Amos became known for his quirky camera work; frequent shots of feet, etc.,). The show ran for about ninety episodes and guests ran the gamut: members of the Clash, Talking Heads, Klaus Nomi, Debbie, Iggy, a rare TV appearance by George Clinton and the Brides of Funkenstein—really too numerous to mention here.

The show cost about ninety bucks per episode so, rather than go to a club on Tuesday nights (somehow it was decided that Tuesday was the ideal day to be on a TV show, it being the right distance from the weekend . . . there was some truth here—years later, Clem and I realized we never saw *SNL* in the early days because we were always out on Saturday nights), everyone would collect in the Blarney Stone bar on 23rd Street, then go up to ETC Studios and do the show. Sometimes, we would collect funds from the twenty to fifty or so people who would wind up on the show or in the audience.

The show was live, which made for some very spontaneous and crazy moments. I always thought that answer-ing phone calls from the viewers made up for us not really having a clue as to how many people were really out there. The phone calls were often really abusive, but we encouraged that and we had people who called up regularly to shout insults at us. After a year or so we started having "theme nights"—Primitive Night, Medieval Night, Heavy Metal Night, Country and Western Night, etc. One Halloween, Freddy came dressed as a nickel bag. We smoked pot constantly on the show. Finally, I hooked up with a public-access station in LA and we sent tapes out there. The LA version of the show was only a half hour as opposed to the regular hour so we got to say "goodnight to our West Coast affiliates!" To quote Glenn: "We all thought we'd be discovered by Hollywood but all that came out of it was that Black Flag wrote a song called 'TV Party.'" One can find episodes and a good documentary at www.tvparty.org.

Victor Bockris is a writer. He co-wrote the text of my first book of photos with Debbie. He introduced us to Bill Burroughs.

The Lincoln Hotel between 44th and 45th Streets on Eighth Avenue, as seen from a taxi in Midtown Manhattan, New York, early seventies. Relating to taxi drivers is a whole art form unto itself. I've gotten some amazing stories from cab drivers, not the least of which was from a guy who had been a tail gunner in a B-52 during World War II. He told me a long anecdote about bombing an oil refinery in France and how the explosion looked like "a giant rose . . ." On another occasion, I wound up with an extremely crazy female driver. She related that she was married to Steven Seagal, who was being kept from her by the machinations of Scientologists and various Illuminati. She went on to tell me that Mick Jagger was, in fact, two different people—one good and one evil. This was all delivered with the utmost sincerity and lack of irony. I wish I had recorded her dialogue.

NEW YORK

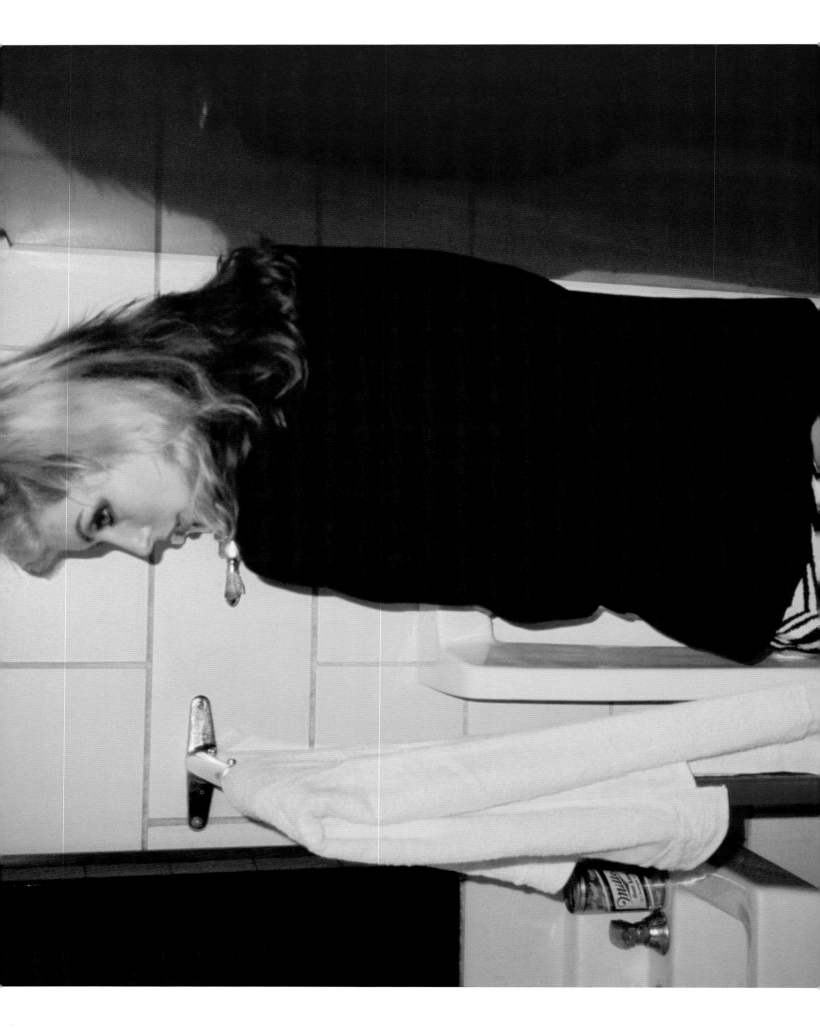

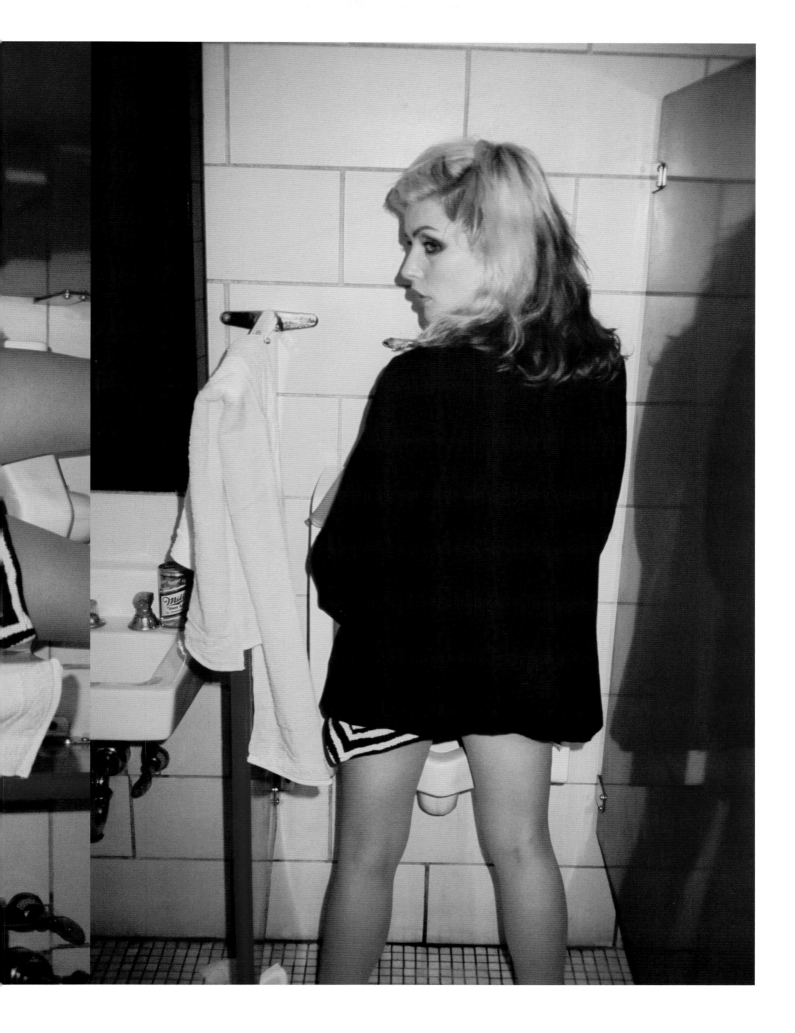

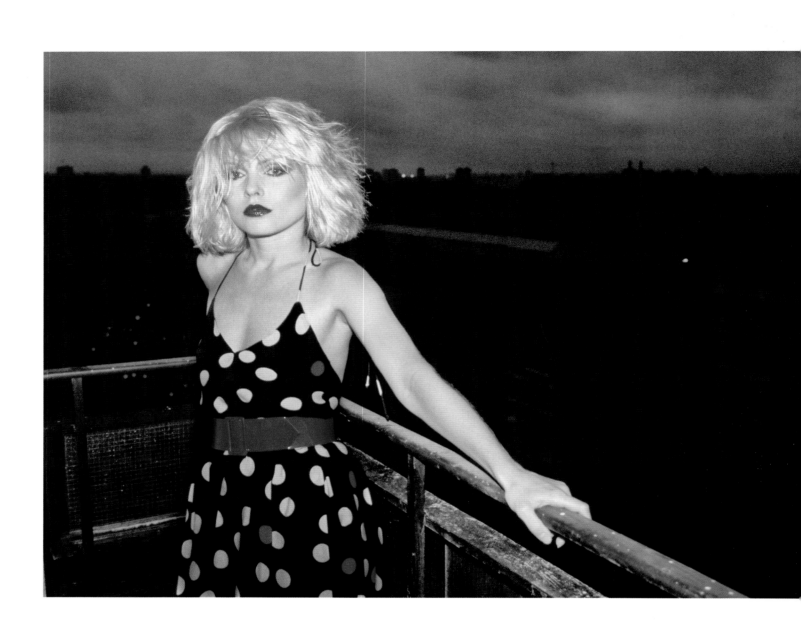

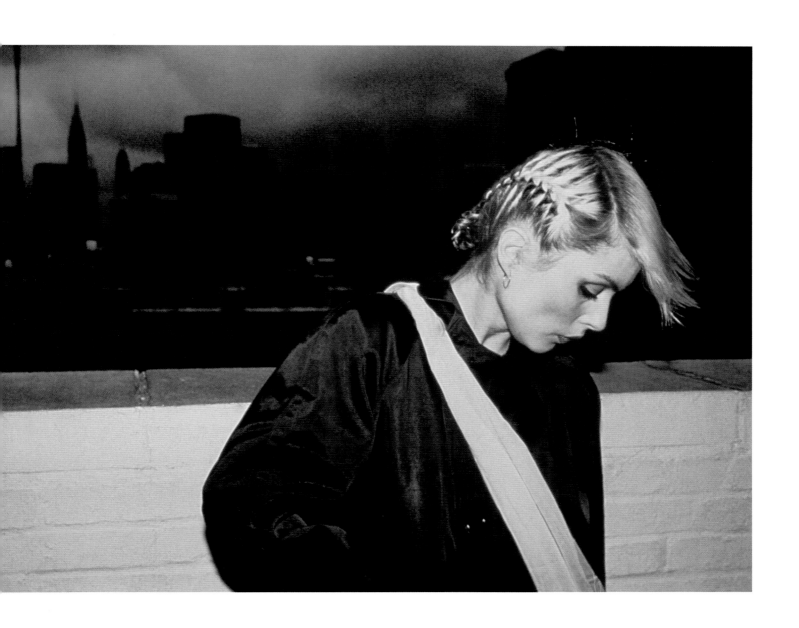

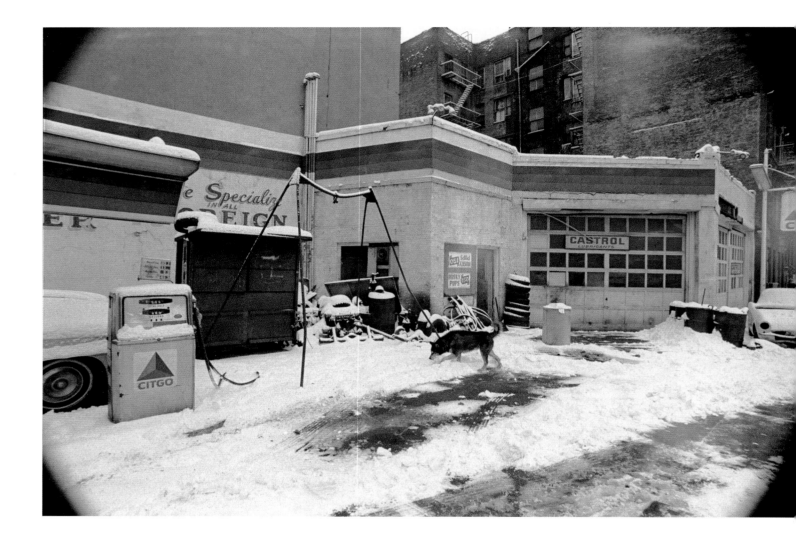

PAGES 22–23 Debbie stands for female equality.

PAGE 24 Debbie on a New York rooftop. The dress was a prop from the film *Union City* that she was the lead in. The film's costume designer got it in a thrift shop. The polka dots were originally all white and some were colored red for the film.

PAGE 25 Debbie after a shoot on top of the Gramercy Park Hotel.

ABOVE Around Great Jones Street, New York, early seventies. This shot amazes me in terms of its contrast to current glamour glossy New York conditions. This is when parts of the South Bronx resembled the bombed-out European cities of World War II. Poverty and rough conditions were all around. Scenes like this were commonplace and oppressive yet fertile ground for artistic endeavor. It was cheap to live in the city. I don't know if I ever heard the word "gentrification" at this time. I know that the intense interest in the period now is in part a reaction to the romantic image of people thriving and creating amid squalor and decay. But there's a practical side, and that is the fact that it didn't cost much to live and be creative in New York then. I often wonder now how young people can maintain a focus on art while having to produce thousands of dollars to cover monthly living expenses. I have never had a job of any kind outside of the band situation. I painted a bathroom once. True story. The gas station in the shot is long gone, replaced by some high-rise or other.

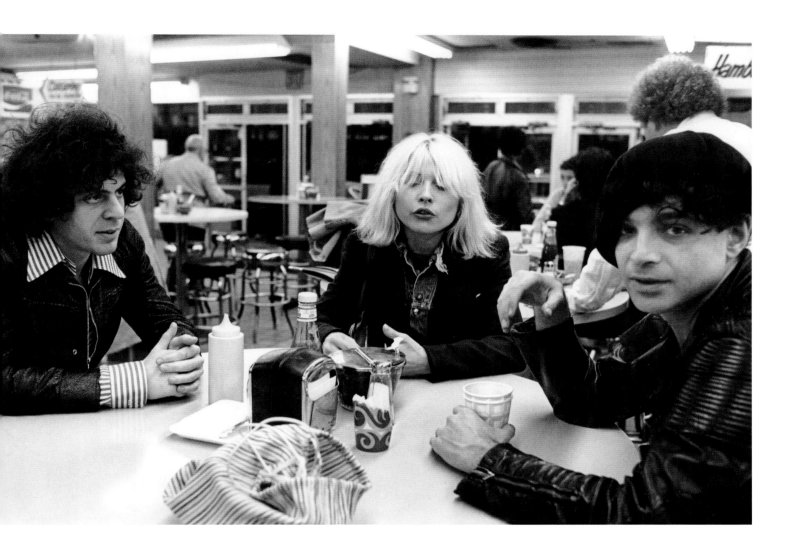

ABOVE Debbie with Suicide. Debbie
with Martin Rev (left) and Alan Vega
(right) at someplace, maybe around
Times Square, back when that area still
had soul. Suicide were revolutionary
genre inventors, even predating the
New York Dolls by a year or so, starting
around 1970. They were pioneers in
experimental electronica.

Eric Emerson and girls from the band Teenage Lust backstage at the Mercer Arts Center, New York, 1973. Mercer Arts was pretty much my first introduction into the new New York rock scene. The place was opened as an arts center in 1971 by artists Steina and Woody Vasulka and soon expanded into a very cool combination of galleries, shops, and several different sized theater spaces. It also had an unofficial connection to Max's and was frequented by a lot of Max's patrons. While still at Visual Arts, I began seeing flyers on the school lobby bulletin boards for a band called the New York Dolls. Oddly, I'd met David Johansen (one of the members of the Dolls, whom you might also know as Buster Poindexter) around 1968 a few times. He was going out with a girl from my Brooklyn crew.

I was a big Rolling Stones fan. I'd gotten to see them at Madison Square Garden in 1969 during the US tour that ended with Altamont (a sort of Woodstock of the West that ended in a lot of violence and chaos that has always been on my list of top ten concerts), so I went to check out the Dolls. They were great, but I really liked the opening act, the Magic Tramps with Eric Emerson. I met Eric and the band and began taking pictures of them.

By the time I started hanging out at the Mercer Arts, it was the home of the glitter rock scene with nightly events. Suicide, The Dolls, The Harlots of 42nd Street, and Teenage Lust were among many bands that played there regularly. Mercer was attended by luminaries in the manner of CBGB later on. My favorite story about the origin of the phrase "punk rock" is from an utterly obscure source. Floating around the Internet is a photo of a page ripped from an unnamed magazine. The one-page story is credited to Alexander Liberman, who was most likely the Russian-American editor/artist/photographer who worked for Condé Nast for thirty-odd years. The story concerns the narrator (presumably Liberman) accompanied by Marlene Dietrich and pianist/singer Bobby Short visiting Mercer Arts and watching the Dolls

play. Marlene becomes fixated with Johnny Thunders, grabs him and exclaims "Look at *heem*, he *eez* nothing but a *leetle* punk! *Dey* should call *dees* punk rock!" (Dialect is directly from the piece.) Thus, the story is usually accompanied by the tag line, "Marlene Dietrich invents the expression punk rock" or similar. I hope this is true but hey . . . all I know about the word *punk* is this story. I can't find the word in German beyond the standard modern usage.

The Mercer heyday was short lived, however. When I was a teenager, a girl I knew was dating an older insane fellow. He was all about being followed by spies, tapped telephones, and whatnot. He told me very seriously that if one came home to their apartment every day and threw up in the same place on the floor, eventually it would rot away and crash down into the apartment below. The Mercer was a part of the Broadway Central Hotel, which, when it was built in 1870, was declared "America's most palatial hotel." By the early seventies; however, Broadway Central was a massive welfare and transient hotel. There was always an outcry about the hotel being refurbished but it never happened and the place kept getting more and more decrepit. Finally, on August 3, 1973, it collapsed, killing four of the three hundred or so people in it. The story circulated that members of the Magic Tramps were sound checking that afternoon and ran out of the Mercer Arts Center holding their instruments over their heads as plaster and debris rained down around them as the Mercer (connected to the hotel) also collapsed. Over the years, when I think about the incident, I often relate it to the story the crazy guy told me about throwing up; that a whole eight-story hotel filled with people puking regularly might have caused its collapse. Anyway, a month later, I met Debbie.

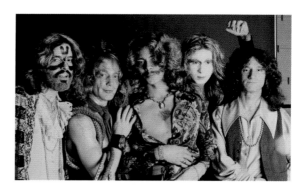

ABOVE Magic Tramps, from left to right: Wayne Harley, Eric Emerson, Kevin Reese, Sesu Coleman, and Lary Chaplan, c. 1972. By a weird coincidence, several years before my induction into the New York music scene, on a hot summer night in what was probably 1972, I wandered into CBGB, near my apartment on First Avenue and 1st Street. At this point, CB's was still called Hilly's on the Bowery and it was a few years before the scene began in earnest. Eric Emerson and the Magic Tramps were playing there and their sound was significantly enhanced by the violin playing of Lary Chaplan, who was a terrific, classically trained musician. Their closing number was usually a rousing rock rendition of the *William Tell Overture* that included Eric doing a signature yodel. I fell in with them a year or so later.

I started out photographing the band, then doing some roadie work, then wound up performing with them in a few shows. I was helping to move gear for an out-of-town gig in Connecticut. We were driving to the show, which was at a bar. I was in the van with Wayne, Sesu, and the equipment, and Eric and the rest were in a small sports car. We stopped at a roadside place and, as we pulled out, the driver of the sports car started playing chicken with the van. Both vehicles began going faster and faster and, of course, the van plowed head on into a telephone pole. I cracked a tooth and Wayne got a deep cut on his chin. Sesu got his head scraped. Wayne began exhibiting symptoms of memory loss. He was taken to a hospital and stitched up—the doctor was quite surprised by his beard, which was dyed green. They still played the show. I returned to the city with another member, while Eric and the rest stayed on to party with the locals. A few days later, I heard the story of their arriving, battered and bruised, at someone's house and being greeted with cries of "THE BAND IS HERE!" and assaulted with jars of Vaseline while they attempted to rest. The Tramps would frequently light candles onstage during shows. At another show I was at, Kevin, the guitar player, backed into a lit candle and his hair burst into flames. He just shook it out and kept playing; it was awesome.

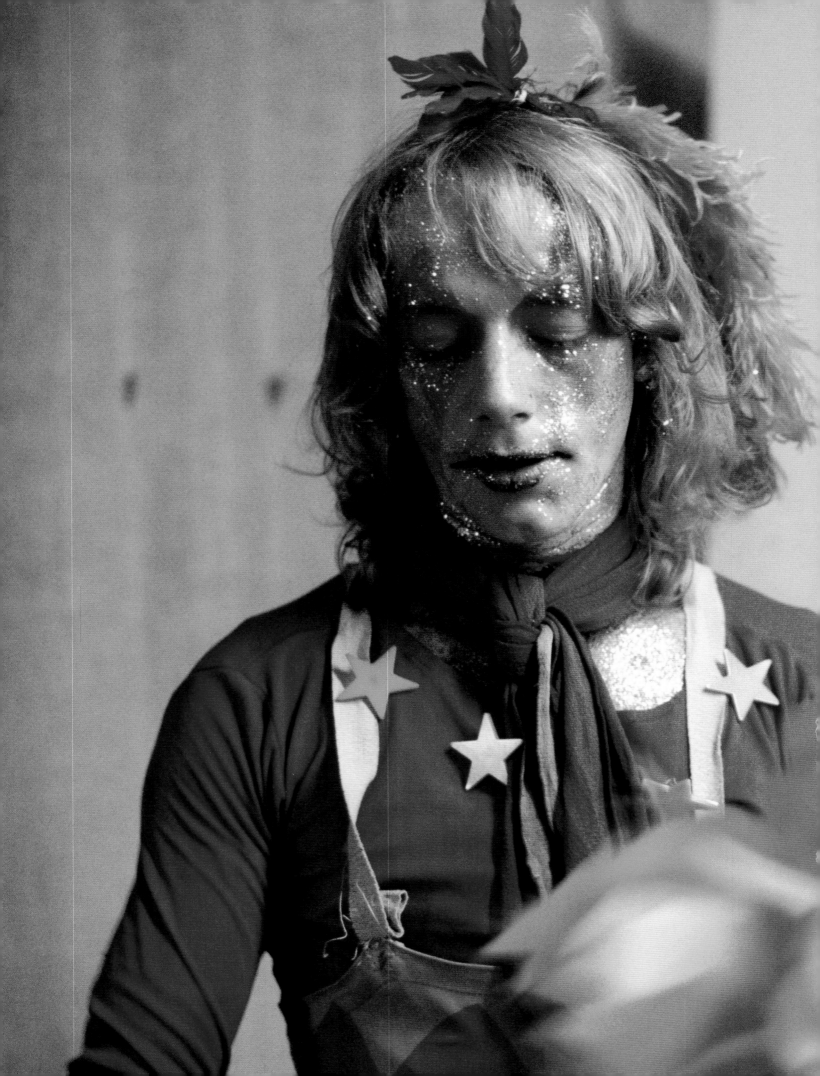

PRECEDING SPREAD Eric Emerson was a downtown fixture, tastemaker, and all-around burning personality. I was lucky enough to be involved with him up to the time of his death in 1975. He was a Warhol Factory regular. The story goes that Andy saw him dancing at the Dom and asked him to be in a film. He has featured parts in *Chelsea Girls*, *Lonesome Cowboys*, and *Heat*, among others. His exploits are legendary; he told me that he once got into a fist fight with Rolling Stone Brian Jones over a girl. I shot him and his band, Magic Tramps, in 1972 during a session at the School of Visual Arts (SVA) in New York, then booked them for the school's Christmas party that same year. This was early on in our friendship. We wound up living together in my apartment at First and 1st on the Lower East Side. In those days, hipsters were few and far between. The building we lived in was almost entirely made up of lower, middle-class working people, and most of them found us very strange to say the least. We were avoided, as my apartment was often abuzz with late-night activity.

Debbie and I visited Eric the night before he died (May 28, 1975) at his apartment on Greenwich Street (what is now Tribeca but then was a nameless part of the larger "SoHo"). He was really intoxicated and it's possible that he went for a bike ride really impaired. We were awoken the next morning with word of his death in a hit-and-run accident on the West Side Highway. I don't know exactly what happened. There are conflicting stories about his end, and we will never really know. It's tragic that he died right before the downtown music scene started receiving any attention. He worked hard with his band and they never even released a record. Eric was a huge influence and a personal mentor; he connected me in a big way with the New York music scene.

OPPOSITE From left to right: Tomata du Plenty, Carol Thompson, and Joey Freeman on the roof of Joey and Howie's loft (Howie was Joey's partner), New York, c. 1971–72. Joey is an old friend who worked for Warhol in the late sixties and got my Brooklyn-based blues rock band the gig opening for the Velvet Underground in 1967. He was a photographer and very early videographer, and together we shot a series of video "shows," which we put on public-access cable TV in Manhattan at the very start of cable service in New York. The show was called *Hollywood Spit* and featured some of our associates from the New York underground music and art scene, including (on the left, in a wig) Tomata du Plenty, who went on to reinvent himself and become lead singer of the Screamers. Other regular participants were Screaming Orchid, Gorilla Rose, and Fayette Hauser. Fayette was an original member of the San Francisco theater group the Cockettes. She was the sister of Tim Hauser, a member of the then well-known pop-cabaret quartet Manhattan Transfer. The four members of the main group did various drag-oriented skits, and they would spend much longer putting on makeup than it took for us to shoot them. We must have done about ten shows, which we would bring to Manhattan Cable on 23rd Street.

In those days, very, very few people had cable in their houses. It was only available above 23rd Street, where it originated, and it wound up mostly in upper Manhattan, in the homes of the more well-to-do. As a result of this lack of attention, the public-access channels were virtually empty. When we gave them a tape to run, they would play it like two or three times a week for months on end—or until we retrieved it. The reel-to-reel tapes were shot with the first generation of portable Sony video equipment.

Joey and I would stay up all night with the cast doing sound, lighting, set decoration, and eventually shooting. Unfortunately, the tapes of *Hollywood Spit* and various other tapes I had shot were destroyed in a fire in Joey's loft, the place we used for a location.

In the middle of the shot is Carol Thompson, who was a close friend of Vali Myers. This was before I met Vali, sometime in the mid-eighties. I had seen images of Vali, the "Witch of Positano," in the West Village scene when I was a teenager hanging out in the MacDougal Street milieu. Vali was an Australian artist who immigrated to Paris in 1949. She hung around the amazing Left Bank underground scene in Paris and became friends with Jean Genet, Tennessee Williams, George Plimpton, and other people, both famous and unknown. In his introduction to *Orpheus Descending*, Williams states that the character of Carol should "look like Vali Myers." Although most people consider the free-spirited character of Carol (Joanne Woodward in the Sidney Lumet-filmed version of the play *Fugitive Kind*) to be based on Vali, I have always thought that the male lead (played by Marlon Brando in the same film), Valentine Xavier, is also a reference to her; the name is right there as a clue. When I asked Vali about this, she said, "Oh Tennessee and me were like that" (crossing her fingers). Vali was a big influence on me. She died in 2003.

Carol was a magical creature. Vali had tattooed Carol's face, and Carol styled herself like Vali, with wild red hair and dense, black kohl eye shadow. She was always accompanied by a ferocious little dog whose name was Oofie—or Oufie. The dog wouldn't let anyone too close to Carol and would guard her fearlessly while she slept. Carol was the only one who had any control over him.

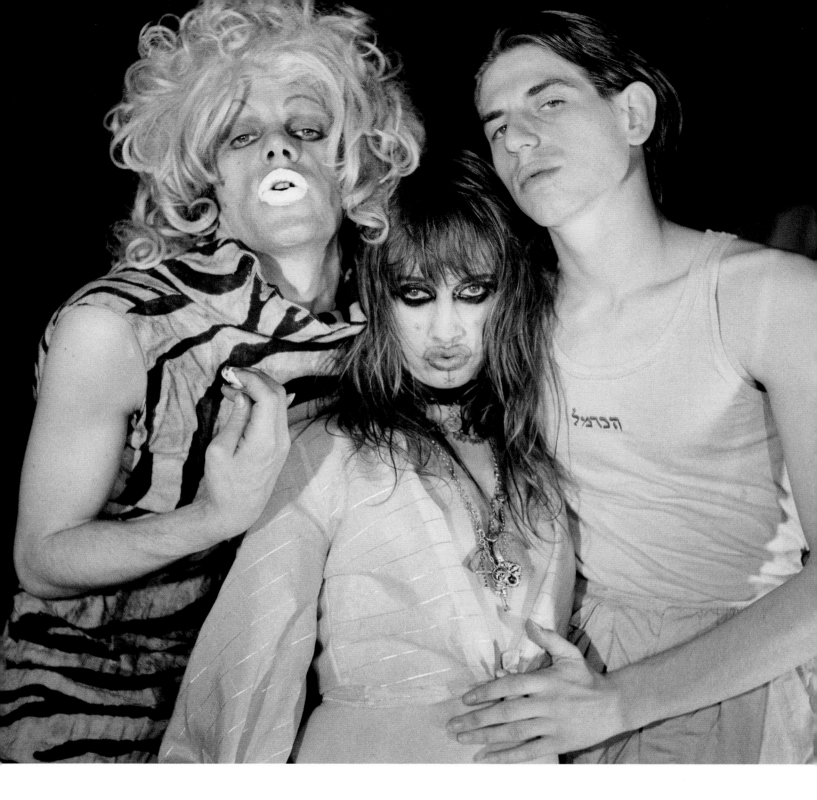

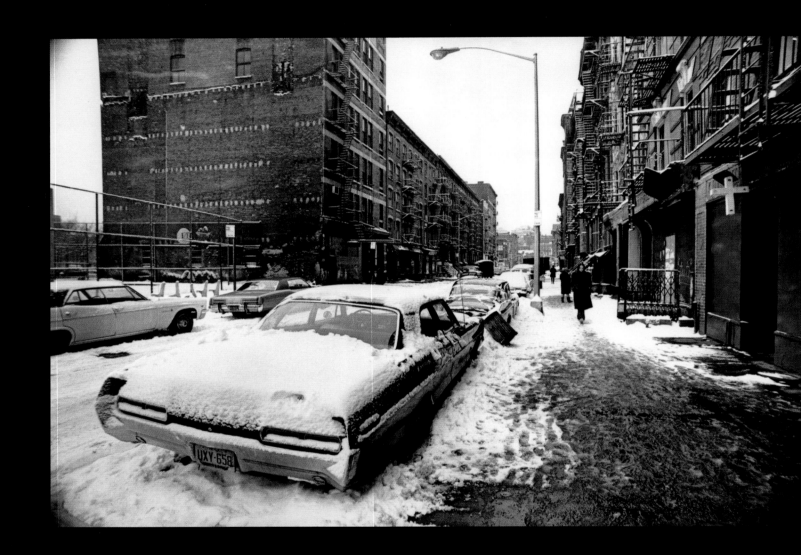

Lower East Side, First Avenue and 1st
Street, New York, 1970. This shot was
perhaps taken the same day as the
gas station/snow shot **(PAGE 26)**,
before I lived on the Bowery. The
apartment I had here was the first of
many in New York. CBGB was nearby.

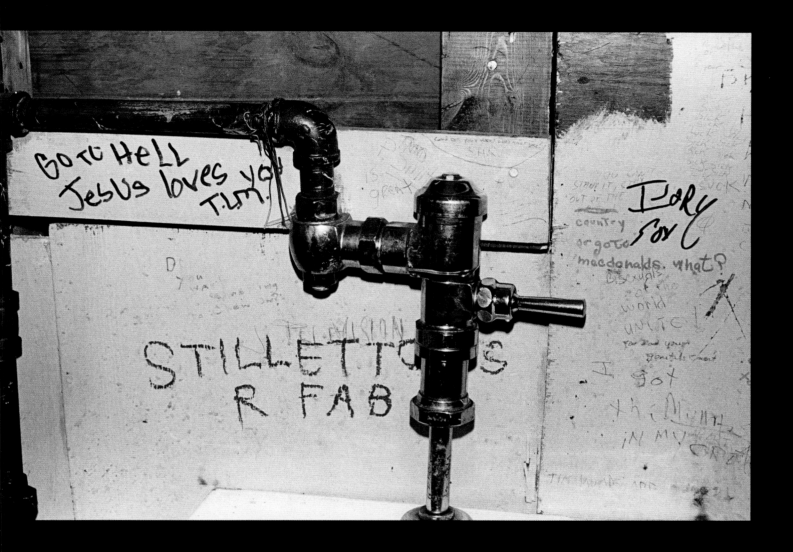

Original bathroom at CBGB, New York, c. 1970s. When we first started going to CB's, the bathrooms were upstairs in the rear. They were moved downstairs during a big renovation that included moving the stage. The downstairs bathroom is the one that gained some iconic notoriety when it was reproduced for the Metropolitan Museum of Art's *PUNK: Chaos to Couture* event and show. I have often come into contact with a circulating story that states that Debbie and I had intimate contact in the CB's bathroom. I can state unequivocally that there is no validity to these tales. Actually, the bathroom was so gross that I avoided it as much as I could.

Deborah Harry, *Punk* magazine center-fold shoot, Bowery loft, New York, 1976. I originally shot sexier images of Debbie, but John Holmstrom wanted something "more punk" and we re-shot. The shot that was used for the centerfold is pretty well known, the one with the baby dolls. For what it's worth, the UK magazine Q voted it the sixth greatest rock photograph (number one being Pennie Smith's amazing shot of the Clash's Paul Simonon smashing his bass guitar). The dolls were just found in the street and brought in by Benton, our landlord. The black leather briefs were also made by Benton, who was a good illustrator and all-around artiste. The Vulture shirt is a sacred relic that Debbie still has, I keep asking her to have it framed. The studded belt is probably the same one "borrowed" from the Dictators. The spider is plastic. The Metropolitan Museum used this shot as one of several images connected to its *PUNK: Chaos to Couture* show in 2013.

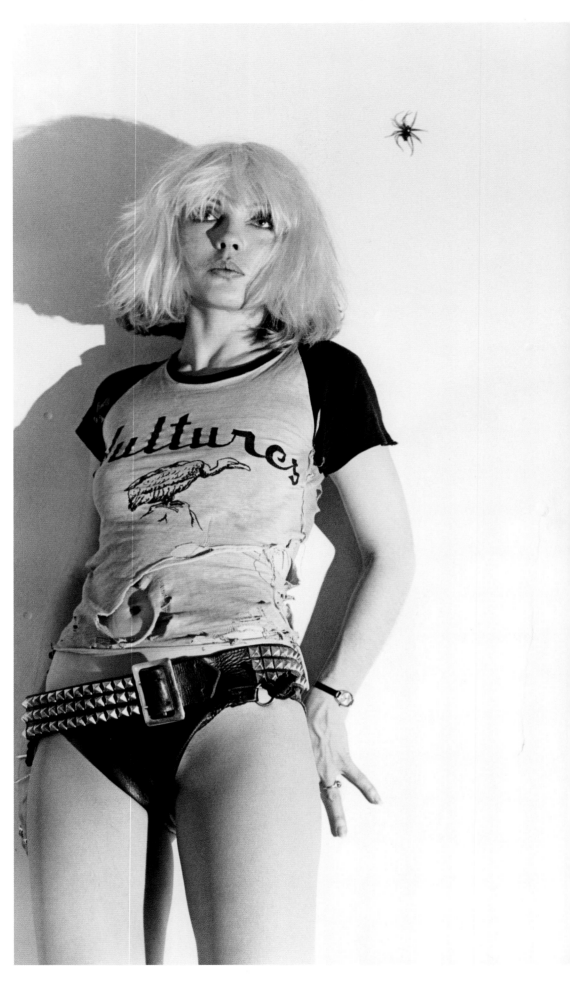

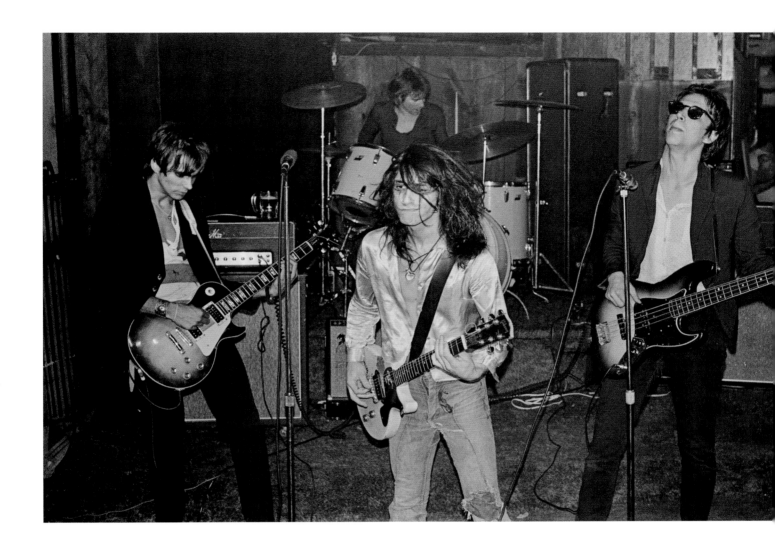

ABOVE The Heartbreakers live at CBGB, c. 1975. From left to right: Walter Lure (guitar), Jerry Nolan (drums), Johnny Thunders (guitar), and Richard Hell (bass). The Heartbreakers were a sort of super-group, composed of ex-members of the New York Dolls, Television, and the Demons. There was a bit of drama as Johnny Thunders was very close with Eliot Kidd, who was a scene regular and, later, lead singer of the Demons. Walter Lure, a terrific guitar player, was a real asset to the Demons and his joining the Heartbreakers shook up Eliot's situation.

Johnny felt bad about taking Walter from the Demons but the change was made. (Eliot died in 1998).

This shot gives a good view of the early CB's configuration. The stage was originally on the left and the bathroom was upstairs in the rear. Later, I guess in the eighties, the stage got moved to center right, where it took up much more space than the old one. Johnny's Les Paul TV model guitar was a personality unto itself. It was allegedly destroyed by Dee Dee Ramone at Stiv Bators' flat in Paris.

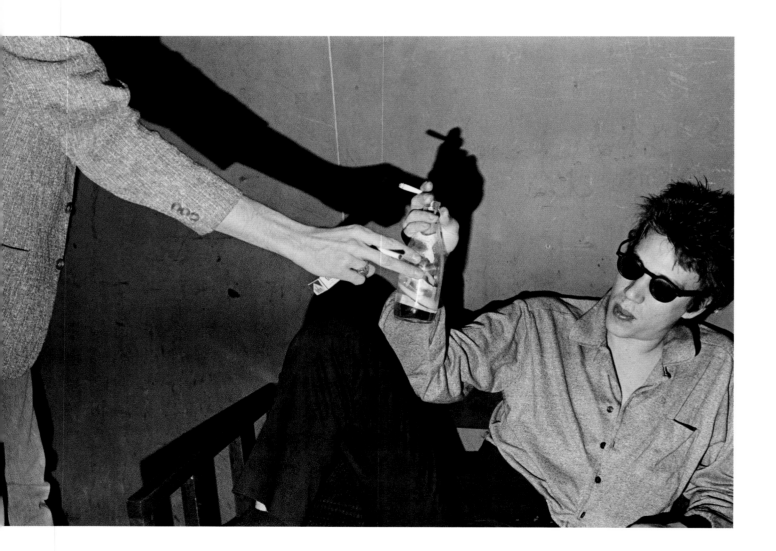

RIGHT The Heartbreakers "backstage" at CBGB, 1975. From left to right: Richard, Johnny, Walter, and Jerry. Backstage at CB's was really just the former kitchen area, which had been the scene of a grease fire, and sections of the ceiling were still burnt. The remains of the kitchen were grotesque and we would joke about ancient hamburgers having been fossilized there. I don't think that food was ever served at CB's during the punk/new wave era [hopefully].

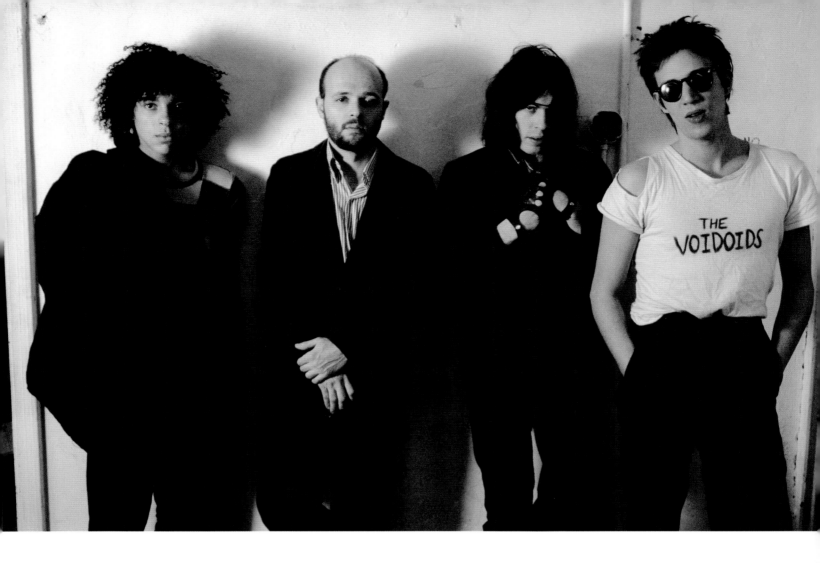

OPPOSITE Richard Hell at the Heart-breaker's last show, Max's Kansas City, 1976. I spent a lot of time hanging around Max's and CB's both. This was shot the night of the last Heartbreaker's gig, and I think Richard Hell was sort of morose. This is a favorite photo of mine—it's very noir. The hand belongs to Walter Lure, who played guitar along with Johnny Thunders in the band. The shadow is produced because the flash is on a long cord away from the camera. I really don't like direct flash.

ABOVE Richard Hell and the Voidoids, from left to right: Ivan Julian, Robert Quine, Marc Bell (aka Marky Ramone), and Richard Hell, 1976. After the Heartbreakers, Richard Hell's last foray into rock music before devoting himself to writing was Richard Hell and the Voidoids. Marc Bell (who went on to become Marky Ramone in the Ramones) was an underground star already with his band Dust, which was a very early incarnation of a metal band. At age seventeen, Ivan Julian toured around Europe with the Foundations. Robert Quine was an innovative genius guitarist

who was embedded in the New York rock underground. He plays on Lou Reed's album *The Blue Mask*, which is considered to be among Lou's best work. Quine's style was singular, bridging jazz, rock, blues, and other elements. He was really respected by his fellow musicians—me included— he was a musician's musician as it were. He committed suicide in 2003, after the death of his wife, Alice. I had seen him on the street not long before, and he told my wife, Barbara, and I how sad and depressed he was.

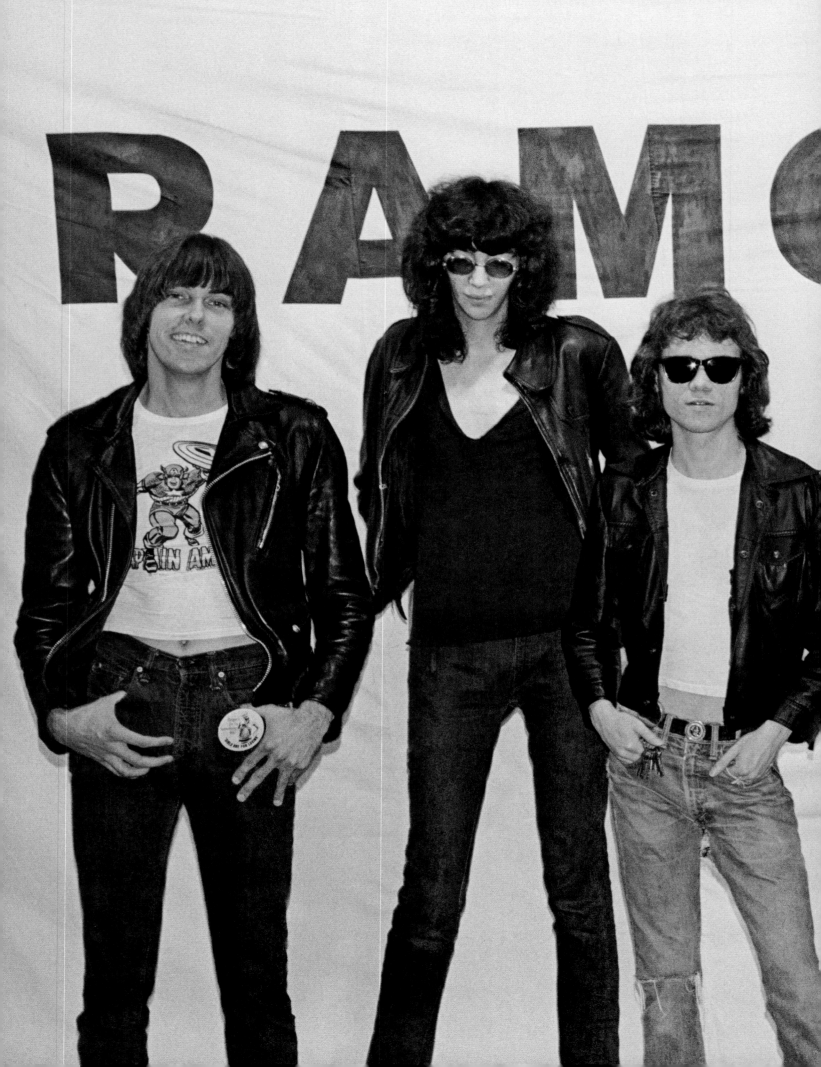

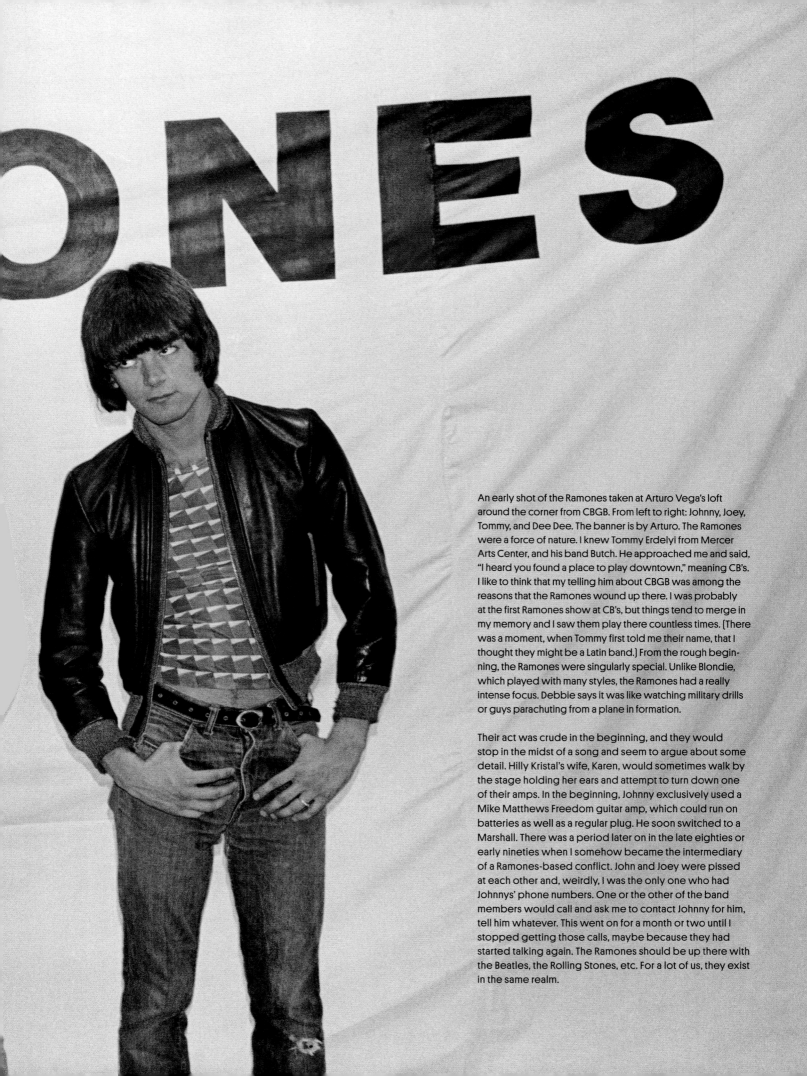

An early shot of the Ramones taken at Arturo Vega's loft around the corner from CBGB. From left to right: Johnny, Joey, Tommy, and Dee Dee. The banner is by Arturo. The Ramones were a force of nature. I knew Tommy Erdelyi from Mercer Arts Center, and his band Butch. He approached me and said, "I heard you found a place to play downtown," meaning CB's. I like to think that my telling him about CBGB was among the reasons that the Ramones wound up there. I was probably at the first Ramones show at CB's, but things tend to merge in my memory and I saw them play there countless times. [There was a moment, when Tommy first told me their name, that I thought they might be a Latin band.] From the rough beginning, the Ramones were singularly special. Unlike Blondie, which played with many styles, the Ramones had a really intense focus. Debbie says it was like watching military drills or guys parachuting from a plane in formation.

Their act was crude in the beginning, and they would stop in the midst of a song and seem to argue about some detail. Hilly Kristal's wife, Karen, would sometimes walk by the stage holding her ears and attempt to turn down one of their amps. In the beginning, Johnny exclusively used a Mike Matthews Freedom guitar amp, which could run on batteries as well as a regular plug. He soon switched to a Marshall. There was a period later on in the late eighties or early nineties when I somehow became the intermediary of a Ramones-based conflict. John and Joey were pissed at each other and, weirdly, I was the only one who had Johnnys' phone numbers. One or the other of the band members would call and ask me to contact Johnny for him, tell him whatever. This went on for a month or two until I stopped getting those calls, maybe because they had started talking again. The Ramones should be up there with the Beatles, the Rolling Stones, etc. For a lot of us, they exist in the same realm.

Arturo Vega (the Fifth Ramone) in New York, c. 1975. Arturo was the guy who designed the iconic Ramones eagle logo that one sees everywhere in a huge variety of configurations and that has been co-opted by everyone. I recently noticed that the US Department of Homeland Security logo is reminiscent of the Ramones'. Yes, the band's logo was copped from the Great Seal of the United States, but somehow Artie's use of it put it out there in the mainstream, where it had never held a place. In the shot here, Arturo is wearing a shirt that he bought on 14th Street, the pattern of which he incorporated into the eagle logo. A footnote here is that the eagle logo evolved somewhat from the logo used by the New York bar the Eagle's Nest. Joey is pictured wearing an Eagle's Nest T-shirt very early on. The first Ramones eagle logo was simpler. Clem is wearing one in the shot taken at the Liverpool Lime Street Lower Level station **(PAGE 137)**.

When Arturo first appeared on the CBGB's scene, he would dress in a very neat suit with a *luchador*-style mask (like the ones worn by Mexican wrestlers). It was months before he showed up without the mask. Arturo became very close to the Ramones and began working for them. He handled lighting and was an integral part of their organization. Artie attended and worked at almost all of the Ramones' 2,261 shows, only missing two when he was in jail. This photo was taken at his loft around the corner from CBGB on what is now called Joey Ramone Place. Arturo, like Joey, was one of the nicest people on the music scene. His death in 2013 really shook me up.

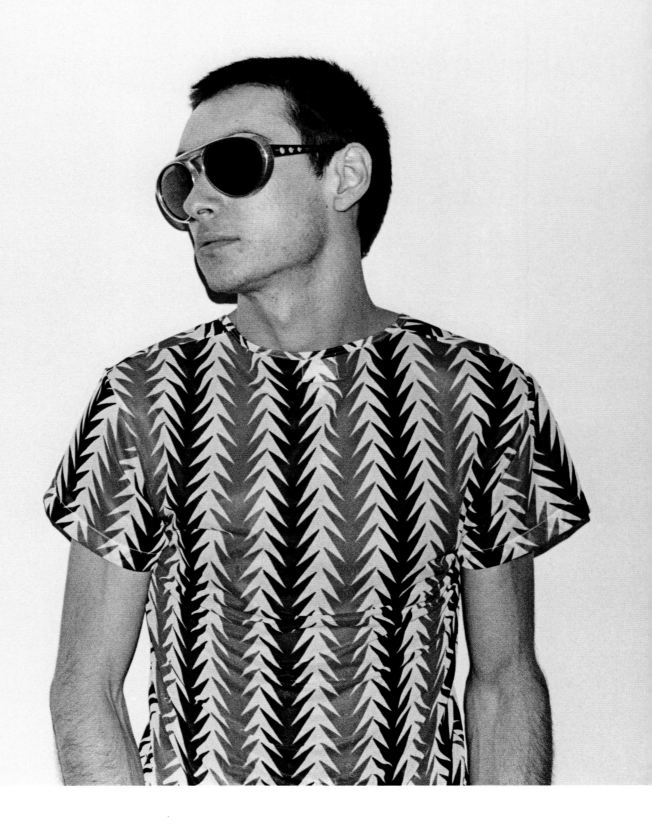

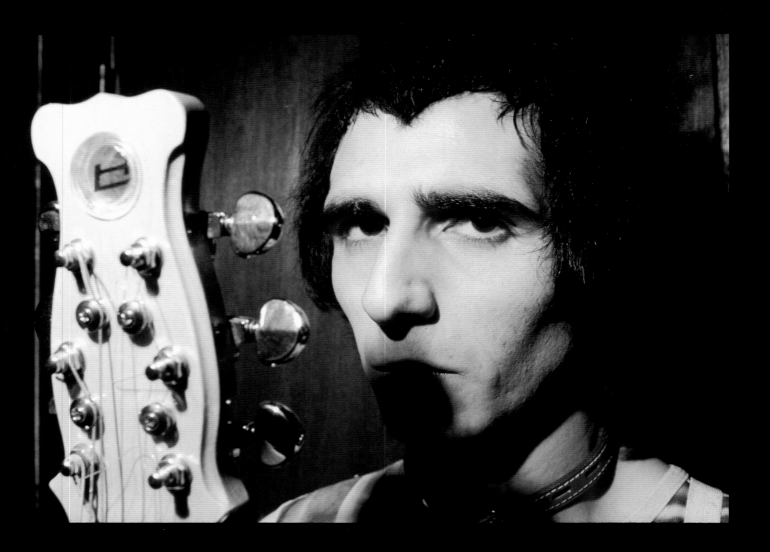

Miki Zone backstage at Max's, c. 1976. Miki was a very close friend. One of three brothers who eventually formed the core of the Fast, a really brilliant New York band that combined many elements and musical references (including the Sparks, the Who, and Roxy Music—all in a punkish format) while still being really original. Initially, only two of the brothers were in the band, Mandy and Miki, with Miki on guitar and Mandy as lead singer and on keyboard. Everyone on the scene knew their other brother, Paul, who was the youngest and a really charming kid.

Paul was and still is really striking looking as well. People close to the Fast began lobbying for Paul's admittance. I remember Jimmy Destri finally arriving with the news, "Mandy has abdicated!" Miki was an amazing guitarist and songwriter. Debbie recorded a version of one of Miki's songs, "Comic Books." Both Miki and Mandy died of HIV complications. Paul works with his current groups, Man 2 Man and Blow Up. He has had several hit dance tracks and recently produced his own book of photography.

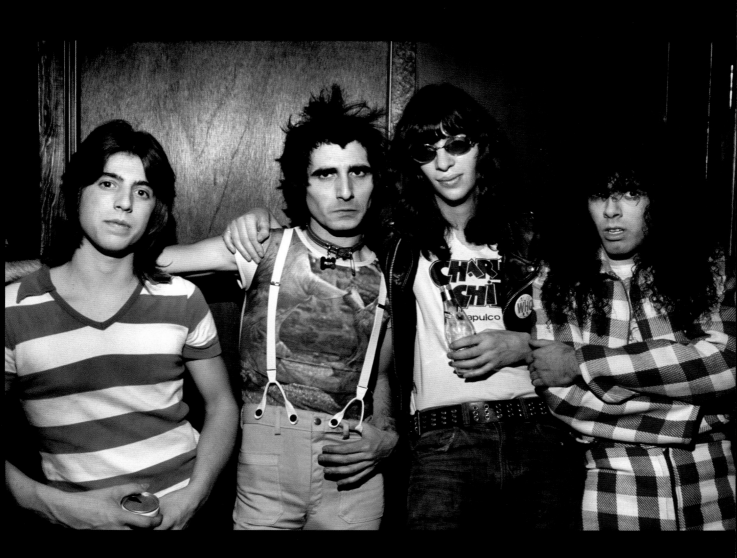

The Fast with Joey Ramone. From left to right: Peter Hoffman, Miki Zone, Joey Ramone, and Paul Zone, Max's Kansas City, New York, 1976. This shows how close all the bands were at the time. There really was a whole familial thing going on.

RIGHT Debbie and Joey Ramone from *Punk* magazine's "Mutant Monster Beach Party," photographic comic or *fumetto*, New York, 1978. "Mutant Monster Beach Party" was the second epic *fumetto* (a comic-style photo story, a form made popular in the sixties in Europe/Italy and South America) from *Punk* magazine. It was shot by several photographers, mainly Roberta Bayley and myself, but some others, too, in the early summer of 1978. The story is vaguely *Romeo and Juliet* about rocker bikers and surfers at war. Joey Ramone (who wrote several scenes) and Debbie are the stars along with Holmstrom, with cameos by Andy Warhol, John Cale, and Lester Bangs, amongst others. *Punk* was always in financial difficulty and "Mutant Monster" pretty much sunk it. Holmstrom talks about the irony of the two photo issues being their worst selling at the time while today they are the ones most in demand. This is the moment when, after pursuing and romancing Debbie, she turns into Edith Massey (Edie "The Egg Lady" in *Pink Flamingos* and other John Waters' films. Edie also had a cameo in the "Monster" shoot). This was shot at our 17th Street apartment prior to the fire. The magazine on the bed is some kind of commemorative "Son of Sam" thing put out by one of the local papers after David Berkowitz was apprehended in August 1977, the "Summer of Sam" as it's now called. There were true moments of trepidation walking around the streets at night while Sam was still at large, and some vague relief when he was caught.

Joey was one of the nicest people I knew in the music business. He was just all-around fantastic. All of Blondie and the Ramones were very close. As Clem often says, they were like people that you'd gone to school with. Joey himself was an example of "triumph of the will." It was great to watch him overcome his shyness and awkwardness and manifest as the rock idol that he grew into. I spoke to him for the last time when he called me from the hospital. I've always been grateful that I got to say goodbye.

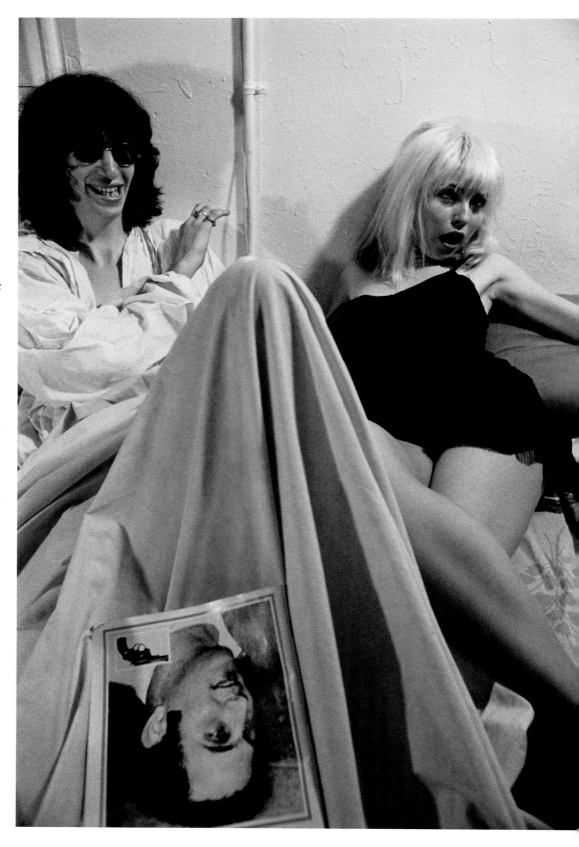

OPPOSITE Joey Ramone with surfboard, New York, 1978. An outtake from *Punk* magazine's "Mutant Monster Beach Party."

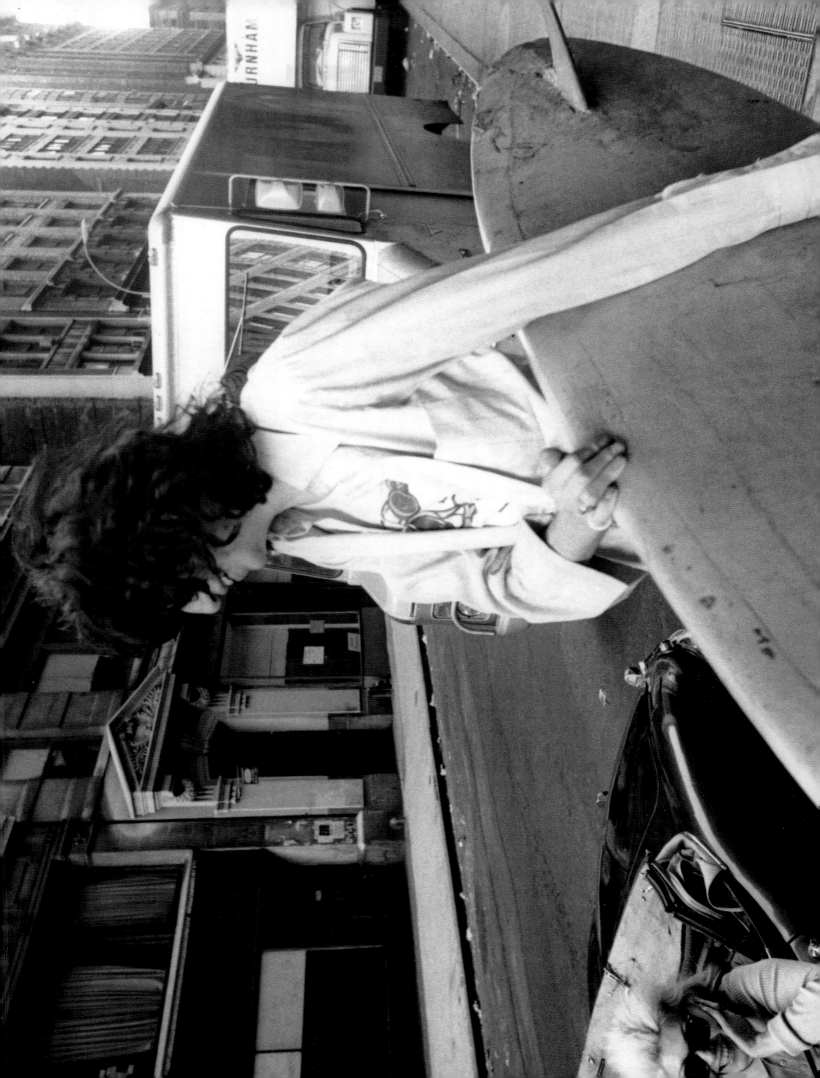

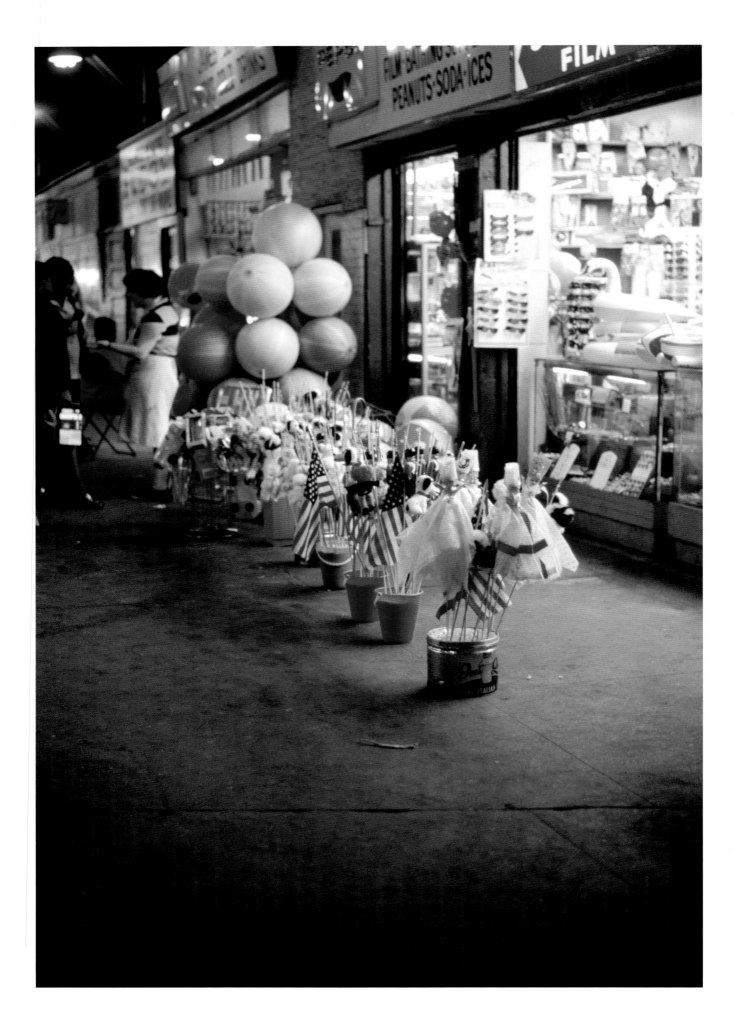

OPPOSITE Coney Island boardwalk, New York, early seventies. Growing up in Brooklyn, my parents would make frequent forays to Coney Island, so I was able to see it back at the end of its heyday in the fifties. By the time the *Punk* magazine crew went there, Coney Island was at a particularly low point in its decline. Coney Island is and always was a place of strange magic. It's always been closer to a sideshow at a carnival than any sort of legitimate venue for entertainment, the funk and offbeat elements linger even now that it's being somewhat upgraded.

ABOVE Lester Bangs during a shoot from *Punk* magazine's "Mutant Monster Beach Party," New York, 1978. Lester was a well-known rock journalist even back then. The character in *Almost Famous* is based on him. We had a slightly adversarial relationship with Lester, which developed when he announced his intention to write a book about Blondie—a book that is very odd. It rages back and forth between condemnation and affection. His cries of outrage at Debbie's overt use of sexuality are really naive in retrospect (and ironic looking at the photo above). But he was a great character.

He went through a period of trying to front a band. Debbie recounts the story of his coming up to her in a sweat after leaving the stage at CBGB and telling her, "I never realized how hard doing this is." One must credit him a lot: If more journalists tried to do what their subjects were doing, there would be a new level of artistic criticism.

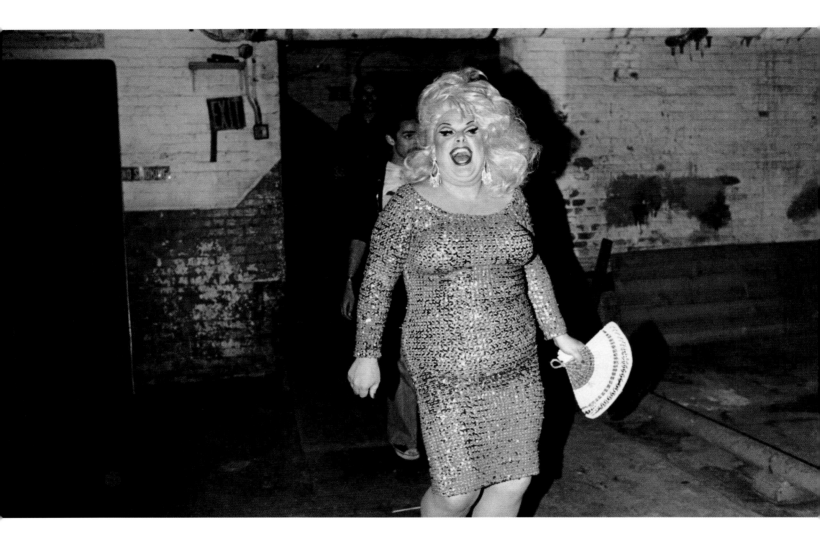

Divine arriving for some sort of event
held in a cellar that I really can't recall.
I had met her earlier, in 1976, when
she appeared in a stage version of
Tom Eyen's *Women Behind Bars*. Lisa
Jane Persky, who was the girlfriend
of Gary Valentine, and Fanne Fox, an
exotic dancer who was involved with
Arkansas congressman Wilbur Mills
in one of the biggest political sex
scandals of the seventies, co-starred
in the production.

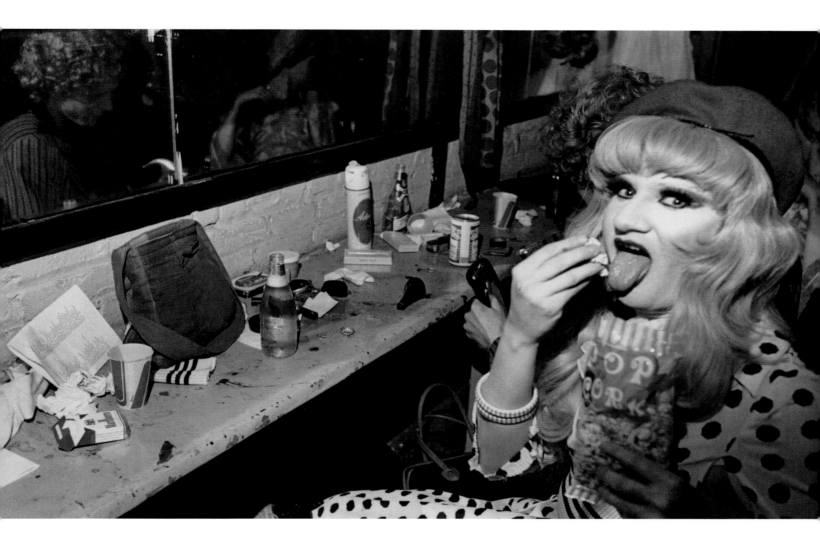

Jayne County at his legal fund benefit, New York, 1976. One evening, I remember approaching CB's and being confronted by someone who reported that we had just missed a dramatic altercation between Jayne County and Richard "Handsome Dick" Manitoba. Apparently, Jayne was doing a show, and when Dick heckled Jayne, Jayne had responded by clobbering him with a mic stand in front of the audience. This was sort of ironic due to their respective personae, but everyone really knew that Jayne was a tough customer indeed. The people in the scene split, forming opposing camps that supported one or the other, and a lawsuit ensued. I can't remember the details, but this shot of Jayne is backstage at a benefit show put on to raise money for her legal fees.

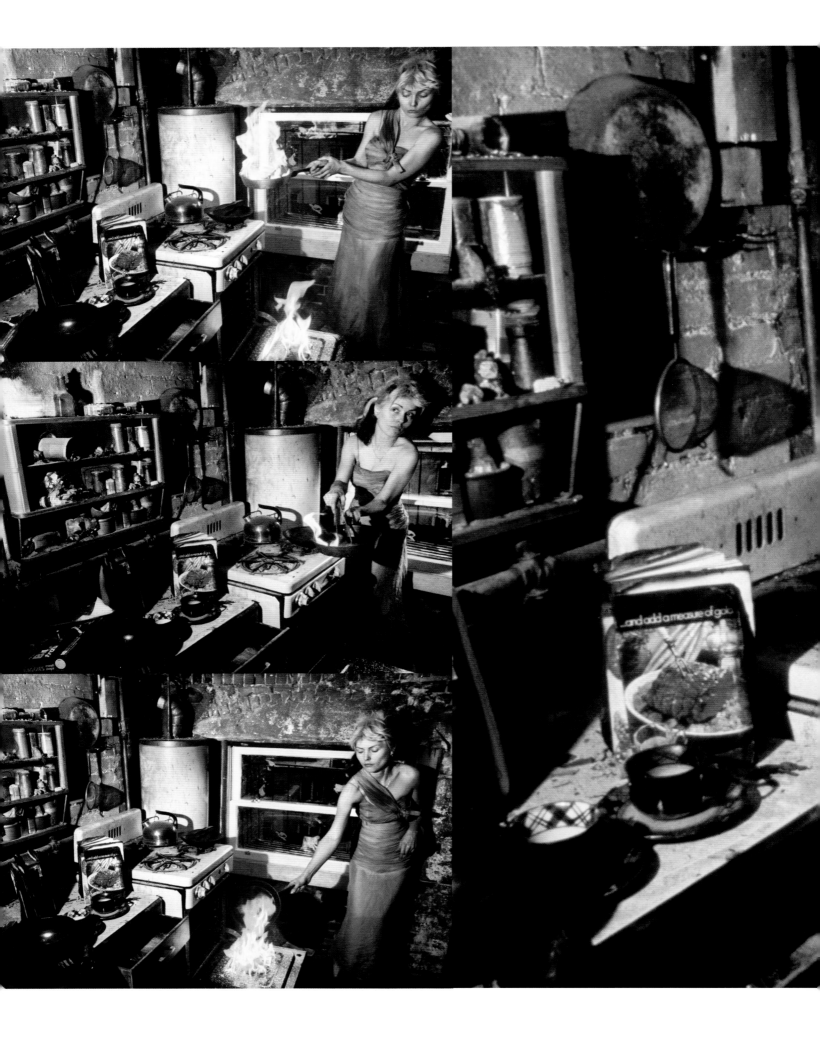

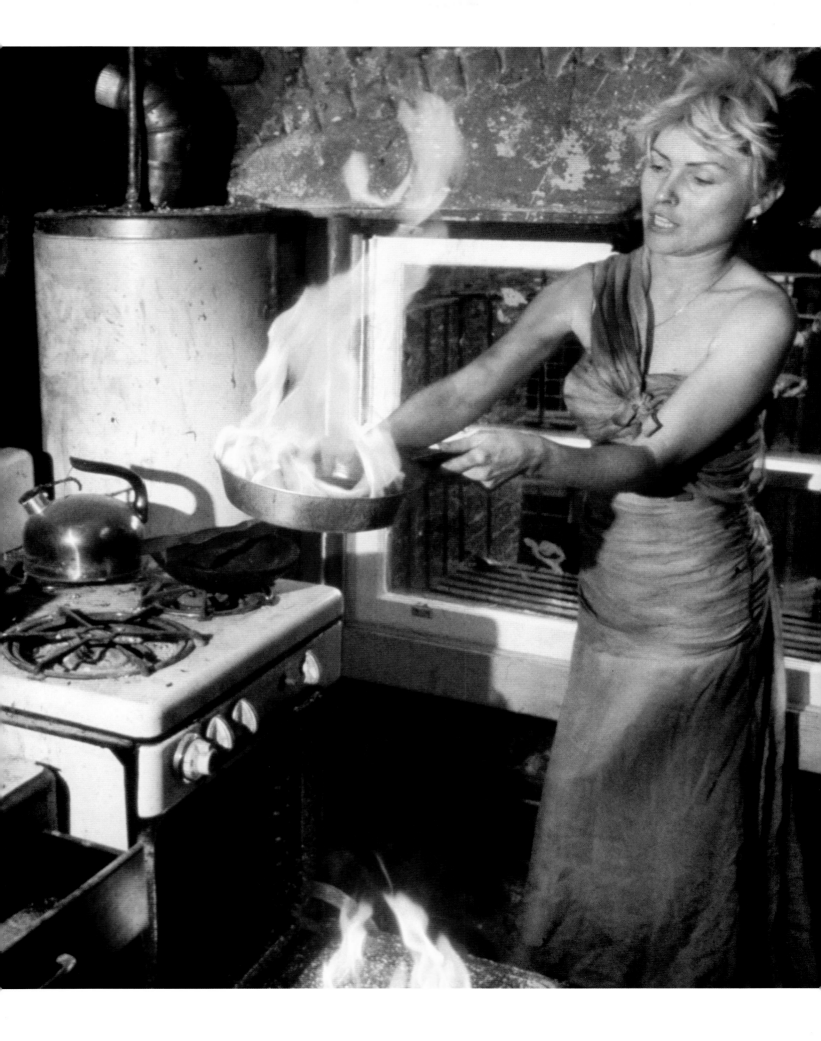

PRECEDING SPREAD Debbie with frying pan and dress at our 17th Street apartment after the fire, c. 1977–78. We were on tour when I got a call from my mother, Stel. She said something like, "Now, don't be concerned but your house just burned down" The small loft/apartment that we lived in was on 17th Street off Sixth Avenue. Various photo sessions took place there, and it was where we were when I heard one of our songs on the radio for the first time. There were a lot of weird characters about the place such as this really sweet, older guy on the first floor who was a sort of Bobby Short–type cabaret entertainer. He taught piano and also worked for some men's shelter. Some of his clients from the shelter would hang around the building. Once, we found a bloodstained mattress on the roof. It looked like someone was living there occasionally.

I never knew if the fire was the result of electrical failure or somehow the outcome of human intervention. Luckily, when it happened, Debbie's three cats hid in a closet and were OK. The greatest loss was my comic book collection [I had almost the entire set of *The Fly*—there were roughly forty issues before it morphed into *Fly Man*] and a notebook that I had kept during the sixties. We were friends with the girl who lived downstairs and she had loaned us a blue dress that was allegedly worn by Marilyn Monroe onscreen, perhaps in *The Seven Year Itch*. The dress was badly singed in the fire. When we finally got back to the place, the kitchen, which had received the brunt of the fire department's attention, was piled with debris. After some clearing out, we took pictures of Debbie "cooking" in the burnt dress.

OPPOSITE Debbie at the Gramercy Park Hotel, New York, c. 1978. After the fire in our apartment on 17th Street, we lived in the residential section of the Gramercy Park Hotel for maybe six months. In 2003, the hotel was taken over by Ian Schrager and redesigned by him and Julian Schnabel, but when we were there, it was very old-school and inhabited by a lot of old-time semi-rich folk; old ladies with fur coats in the warm weather and old dudes in tweed suits. The hotel was built in 1924–25 but was pretty run down in comparison to its glory days when it was frequented by celebrities like James Cagney and Babe Ruth . . . JFK lived on the second floor for a few months.

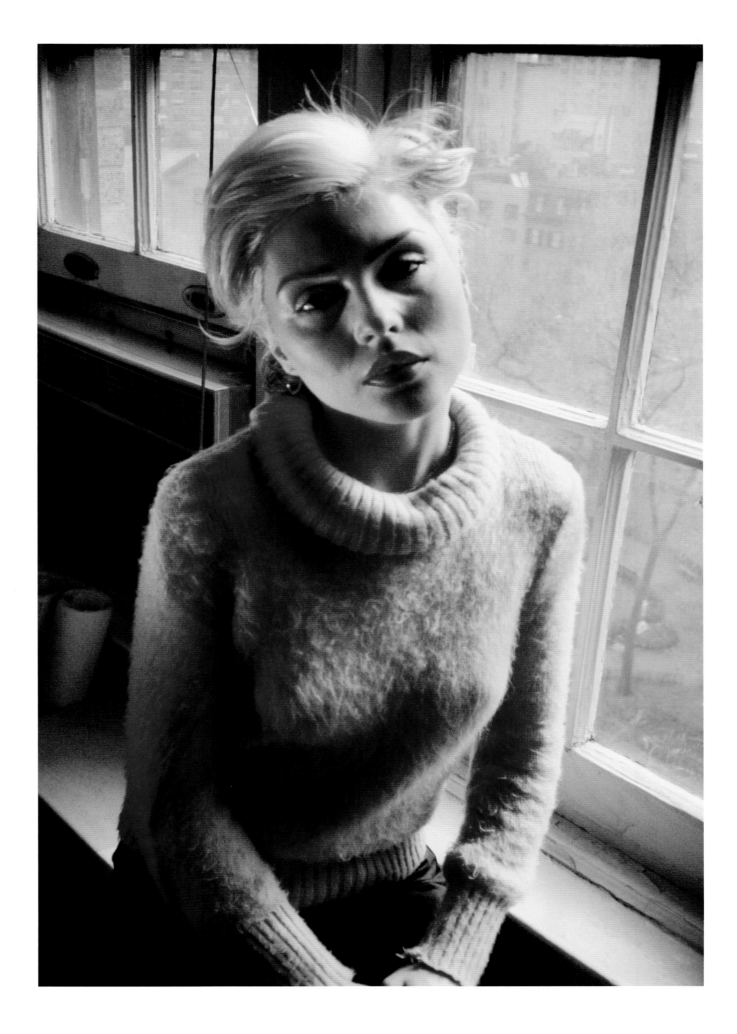

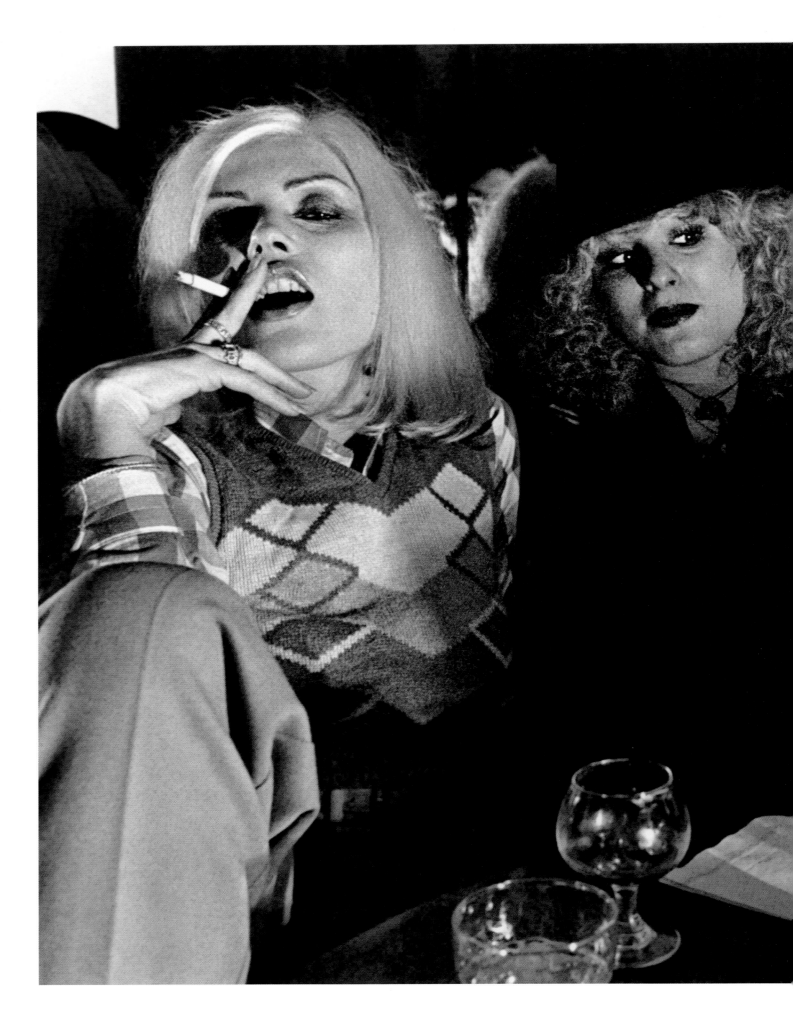

LEFT Debbie and Nancy Spungen at the Gramercy Hotel bar off the lobby, c. 1977–78. We were close to Nancy in her pre–Sid Vicious period. She was much smarter than she is portrayed in her cultural stereotype. We spent a lot of time at this hotel, living there for months after the fire at our apartment on 17th Street. We had the opportunity to see her and Sid perform in London when they played Iggy's "I Wanna Be Your Dog" three times for lack of material. I don't think Sid killed her. They were too close.

FOLLOWING SPREAD Debbie looking like a glam Patty Hearst (maybe not politically correct) and wearing the cheap designer shades that she bought from the Bowery junk store, New York, sometime after 1974.

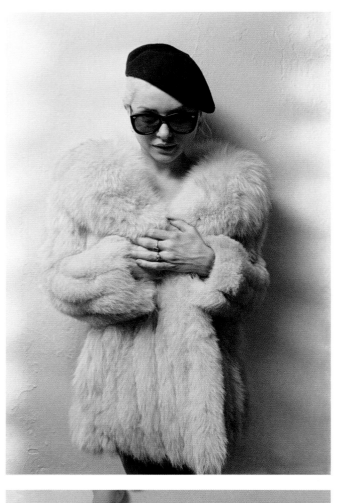
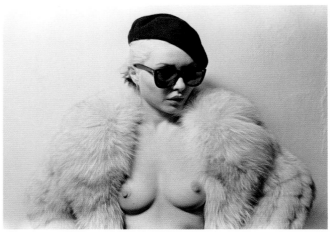
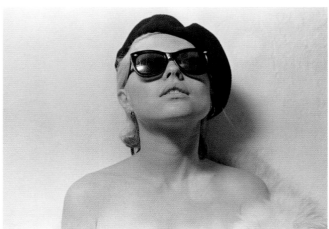
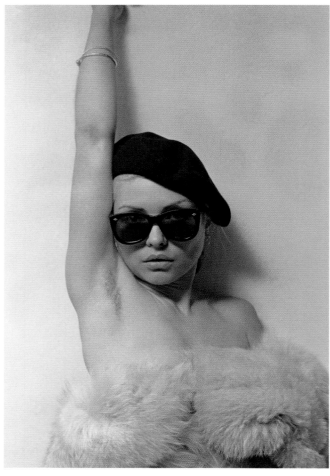
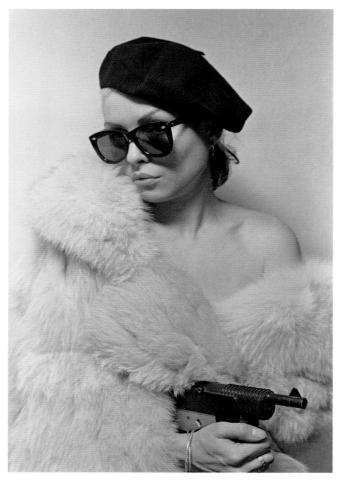

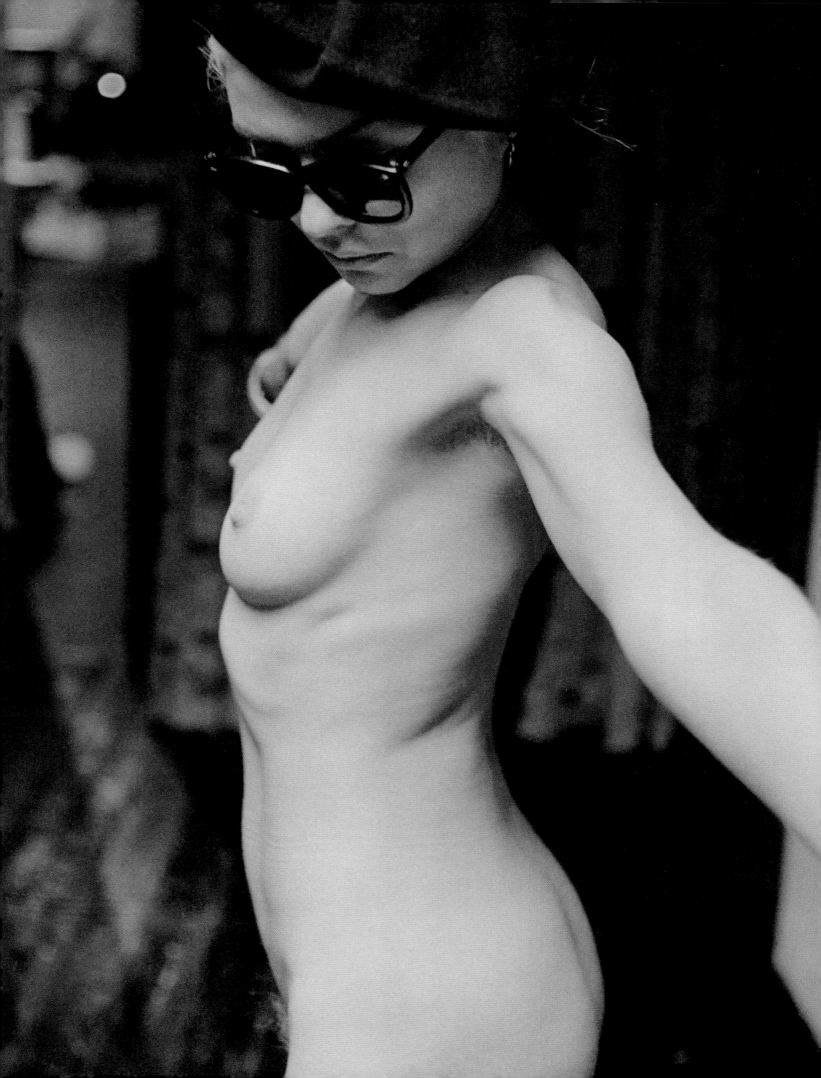

Anthony Ingrassia in front of a poster for his Broadway show *Fame*, New York, 1974. He was a playwright, director, and producer. His connection was through Andy Warhol/Holly Woodlawn, who roomed with Elda Gentile (aka Elda Stilletto of the Stillettoes) in the loft above Bobern Tavern on 28th Street where the Stillettoes would perform their first gigs. Tony wound up directing the Stilettoes; doing some choreography and motivational approaches to performing the songs. In 1968, Tony put on a radical play, *Sheila,* which included lipstick and eye shadow on male characters and might be the first New York show that contained total nudity on stage. Andy Warhol and Brigid Berlin would tape their long phone conversations. They had boxes and boxes of tapes. Andy later had them transcribed. Tony edited the transcriptions into a play called *Pork,* which opened in London in early August of 1971 and was wildly successful. David Bowie attended at least one performance.

In 1972, Bowie's then manager, Tony Defries, established a company called MainMan that Ingrassia worked with when we met him. MainMan was very, very exotic to us—its connection to Bowie and other stars was a glimpse into the "big time," and I remember being buzzed by our proximity to this professional world. Defries was right alongside Bowie all through his incredible rise. Defries also worked with Lou Reed and Iggy. MainMan had an artist roster that included John Mellencamp in his early Johnny Cougar incarnation, guitarist Mick Ronson, Cherry Vanilla, Wayne County, and others. The relationship between Bowie and Defries didn't end well. At the end of MainMan, Debbie and I (maybe with Ingrassia) visited the demolished MainMan New York office and picked through some piles of clothes that had been abandoned. The vultures (us included) had descended on the remains of the empire to pillage. For the longest time, I wore a grey vest that I got there that had a slight connection to Bowie.

In 1974, Ingrassia directed a rock event with Wayne County. This was "Wayne County at the Trucks." It ran for several shows at the Westbeth Theater in the West Village. "The Trucks" was a reference to the area in the West Side that was frequented by gay men who would meet amongst parked trucks there. The show was a breakthrough rock moment in that the band was off-stage and Wayne was out there alone with sets and props in an environment that was as close to theater as to a concert. It's generally assumed that Bowie's Diamond Dogs tour, which also used sets and had the band offstage, was at least in part inspired by Wayne's "Trucks" event. (The Trucks concert was recorded by MainMan but never released. Thirty years later, an old acetate disc pressing master of the concert was sold on eBay and the tracks are now out in the world.) Although there is info about the Wayne and the Trucks show, Tony Ingrassia's name is not generally linked to the concerts.

MainMan finally produced a play that Ingrassia wrote and directed about Marilyn Monroe called *Fame*. It ran for several months in previews at the Truck and Warehouse Theater on the Lower East Side. *Fame* was quite ahead of itself in design, featuring stark white sets that moved and were changed during the onstage action. A white telephone was central to the action onstage and various Marilyn monologues were delivered into the phone. The actors all played multiple roles. Debbie and I saw several run-throughs of *Fame* prior to its being trimmed and presented on Broadway. We attended the opening (and only) night and everyone involved did the traditional Broadway "evening-at-Sardi's-waiting-for-reviews" deal which is apparently some old tradition. The reviews came in and they were horrendous. Clive Barnes of the *New York Times* called it a "limp rag of a comedy." Another critic went on to say that not only should no one see the play but also avoid anything Ingrassia was ever associated with. People at Sardi's were in tears. (I've often wondered if Tony's portrayal in *Fame* of Arthur Miller as possessing Marilyn as a "trophy wife" is part of what stirred up the Broadway critics' wrath. One of several bits of irony here is that in 1978 Miller wrote and produced a TV play called *Fame*. And, of course, we have Bowie's hit song of the same name in 1975.)

Tony was pretty much washed up. He left for Berlin and began working at the cabaret nightclub Chez Romy Haag. (Romy Haag is one of the most renowned European transgender performers and has links to Bowie, Jagger, Freddie Mercury, and Lou Reed, among others.) We visited Tony at Romy Haag. Tony returned to the US and died of a heart attack in 1995. He was a really big guy and had breathing and heart problems. It's a bit sad because people really don't know who he was, info about him is sparse. I thought I'd include some in here.

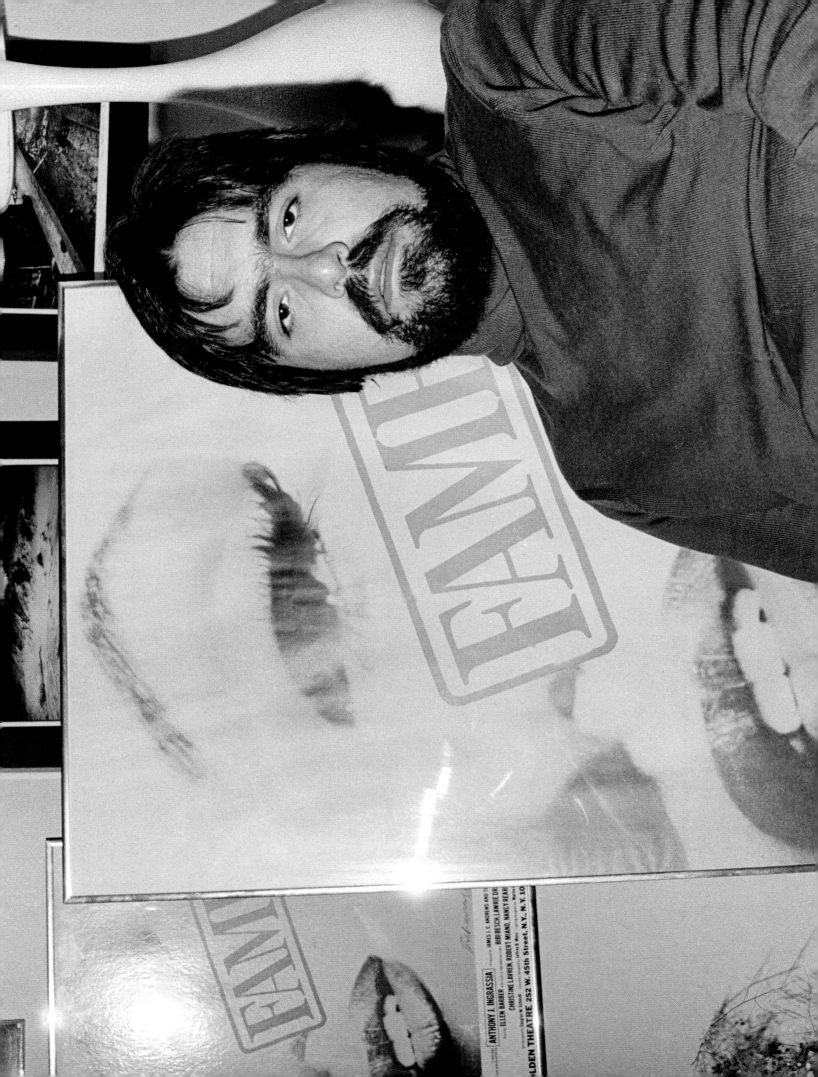

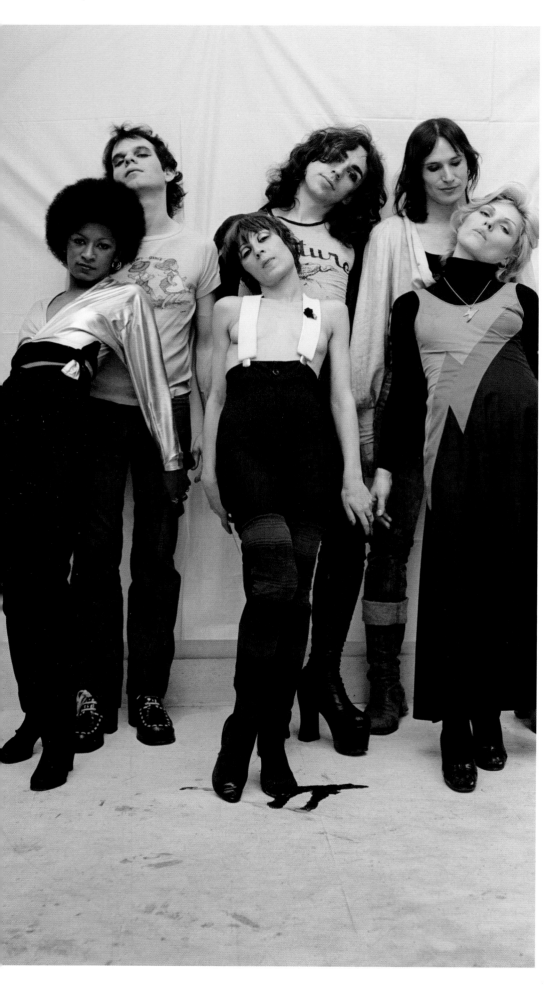

One of the later incarnations of the Stillettoes, from left to right: Amanda Jones, Billy O'Connor, Elda Gentile (aka Elda Stilletto), me, Debbie, and Fred Smith (who would later go on to be in the band Television). I took this using a timer. The Stillettoes were formed in 1972 by Elda, who was then dating Eric Emerson, they had a son, Branch. Elda had a loft with Warhol superstar Holly Woodlawn above the Bobern Tavern (named for owners Bob and Ernie) on West 28th Street. According to Debbie, they took the legs off the bar's pool table to create a stage once. I went to one of their first gigs there and met Debbie. We immediately clicked, and soon after, I joined the band. The Stillettoes went on in that form until the summer of 1974, when Debbie and I began working on our own. Elda continued with the Stillettoes. Deb and I would go on to form Blondie.

In that early period, the glam-rock scene was still paramount, and had yet to evolve into early punk. The biggest band on the scene when the Stillettoes started was the New York Dolls, a five-man rock group that was hugely influential, although they would produce only two albums before disintegrating (though they reunited more than twenty years later).

I remember being in the back room of Max's Kansas City when Elda came in breathlessly announcing that she had seen "a great band downtown who all dressed like old men." She was referring to Television, who had just started playing at CBGB.

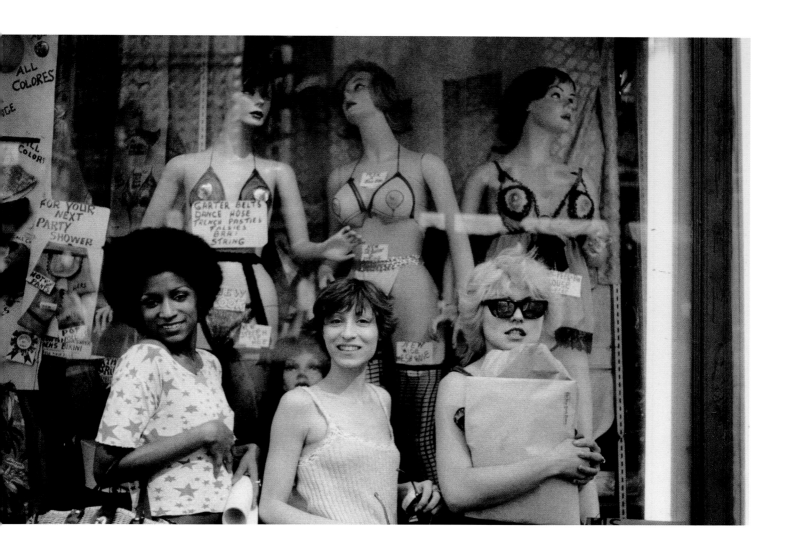

ABOVE The Stillettoes in front of a
stripper-style lingerie store in Times
Square, 1974. From left to right: Amanda
Jones, Elda Gentile, and Debbie.

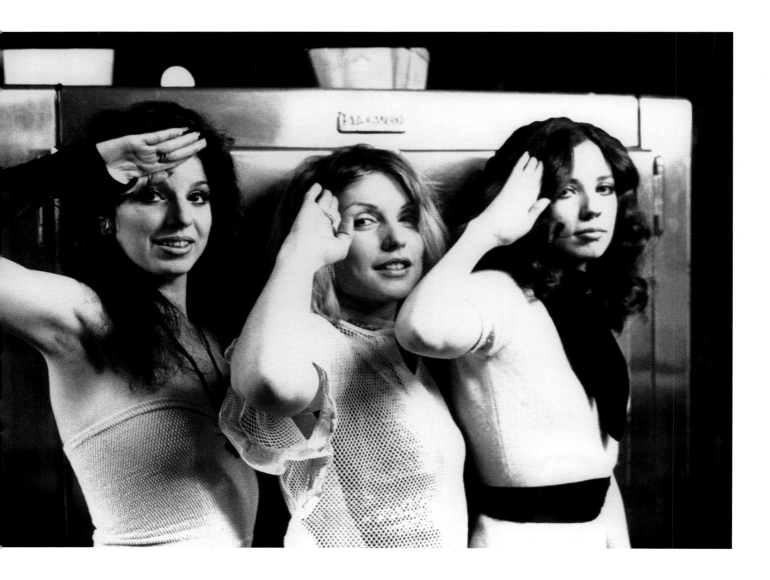

ABOVE Debbie with sisters Tish and Snooky Bellomo, fixtures of the early scene who sang backup with us at the beginning of Blondie, 1975. They went on to form the band the Sic F*cks then the Manic Panic makeup line and boutique.

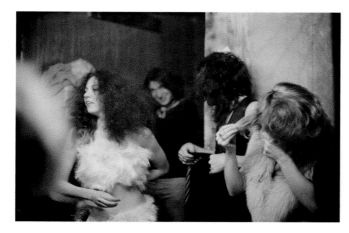

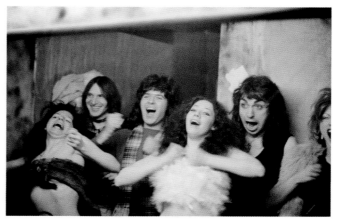

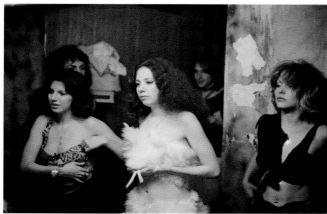

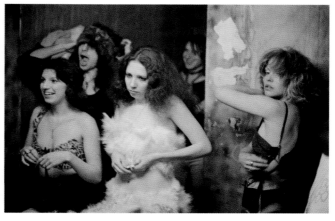

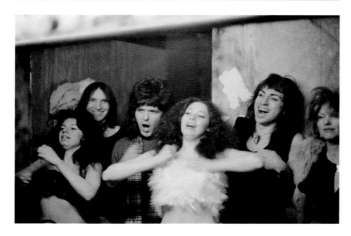

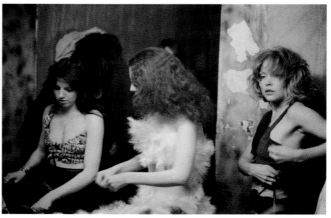

THIS PAGE An early incarnation of Blondie getting ready backstage for a show at CB's, 1975. Clem Blurke had just joined us at this point. The girls were doing some sort of "jungle primitive" look here.

FOLLOWING SPREAD From left to right: Snooky, Debbie, Fred, and Tish performing in an early incarnation of Blondie at CBGB, 1975. During the CBGB era, I would frequently give my camera to people and ask them to shoot us during performances. As a result, I have a decent amount of early "Blondie at CB's" negatives that include me. Also in this shot is Fred Smith. The CB's era was communal and we must have been using the Marbles' drums here. I remember using all of the Ramones' gear at another show—drums, amps, and maybe even guitars. The walls behind the stage at that time sported big images of old vaudeville performers. Also, at this point, the stage was at the left of the club (it was later moved to the right).

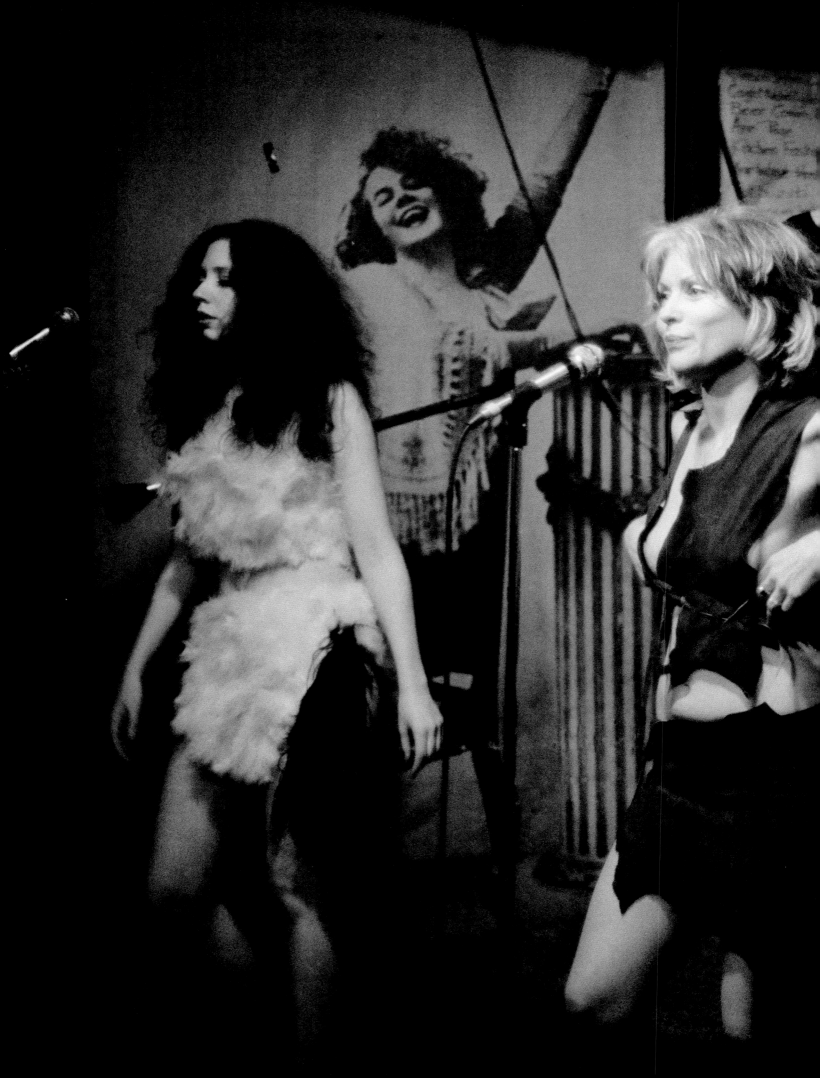

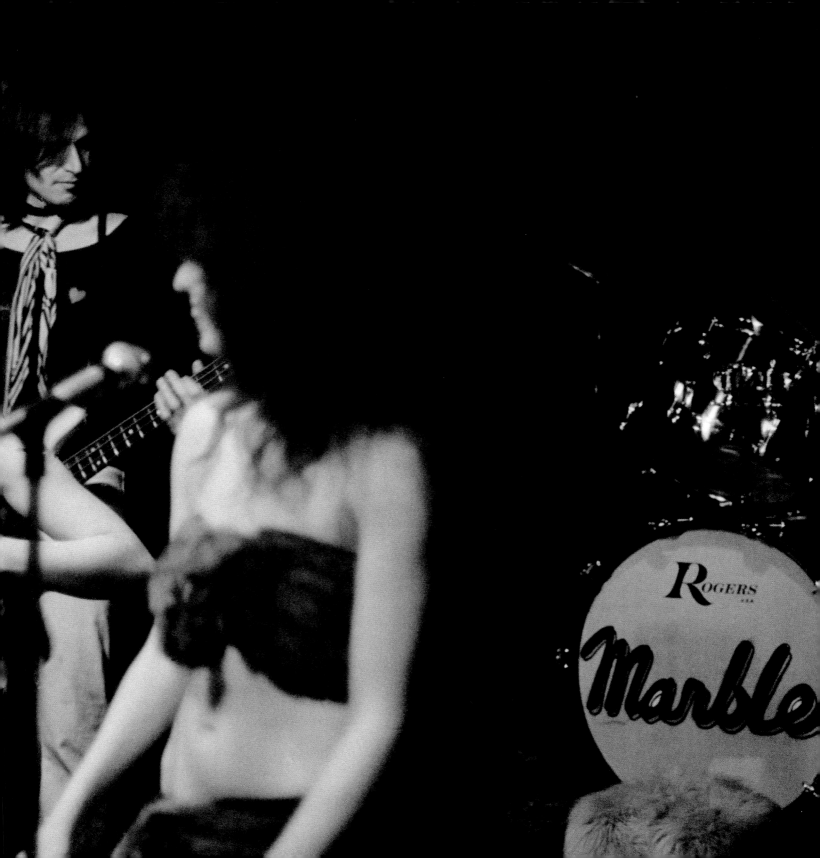

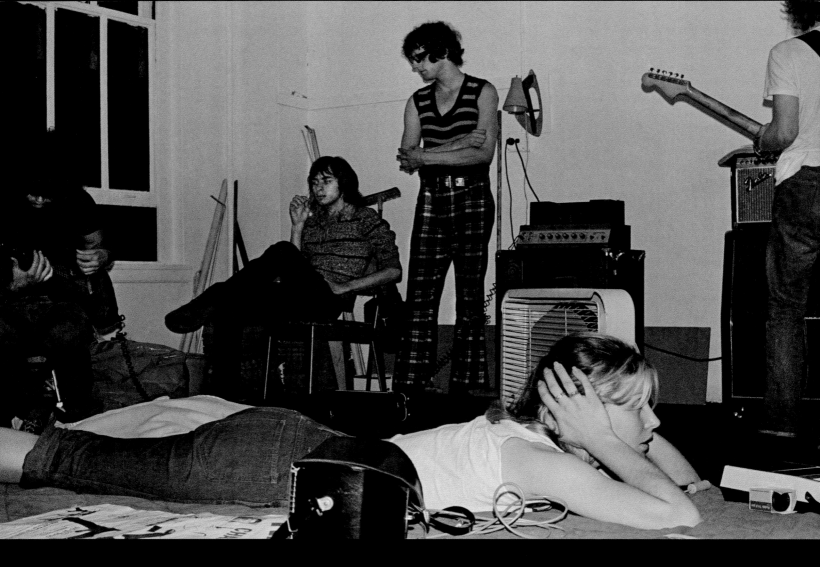

ABOVE Debbie, et al. rehearsing in a studio on 37th Street, New York, 1975. This shot was taken really early on, right after Clem had joined us. That's him on the left in the black T-shirt, playing guitar left-handed. Gary is on the right. Debbie seems to be dubious about the noises being produced around her. Seated is Ronnie Toast, a longtime friend and contributor. Ronnie wrote the lyrics for three of our early songs and the liner notes for our first album. He got the name "Toast" after allegedly burning down the house he lived in with his parents then writing "TOAST" on the burnt exterior of the place with spray paint. Next to him is a guy I only knew as "Prash."

OPPOSITE Debbie drumming at the 37th Street rehearsal space, New York, 1975. Debbie has some drum skills and I once recorded a track that she played on. We shared this rehearsal space with various other bands on West 37th Street in a Midtown Manhattan building. In those days, rehearsal spaces weren't readily available. There were a few around, but for the most part, smaller bands would just rent a room in an industrial space and play there after business hours and on weekends. We shared this space with an anonymous band of young guys who seemed like they had some money. They had expensive Peavey amps (which we didn't really like but used anyway), and one day, we came in to see that they

had cut them all in half. I didn't know if it was for aesthetic or sonic reasons. Another day, as we were leaving the room (which was on an upper floor), we found that the elevator was in use, stuck on a lower floor. We looked down the stairwell and saw some guys moving stuff into the elevator. Someone yelled down at them and the shouting quickly escalated into a back and forth with the guys on the lower floor saying, "Come down and make us move the elevator!" or something like that. Luckily, we took the stairs. The next day when we arrived, we found out that the guys holding the elevator were in fact robbing a furrier downstairs.

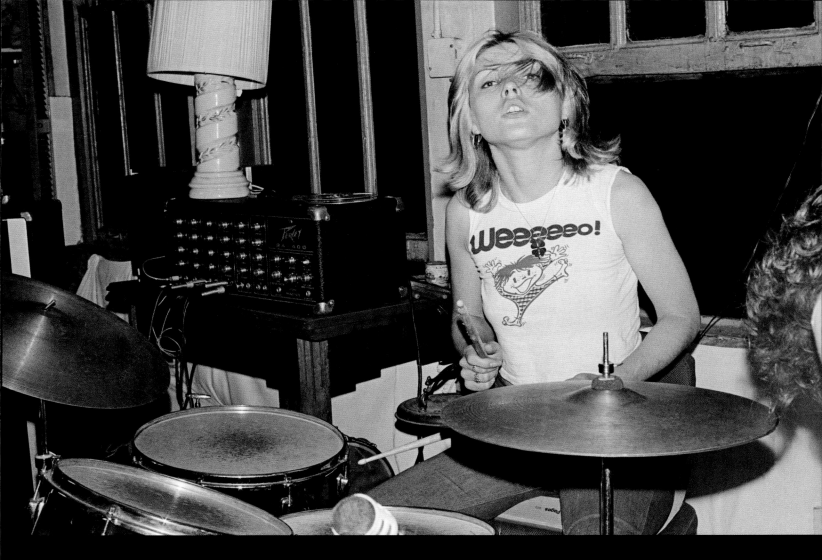

FOLLOWING SPREAD Another Blondie "selfie." This early Blondie group shot (left to right: Gary Valentine, Debbie Harry, me, and Clem Burke) was taken at Debbie's apartment at 105 Thompson Street, 1975. Soon after this, Gary was the first of us to get a haircut. (He was channeling Ian Hunter, a hero of ours from Hunter's Mott the Hoople days; Mott had a huge 1972 hit with the David Bowie song "All the Young Dudes.") It was also at this time that Debbie and I became *personae non gratae* in the neighborhood, so we moved. Thompson Street then was firmly Little Italy: *Mean Streets* replete with old guys sitting in front of social clubs, the whole deal. One day I was waiting for Debbie to return from a trip to see her parents, and I found myself on the street in front of our building at the precise moment when a group of neighborhood tough guys began beating up an African-American kid who had wandered onto their turf. No one said anything as the mayhem continued. Suddenly, a voice was calling out, "Stop! Stop! Call the police!" It was Debbie who had, coincidentally, just then gotten out of her car. I had to shove her into our building to avoid the wrath of our neighbors. That was the end of our tenure as the neighborhood weirdos. After the apartment was broken into for a second or third time, we left. Gary, who stayed with us occasionally, came with us to the Bowery loft.

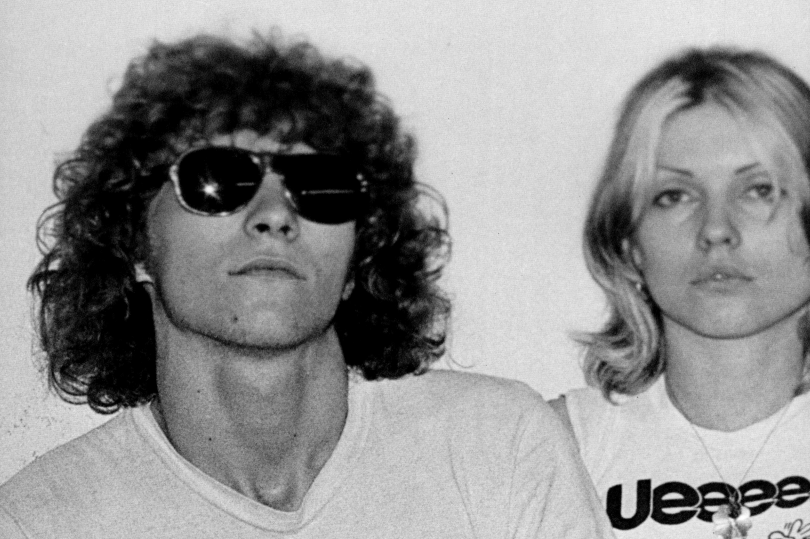

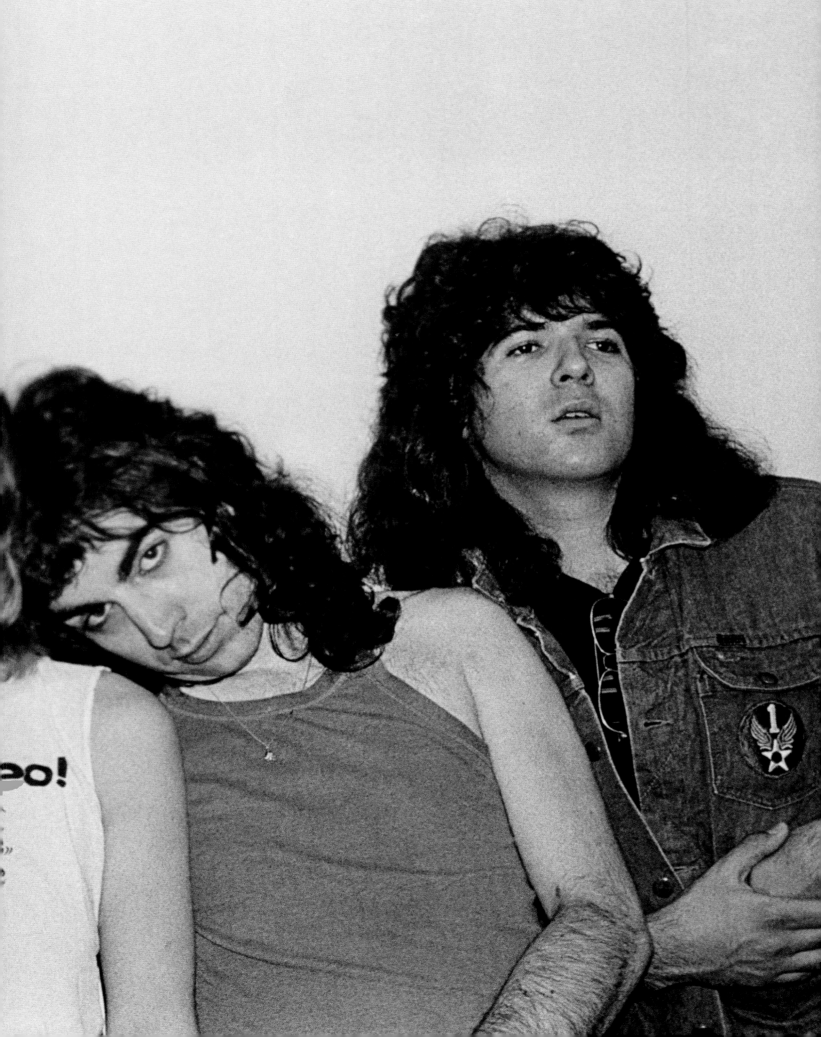

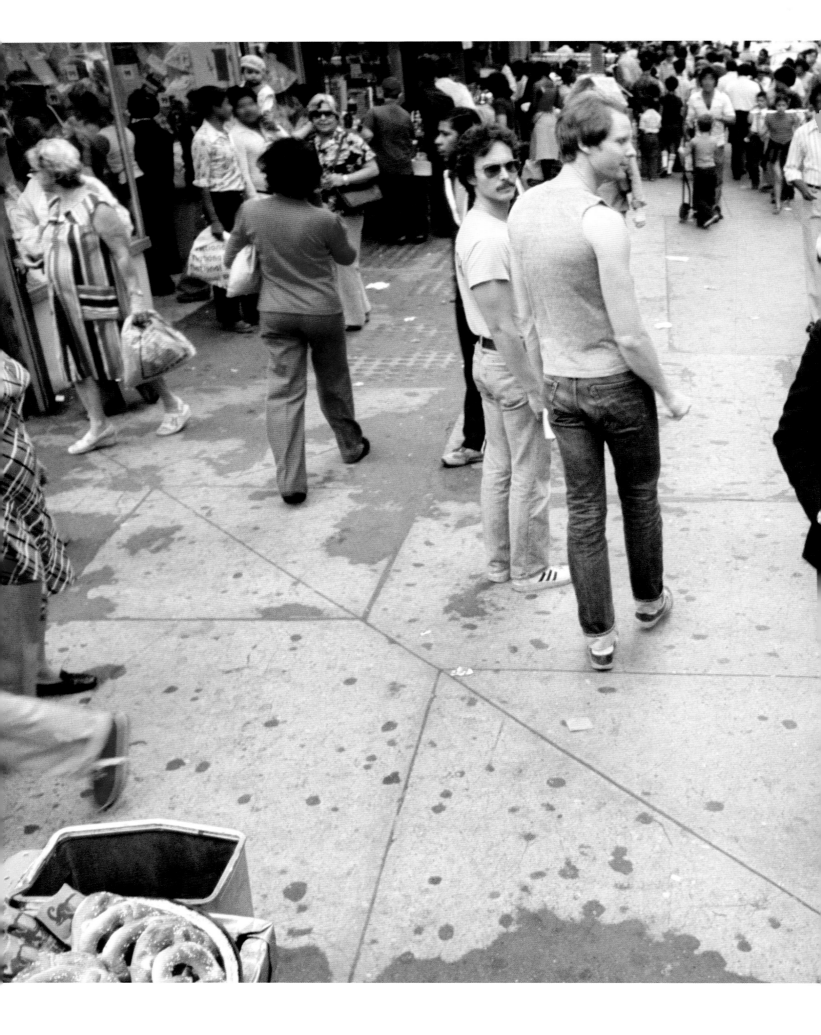

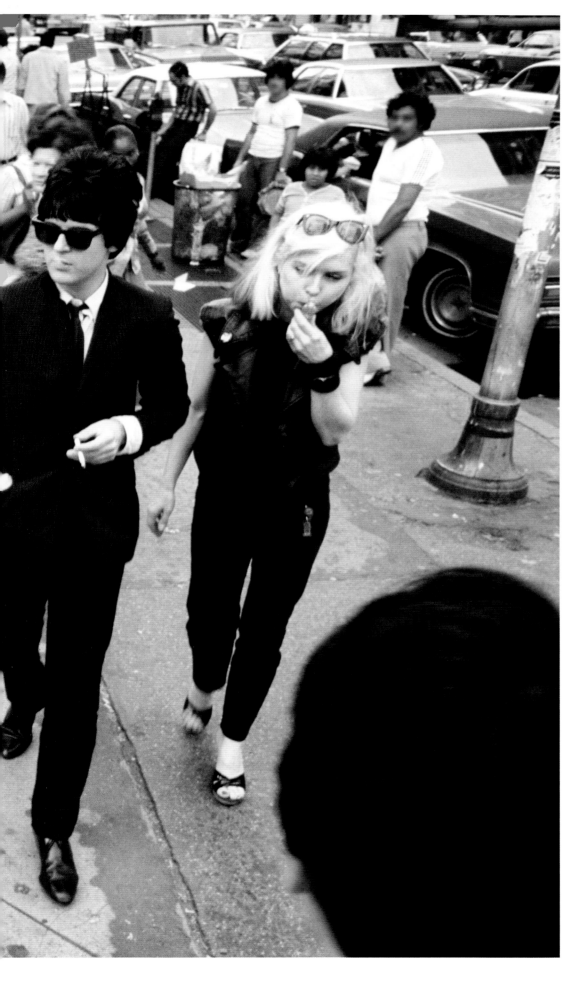

Here are Clem and Debbie walking on 14th Street, probably around 1976. Debbie is blowing one of those little plastic bird whistles filled with water to make a warbling sound. I've had people suggest a couple of things about this shot: One, that it was the whistle that was attracting attention, and two, that the people on the street might, in fact, have recognized Clem and Debbie. In my opinion, the stares are just based on the fact that no one looked like they did at the time. It's as if the two of them had dropped in from the present, from the fashion hipster New York of 2013. Maybe that's a stretch, as they would probably get similar looks now. Clem was always pretty fastidious about his appearance; the hair was an important element in the overall look. That's Jimmy Destri's head in the foreground, and I recently realized that I took this while standing on the base of a streetlight, and so the POV is slightly elevated. And random thought — is it just me or does the guy in glasses look just like Matthew McConaughey in *Dallas Buyers Club*?

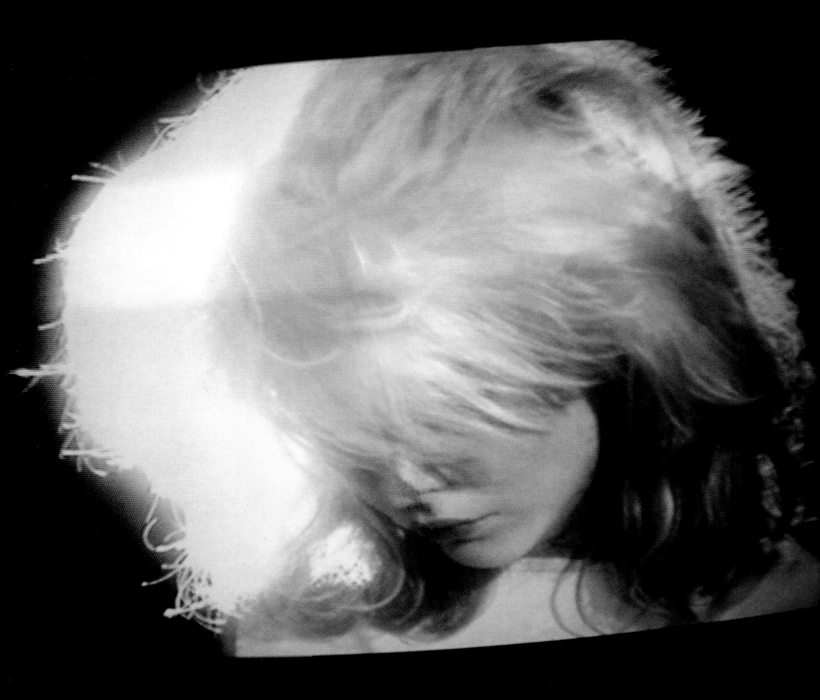

ABOVE Debbie on camera or a monitor during the video shoot for "Picture This," c. 1978. Debbie was constantly asked, "How does it feel to be a sex symbol?" Literally exactly that question, over and over again. I always thought it was kind of absurd. Debbie also likes to joke, "I wish I had invented sex—since everyone likes it, huge royalties."

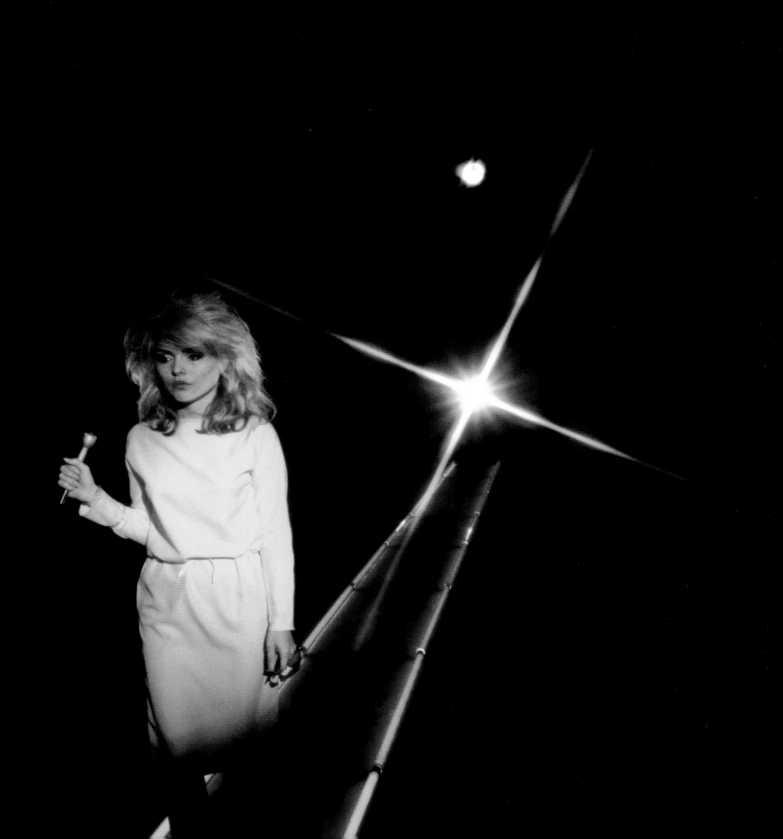

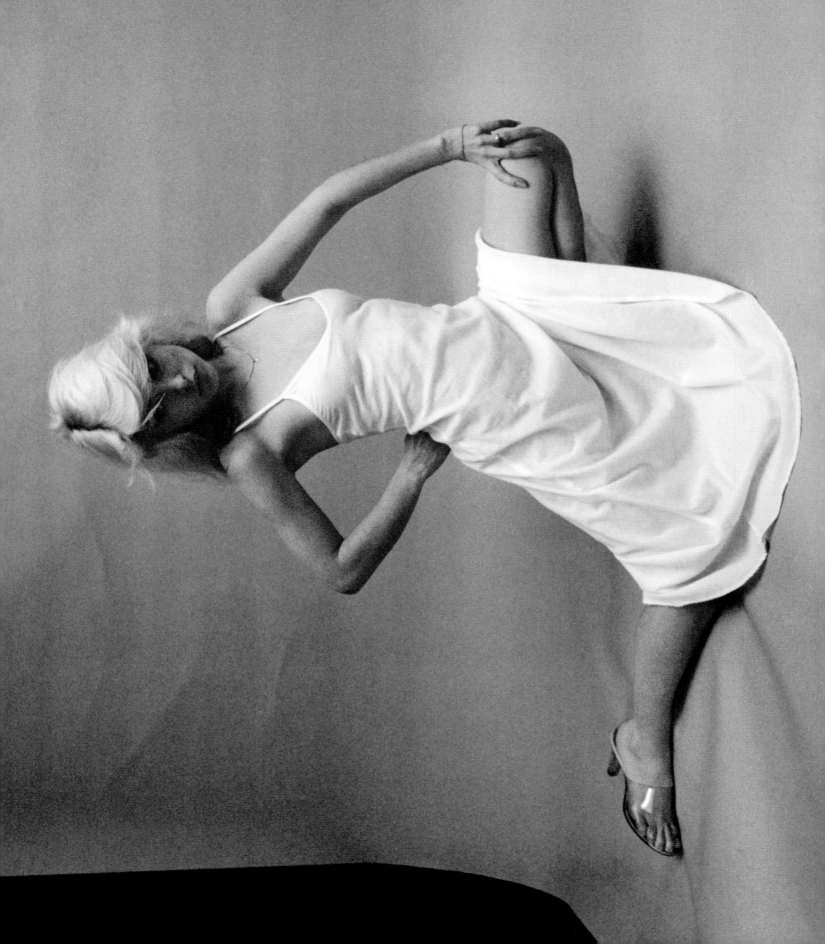

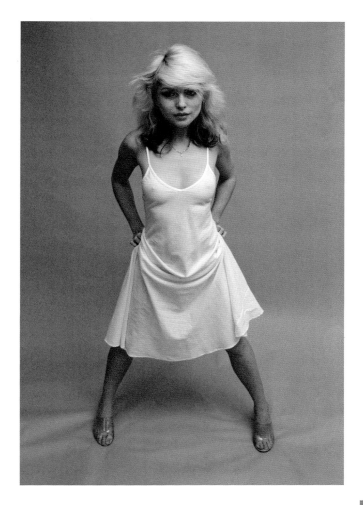

THIS SPREAD Deb, in what is most likely a Halston dress, shot in a hotel room where we set up a blue paper backdrop.

FOLLOWING SPREAD Deb on a rooftop in NY.

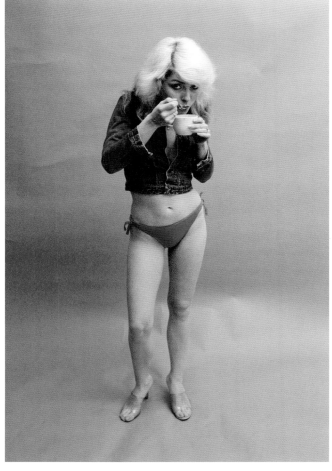

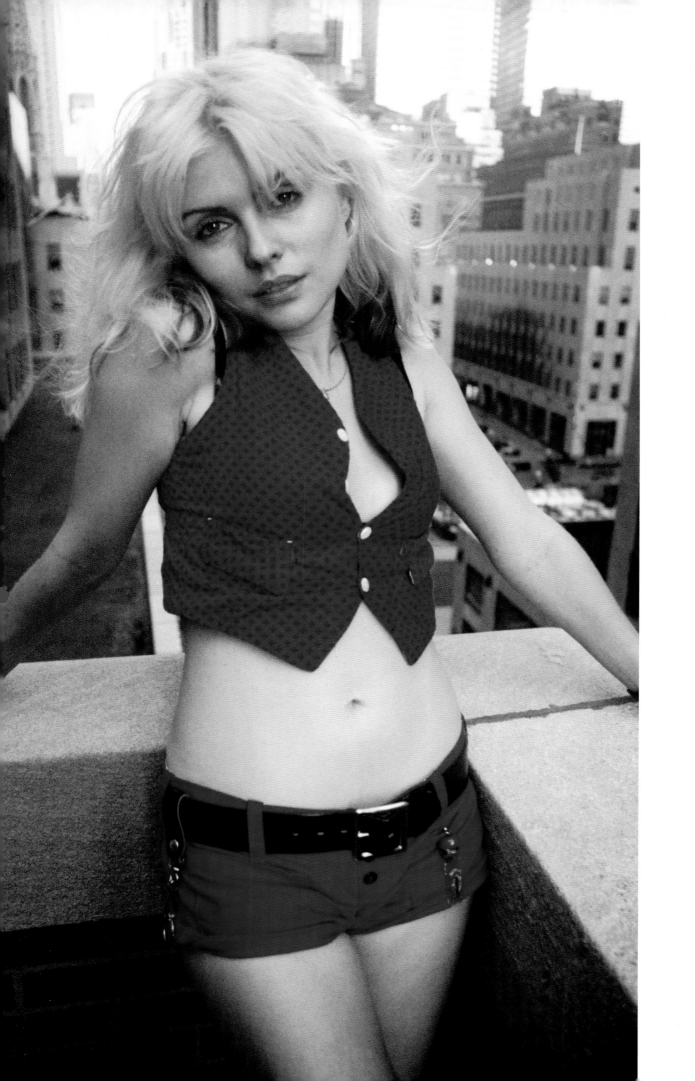

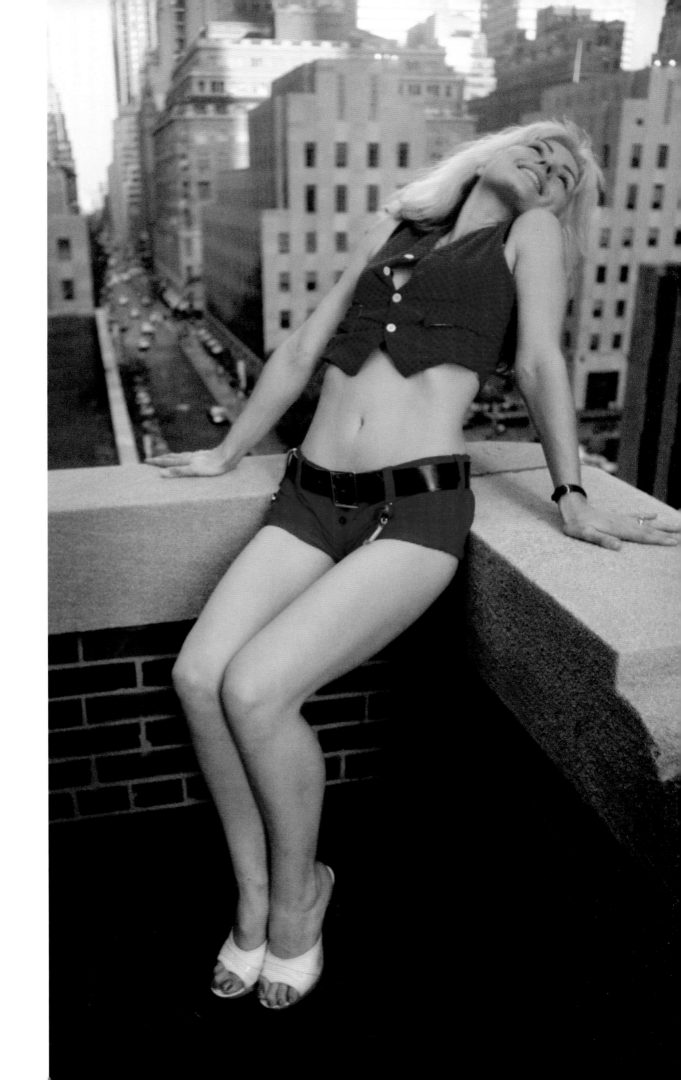

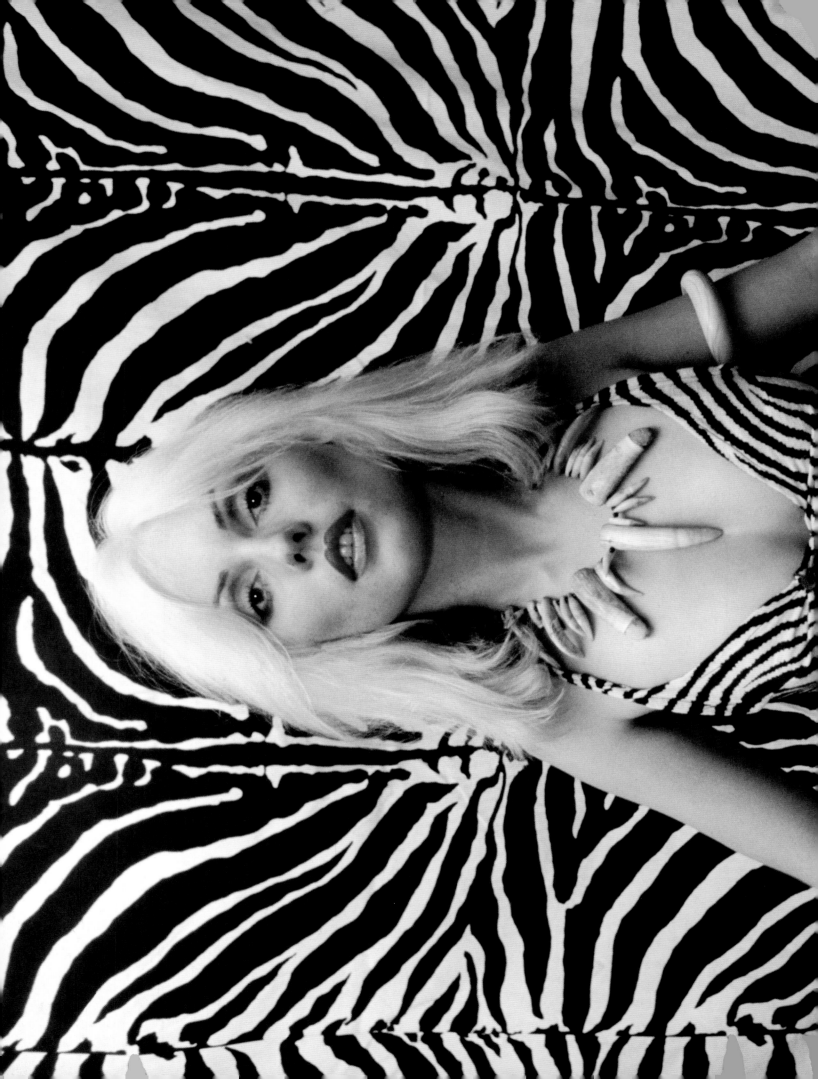

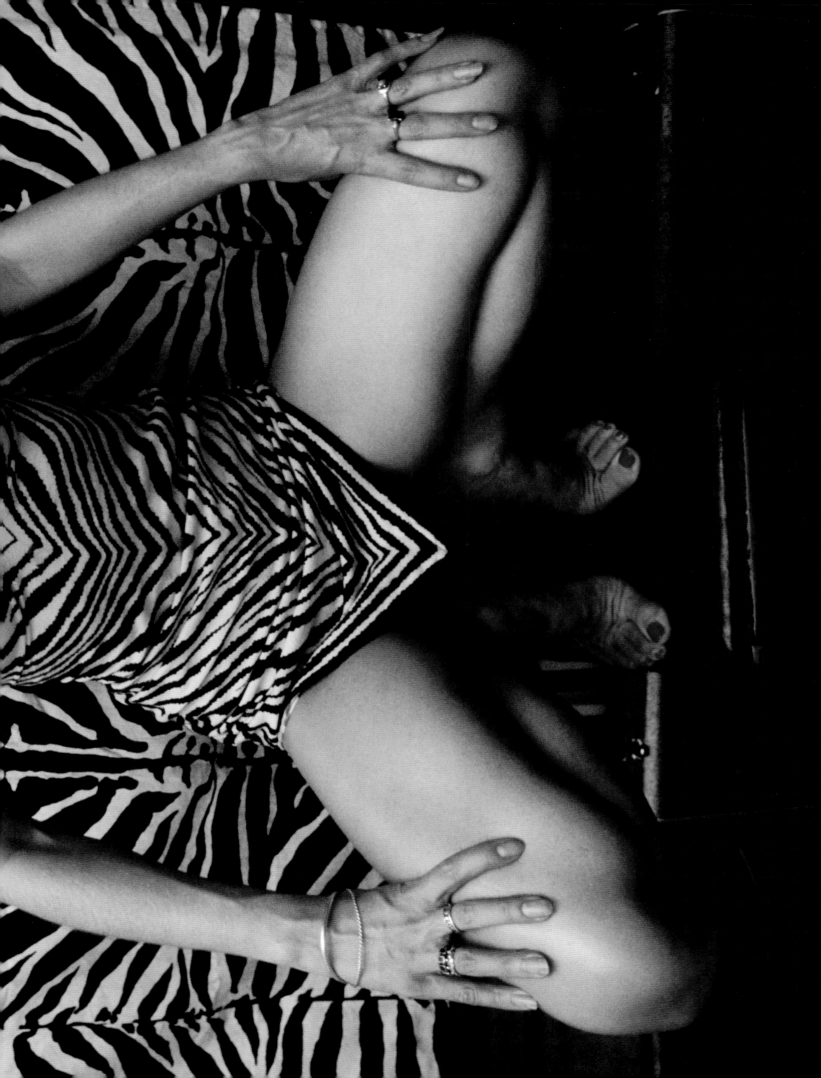

Debbie on an uptown subway platform at 14th Street, New York, mid-seventies. There was a saying in the downtown scene about not going "above 14th Street." This is proof that we occasionally did.

PRECEDING SPREAD Photoshoot for *Creem* magazine, 1976.

Above 14th Street

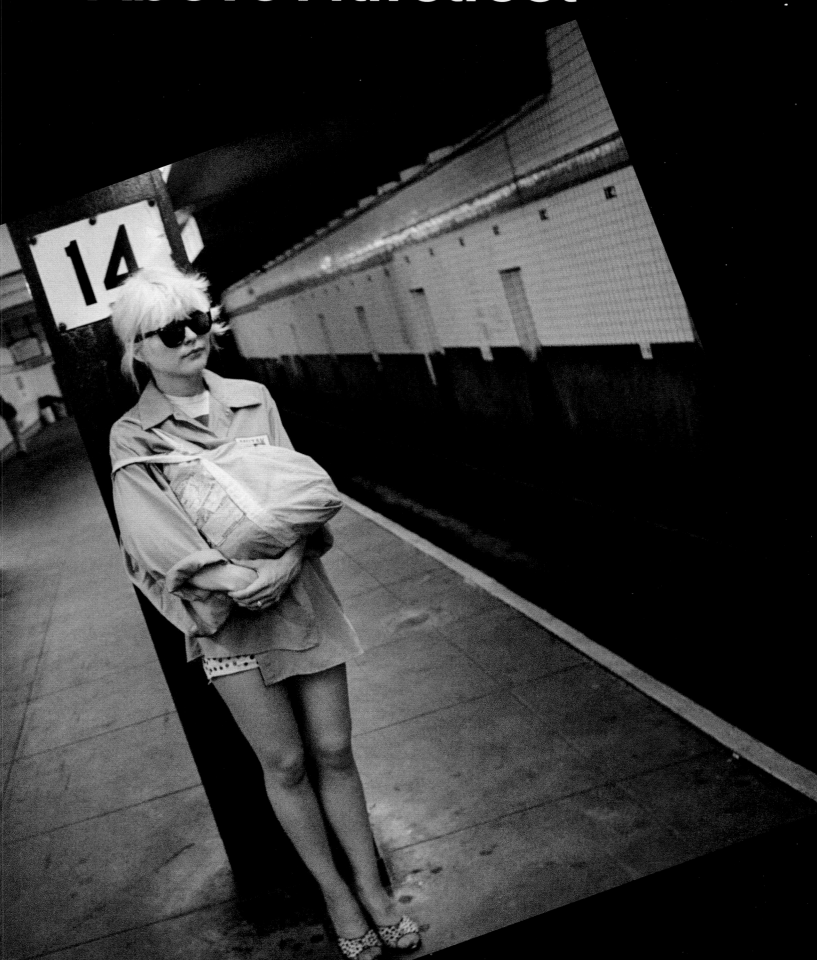

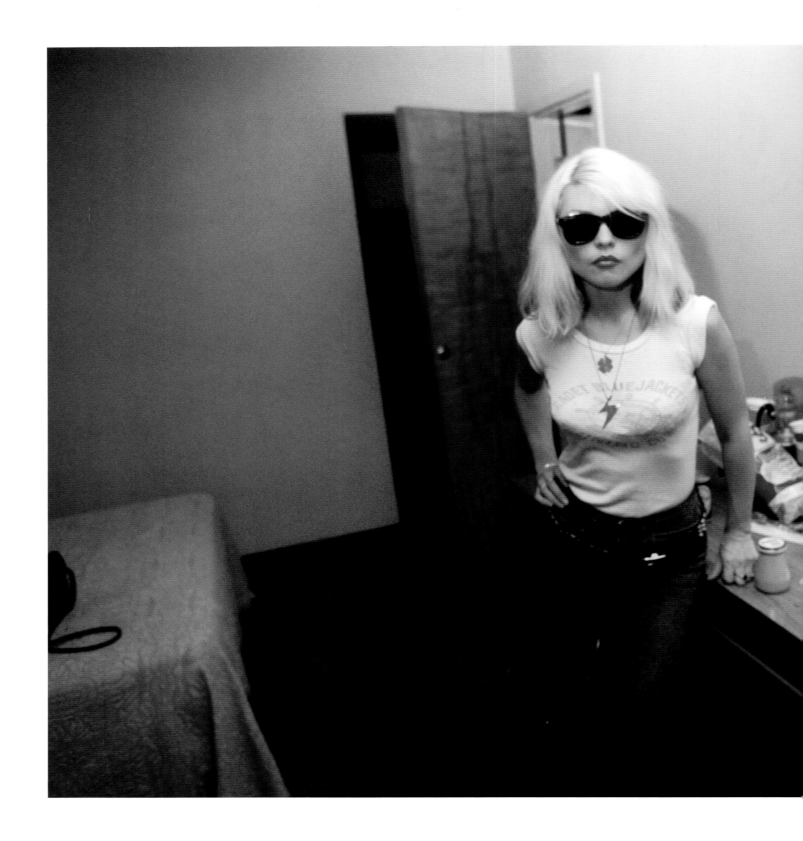

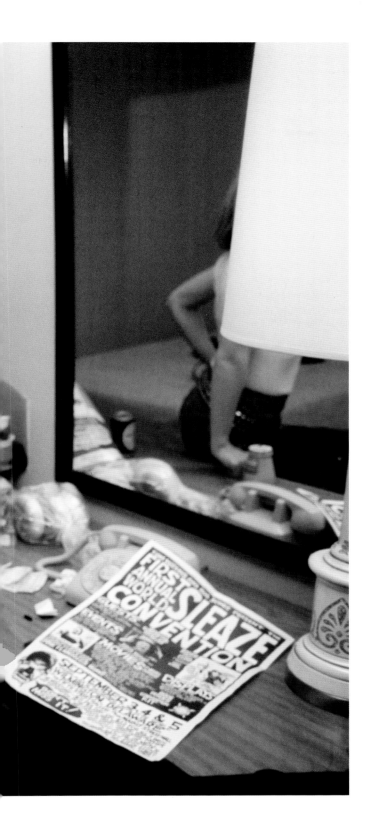

Debbie in hotel room during the First Annual World Sleaze Convention, 1976. This photo is a companion to the cover photo of Debbie with Anya Phillips, a prime shaker in the New York proto-punk movement. Anya was the longtime girlfriend and muse of jazz/funk musician and innovator James Chance (aka James White) and a major developer of his group James Chance and the Contortions. She was cofounder of the Mudd Club with Steve Mass. Her influence on all of us was profound. She made the dress that Debbie wears on the second Blondie album *Plastic Letters*, and they were very close friends. She died at what I think was age twenty-six in 1981—I can't find a definite birthday for her. She was overtaken by cancer very quickly. She was one of the first of our very close friends to die. I can't imagine what influence Anya would have had on the music and art worlds had she survived; it would have been substantial.

This shot was taken on a trip to Wilmington, Delaware, for the First Annual World Sleaze Convention, September 3–5, 1976. I'm not sure if there was ever a second World Sleaze Convention. The convention itself was a gathering of people attracted to subculture, B-movies, etc. We went with Marty Thau and his daughter, Leslie, (who was a little kid at the time, maybe 10 or so) and shared a couple of hotel rooms in an appropriately sleazy hotel. My recollections of the event are a little hazy. I think Legs McNeil and John Holmstrom (founders of *Punk* magazine) were in attendance, along with a small contingent of New Yorkers. This may have been the first time we ran into members of John Waters' inner circle. I remember big warehouse-like spaces filled with strange stuff like mannequins with outlandish outfits and appliances. Edith Massey (the Egg Lady in *Pink Flamingos*) had a booth set up that was an extension of her thrift shop, Edith's Shopping Bag, in Baltimore.

Notable, too, are some of the couture details of the cover shot: Anya is wearing what might be a very early Malcolm McLaren/Vivienne Westwood "Let It Rock" shirt. It also might be a knock-off, or something that she herself made, as it differs from actual examples I've been able to find. The red lightning bolt that Debbie is wearing is one of 500 pieces that were designed by David Bowie and executed by Bijoux jewelers during the Ziggy Stardust period. We got them from our association with his company MainMan.

At one point, we shared a rehearsal space with the Dictators in Manhattan. We arrived one day and found a studded belt they might have left. After we took it, there were some accusations tossed back and forth. I think that belt is the one that Debbie has on. Finally, Debbie's sunglasses were bought at a junk store on Houston Street near the Bowery. There was a big box of these shades in black and tortoiseshell; they sold for five bucks and looked like contemporary designer models. At the time, many people at CB's had pairs that had come from the same cardboard box.

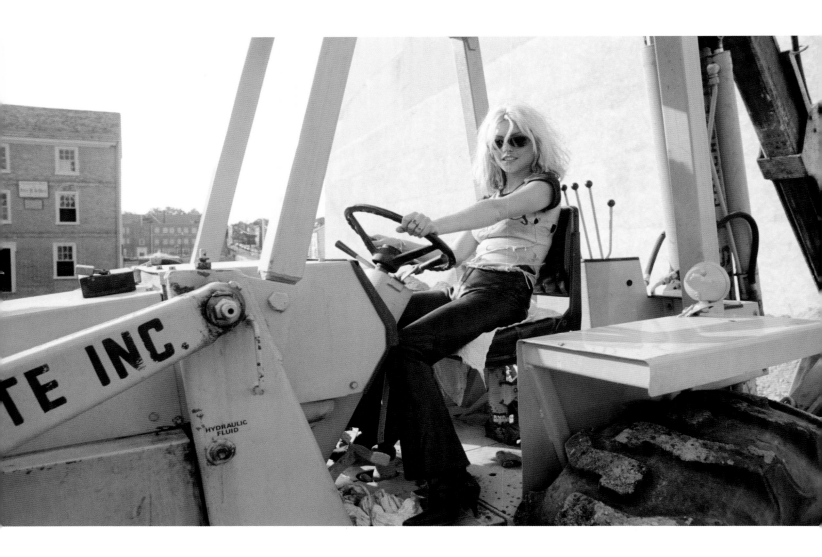

Debbie on an industrial vehicle,
Wilmington, Delaware, 1976. This was
shot during the Sleaze Convention. The
tractor was at a construction site some-
where in the downtown area, and we
came across it while exploring.

Also shot during the Sleaze Convention in Wilmington, Delaware, 1976. Legs McNeil is a controversial figure who partnered with his high school friend John Holmstrom to create *Punk* magazine. He is known for his book *Please Kill Me: The Uncensored Oral History of Punk*, which chronicles various violent anecdotes from the scene.

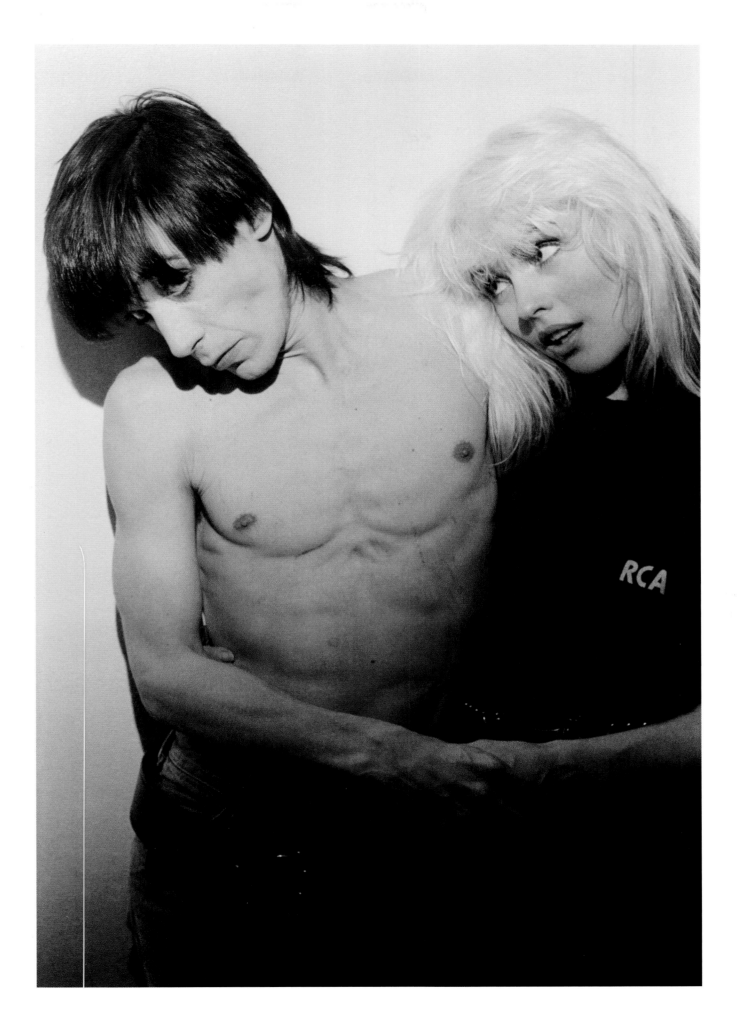

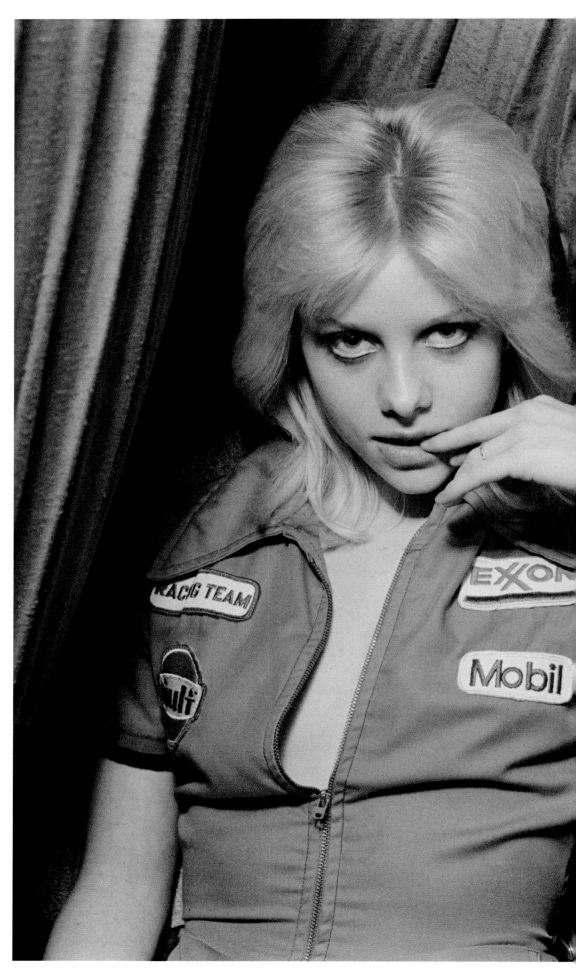

PRECEDING SPREAD The Idiot tour in 1977 was an amazing experience. In a way, it kicked off our life on the road. We got word that Iggy and Bowie wanted us to open for Iggy on the tour. We played a show at Max's in New York, got into an RV that was parked outside the club, and drove to Montreal. I remember staggering out of the RV after some sleep and going into Le Plateau Auditorium to be confronted by Bowie and Iggy, who were standing there, and greeted us. Bowie's taking a "back seat" to Iggy was a huge deal since David was already a mega-star. His taking the role of a session/backup musician said a lot about both his level of self-confidence and his respect for Iggy. In Seattle, Iggy, Clem, Gary, and I went to the local "punk house," a communal house that was the center of local activity. In an upstairs room, we did an impromptu show with borrowed guitars, amps, and drums. Iggy sang; the stage was a board on a mattress. We did "Wild Thing" and maybe a couple of Iggy songs. Years later, when returning to Seattle, I would sometimes be approached by people who said they were at the legendary event. Debbie is wearing an RCA shirt, Iggy's label at the time.

THIS SPREAD Cherie Currie of the Runaways in Blondie's RV, Boston, 1977. This shot of Cherie was taken hours after we first met. They had been performing at the Rathskeller in Boston. Blondie's RV (or tour bus) provided the backdrop. The girls in the Runaways (Cherie Currie, Lita Ford, Jackie Fox, Joan Jett, and Sandy West) were all teenagers then. I remember being particularly taken with Joan Jett—Debbie and I went on to be close with her. The rock-and-roll establishment was firmly male-oriented at the time; Debbie and the Runaways were the first wave of female rockers to pave the road for the more equitable split we now have between male and female musicians. The rock media jumped all over the Runaways. Recently, I read a Runaways review in an old issue of what was, in the seventies, a big rock periodical. The irony was that the writer slammed them for all the things that people now find endearing, basically their youth and sexiness.

RIGHT AND OPPOSITE Kim Fowley in Queens of Noise T-shirt, late seventies. Kim Fowley has a long history in music as a producer, writer, and performer. He's co-written songs for Kiss, Alice Cooper, and Kris Kristofferson, among others, and he has a cameo on the Mothers of Invention's first album, *Freak Out!* In 1974, he began feeling around, trying to create an all-girl band. In 1975, he met Joan Jett and, soon after, with Sandy West, the Runaways were formed. Coincidentally, Nigel Harrison, who went on to be the bass player in Blondie, played bass as a studio musician on the first Runaways album. Kim is an amazing, inventive, and wild character, and this shot shows how unrestrained he was and is. I haven't seen Kim in a while but I've seen pictures of him, now in his seventies, out and about in Hollywood wearing strange face paint.

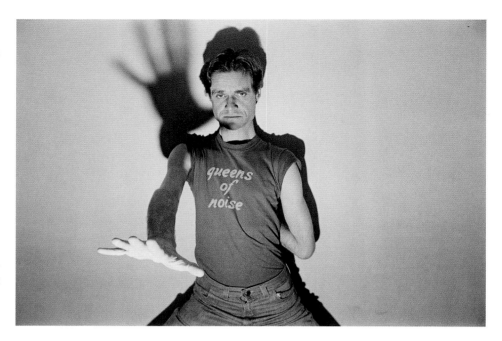

Debbie and David Bowie backstage during the Idiot tour, 1977. Bowie was really gracious with us, and he proved to be the consummate professional. However, not knowing about my photographic skills, he was more wary than Iggy about photo-taking and so, at the time, I only got this one shot of him. I suspect he was, and is, very careful of his image and what goes out. We have had many encounters with him over the years, and he is always a gentleman.

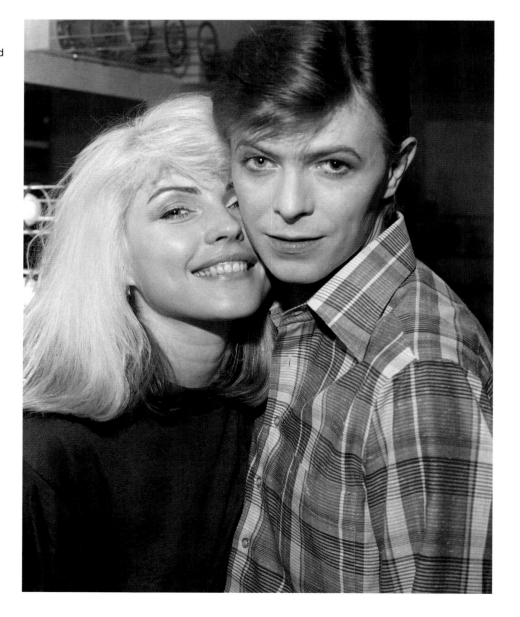

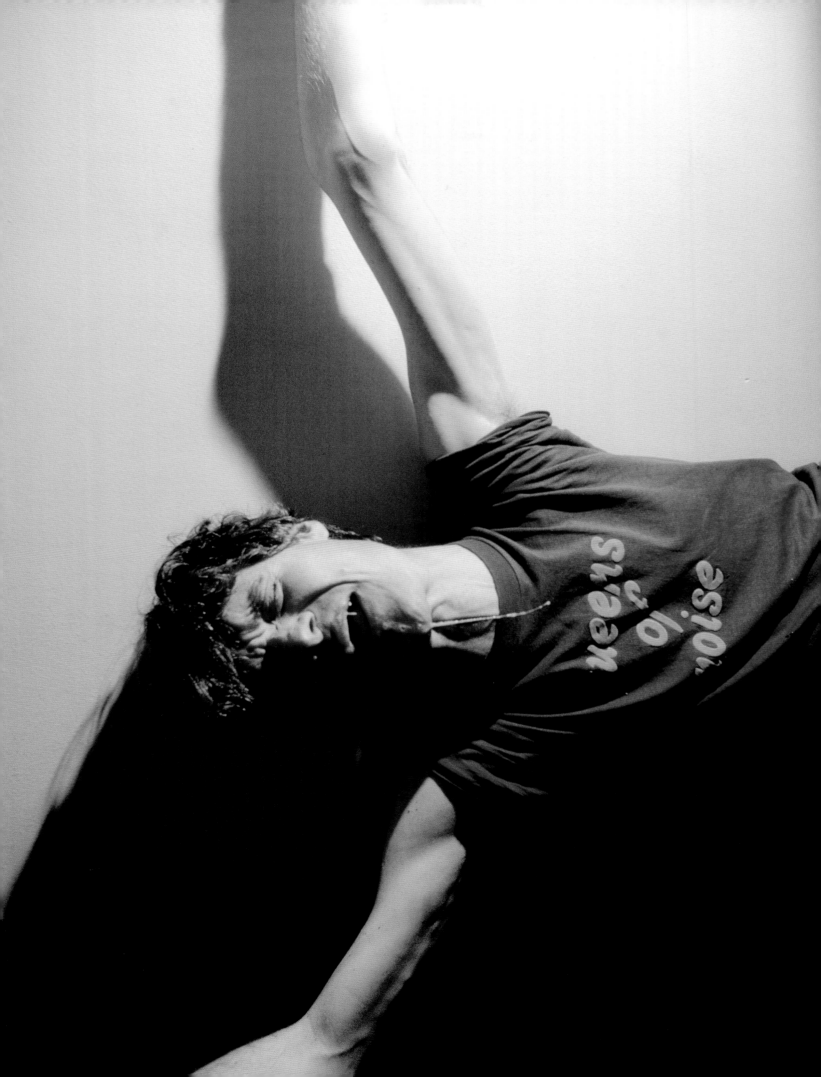

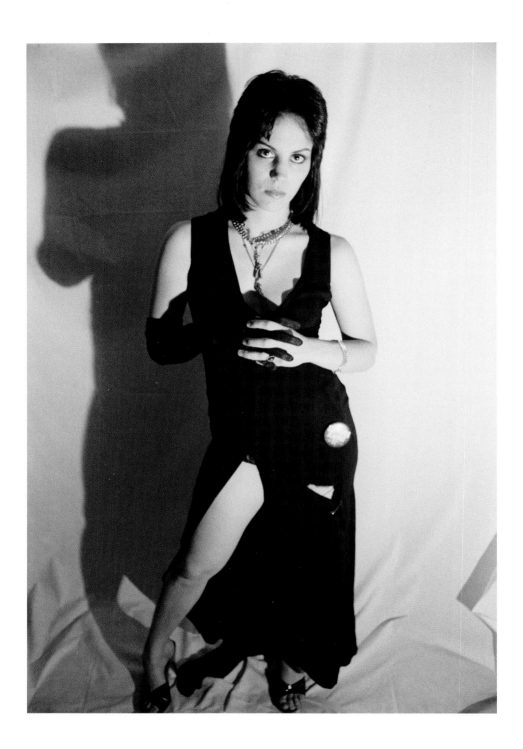

ABOVE I think I saw one other series of photos of Joan wearing a dress—a white one if I remember correctly. Debbie was instrumental in getting Joan in heavy makeup as well as the outfit. I promised that I would never share the photos without consulting with her. I had a photo show at the Morrison Hotel Gallery in Los Angeles in 2013 that included one of the shots. Joan came and I think she was OK with it. Kenny Laguna, her longtime friend and manager, told me that "she is secure in her image these days." I should think so.

OPPOSITE This was shot at the same moment as the Cherie Currie image. A solo shot of Joan from this shoot was recently made into a graphic work by Shepard Fairey **(PAGE 206)**. Debbie is smoking pot in the shot of the two of them. Lots and lots of weed was smoked in those days. I am also amused by the motel key on Joan's jacket. According to legend, Runaway members were pulled over in London then arrested for possession of hotel keys, the theory being that the girls would return to the hotels to rob them. Go figure.

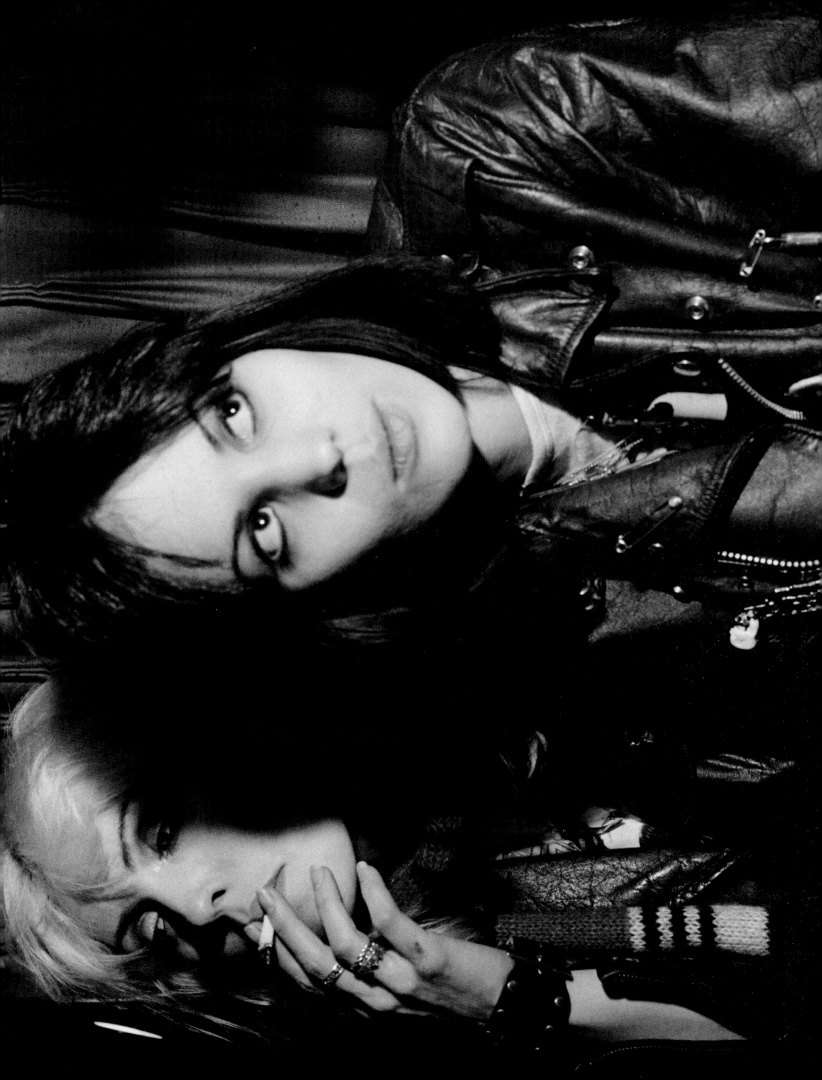

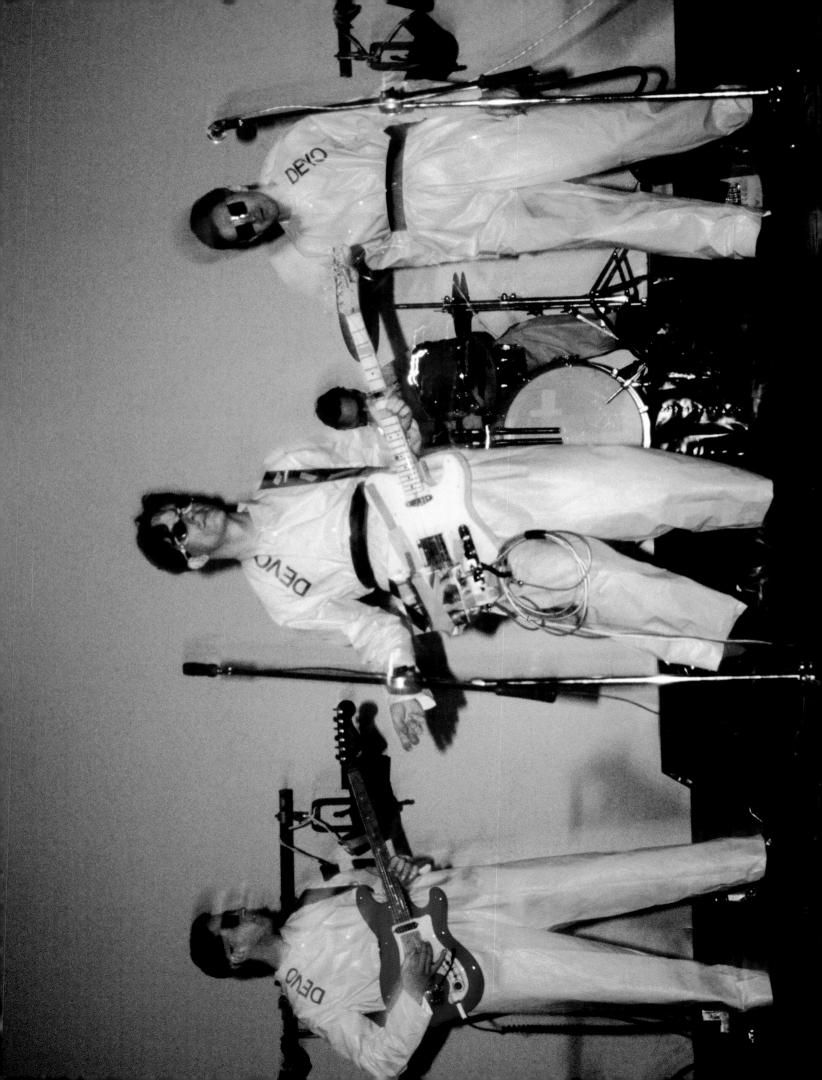

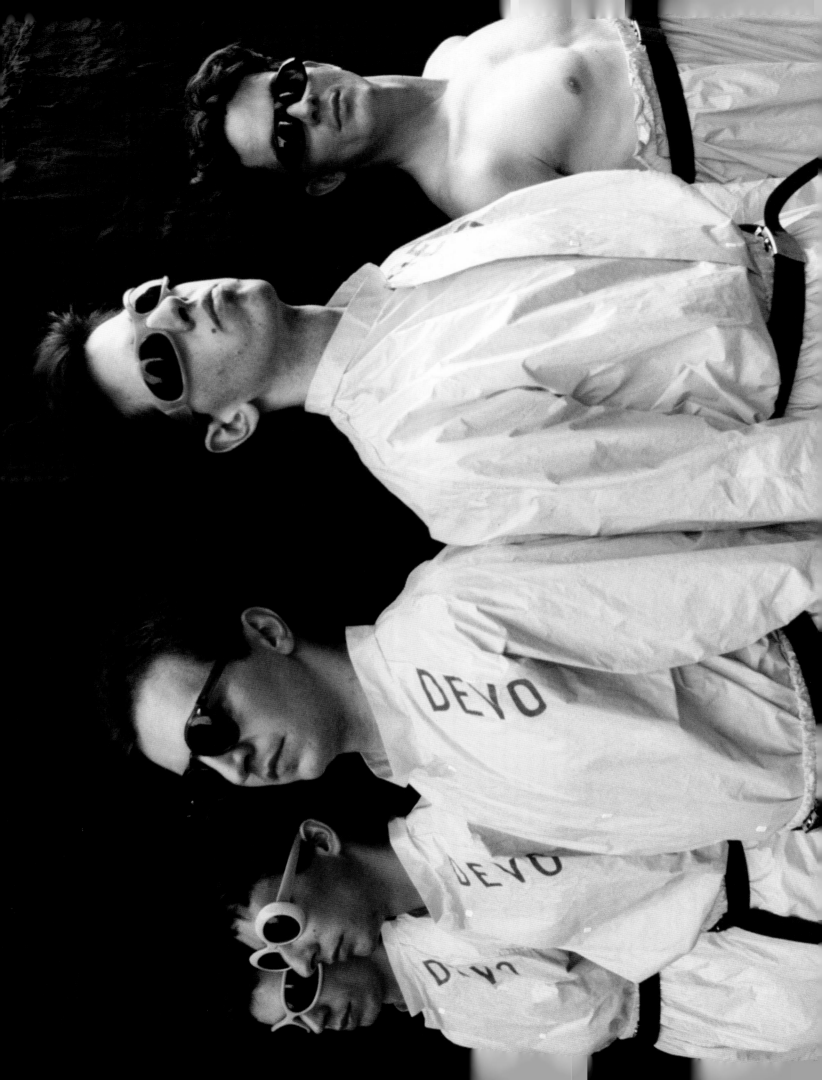

PRECEDING SPREAD, LEFT Devo in Akron, 1977. We met Devo when they first got to New York. I remember Anya Phillips raving about this new band and taking us to see them at Max's. From day one, they asserted their individuality.
We had many encounters and hangout sessions with them over the years.
By some odd quirk of fate, we wound up on tour in Akron, Ohio, on the very day they were filming a video for their monumental version of the Rolling Stones' "(I Can't Get No) Satisfaction." We went to watch them at the big old theater where this shot was taken.

PRECEDING SPREAD, RIGHT Devo on the roof of our 17th Street apartment prior to its burning, c. 1977–78. We toured the US with them in 2012—all these years later. They are still awesome. Drummer Alan Myers (on the left in blue shades) died in 2013 and guitarist/keyboardist Bob Casale (in the forefront of the photo, in orange shades) in 2014.

OPPOSITE This is my favorite image of them taken in the hallway of the 17th Street apartment. They are standing on a narrow ledge over the stairwell.

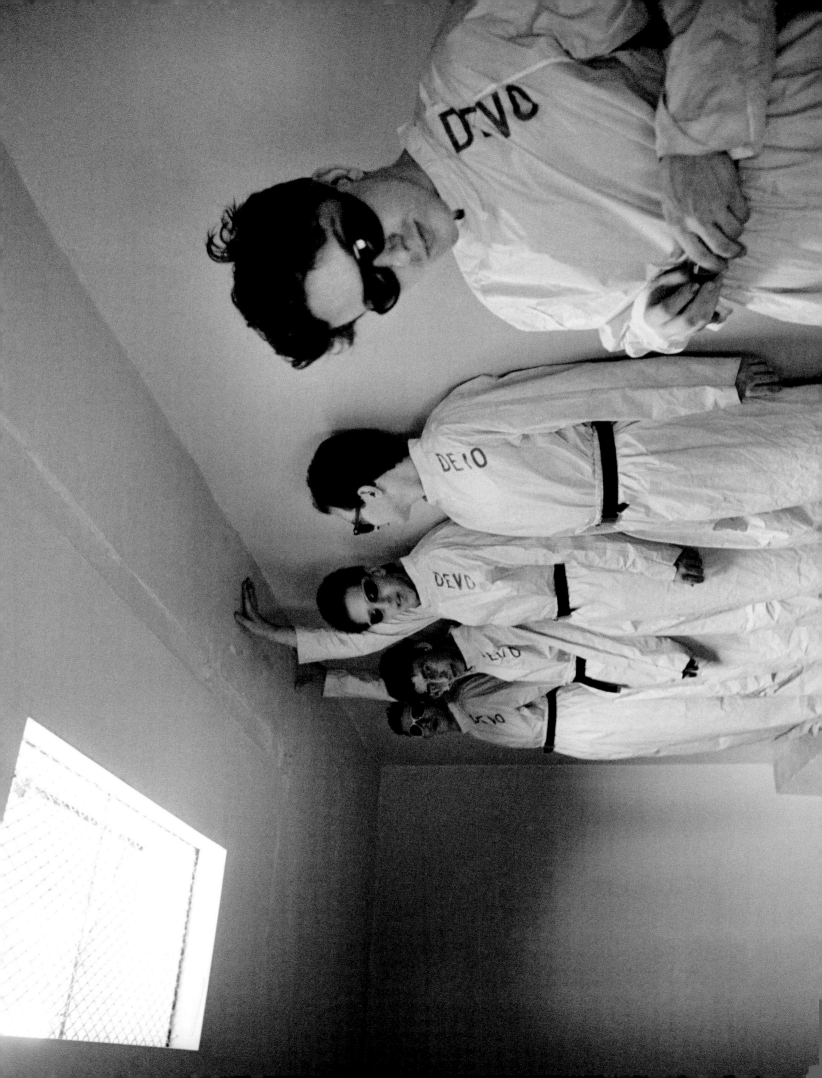

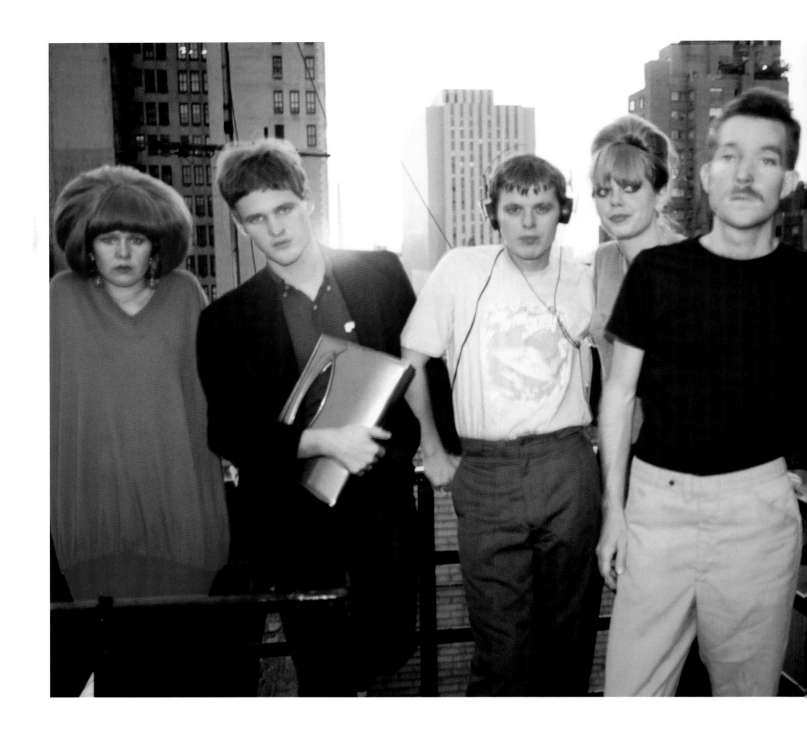

The B-52's, left to right: Kate Pierson, Keith Strickland, Ricky Wilson, Cindy Wilson, and Fred Schneider. We met the members of the B-52's when they showed up at one of our early shows in Atlanta in 1978. They were very cordial. I vaguely recall going out with them for drinks, possibly at one of their houses. They were all about cocktails. Soon after meeting them, "Rock Lobster" made underground history. I was always really intrigued by Ricky Wilson's quirky guitar playing, which was so signature. He would string his guitars in strange configurations, and I'm sure I once saw one that was not only tuned oddly, but was also missing the center two strings (D and G). Ricky died at age thirty-two, one of many friends lost to the AIDS virus.

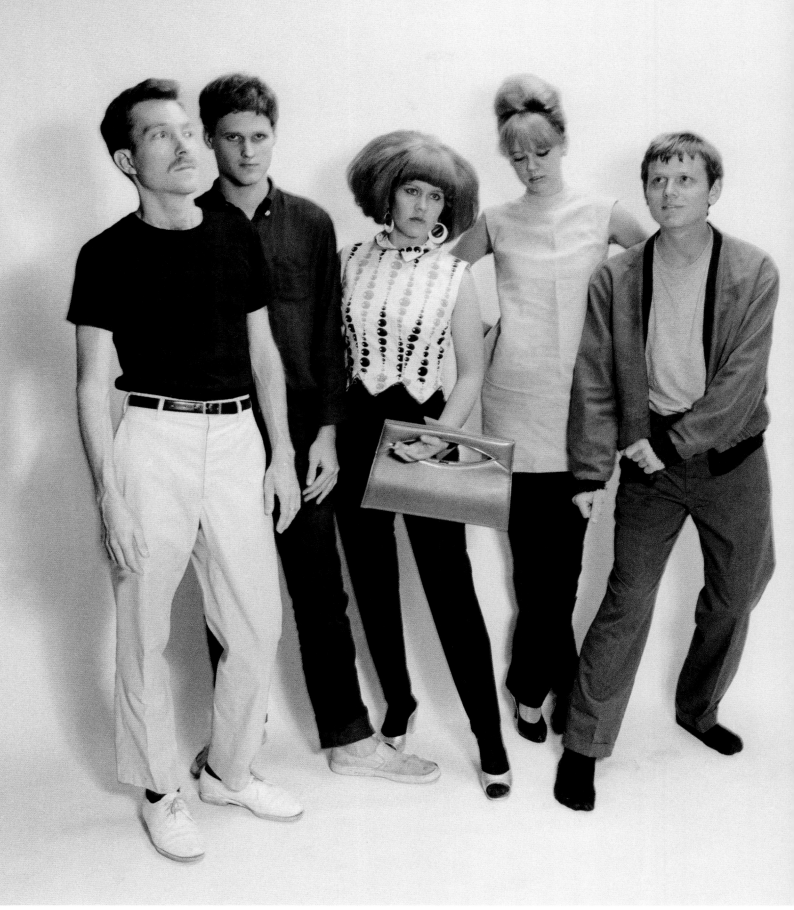

Jennifer Miro, San Francisco, c. 1977. Jennifer died in 2012. She was the singer of the early goth band the Nuns, who hailed from San Francisco. The SF punk scene was thriving by 1977, and the center of activity there was the Mabuhay Gardens bar, near many strip clubs on Broadway. This shot was probably taken during one of the shows at the Old Waldorf in 1977. The Nuns opened up for us for two nights.

The Mabuhay was San Francisco's version of CBGB. The first time Blondie played there, the dressing room walls were blank white. We were the first to add graffiti. This has been documented by great SF photographer Jonathan Postal in shots of Blondie writing "TOAST," and other things. When we came back less than a year or two later, not only were the walls *covered* with graffiti, but parts of them were eaten through from the vast quantities of ink and paint. One night Debbie and I were at a show at the Mabuhay. A huge fight broke out in the club, it was as if every one of the couple of hundred people in the place were dashing about madly trying to catch each other. Some culprits finally escaped the mayhem and things calmed down. I will always remember looking to my left and seeing a huge biker dude, wearing a white-on-black Blondie T-shirt with Debbie's face on it, bleeding dramatically from a gash in his head, the drops of blood falling on Debbie's picture on his chest.

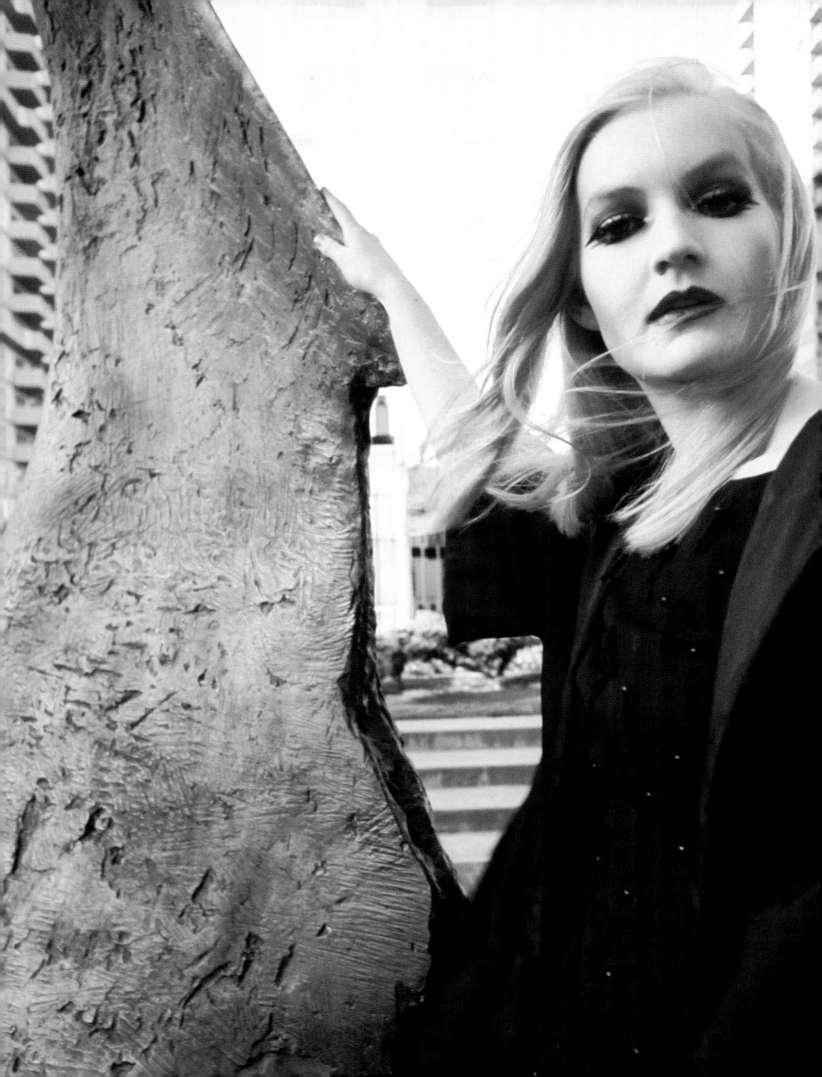

Debbie on Sunset Boulevard, leaping up in front of a sign with the Blondie show marquis, across the street from the Whisky a Go Go, during maybe our first or second trip to Los Angeles, 1977. Joan Jett's Runaways apartment was right around this spot. Blondie had a big impact on fashion sensibilities among the young hip kids who attended our early shows. The first time I was at a show at the Whisky (which was somewhat equivalent to CB's, though it had been around much longer; many of the biggest bands of the sixties, including the Doors, Byrds, Led Zeppelin, Cream, etc., played there) it was at a party for the just-signed Hollywood Stars. These guys represented the old guard, and they dressed in the uniform of the time: bell-bottoms, long scarves, and big hair. These were the last days of hippie/glam style. After that, we played just a few shows there and we noticed that the small crowds in attendance were quickly transforming style-wise, appearing with shorter hair, tight pants, and suit jackets and ties.

Joan, Debbie, and others by the Tropicana pool. This is the same location as the Richard Hell pool shot. By the mid-seventies, most big cities had one or more unofficial "rock hotels." The Tropicana Motel at 8585 Santa Monica Boulevard was, for years, a haven for artists, writers, and musicians. I frequently see it compared to the Chelsea Hotel in New York. Eric Emerson puts in an amazing performance as a mute in Warhol's film *Heat*, which was filmed there [*Trash* was also filmed there]. The rock history goes back to the Doors, who hung out there. Tom Waits lived there for long periods. Alas, the "Trop" is gone, replaced by a parking lot. Debbie is talking to great photographer Kate Simon and, behind them, is Pleasant Gehman and a kid named Randy, who were fixtures of the L.A. scene and close friends of Jeffrey Lee Pierce.

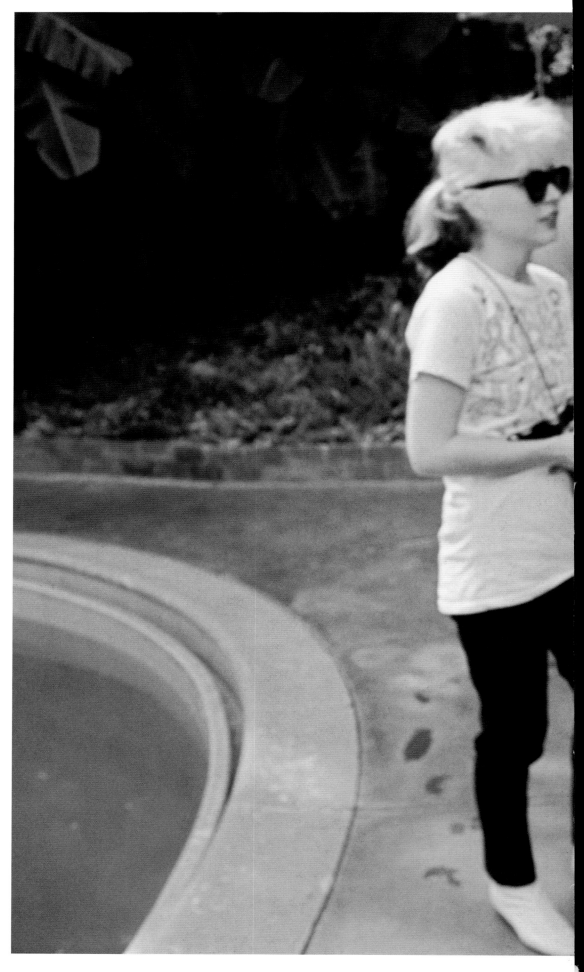

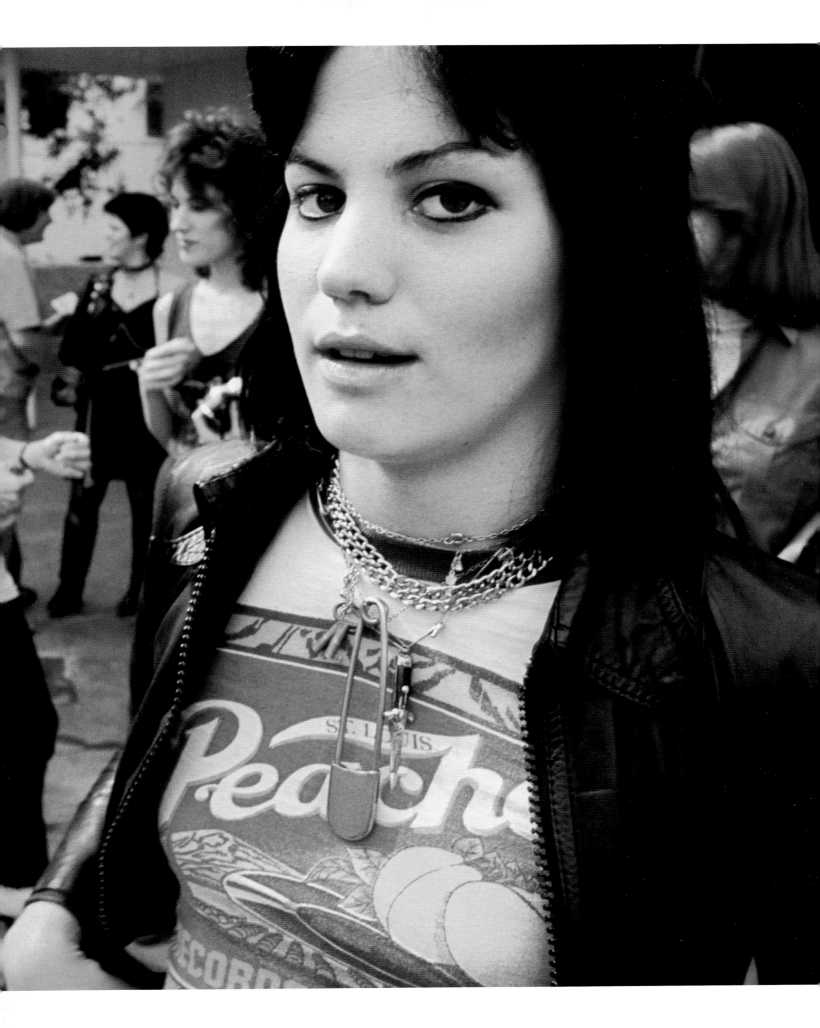

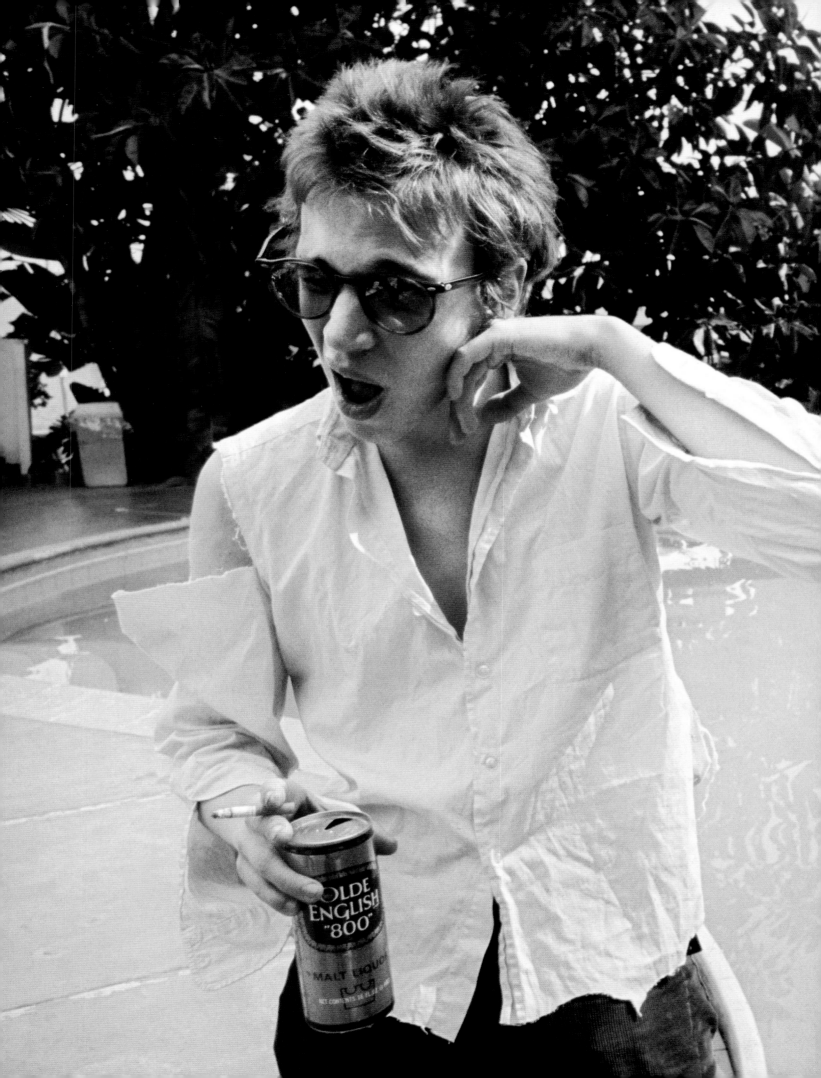

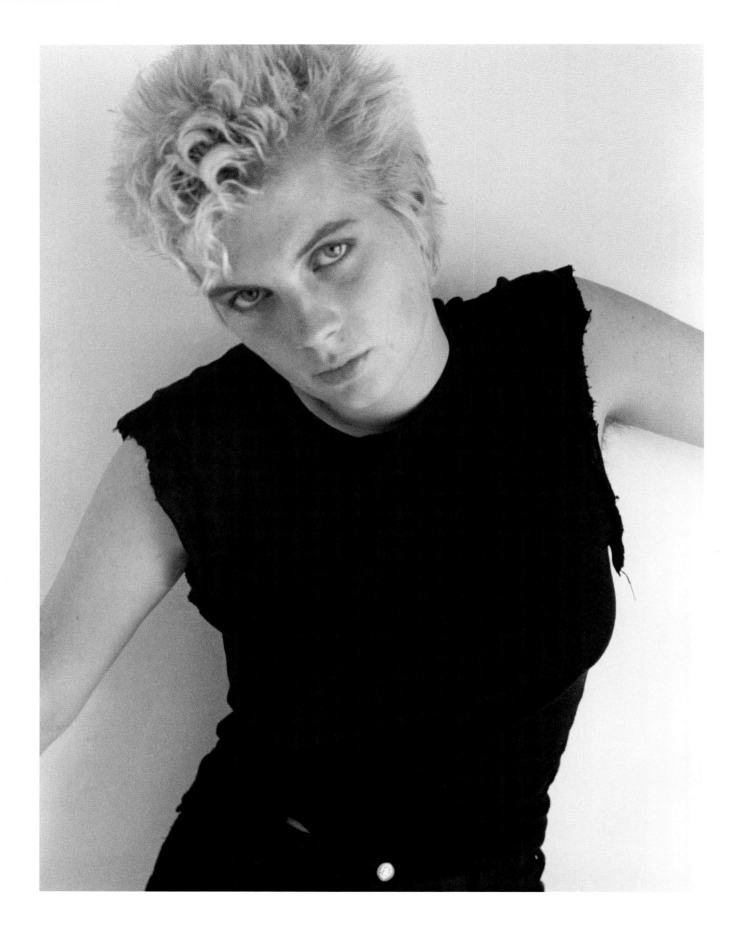

ABOVE Penelope Houston is the singer of the Avengers, an early Los Angeles punk band. The Avengers opened for the Sex Pistols at what seems to be the Pistols' final show at Winterland, San Francisco, 1978. Very photogenic. OPPOSITE, TOP Penelope with fellow Avengers Danny Furious (Dan O'Brien) and BOTTOM Greg Ingraham.

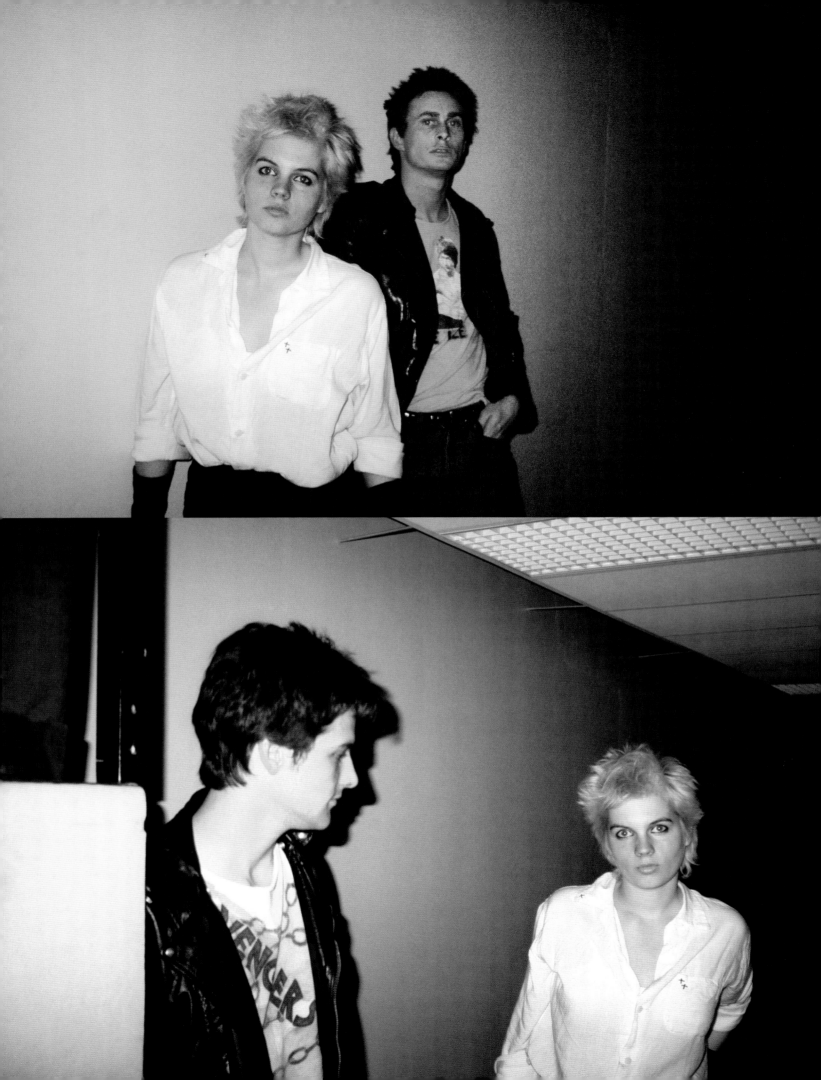

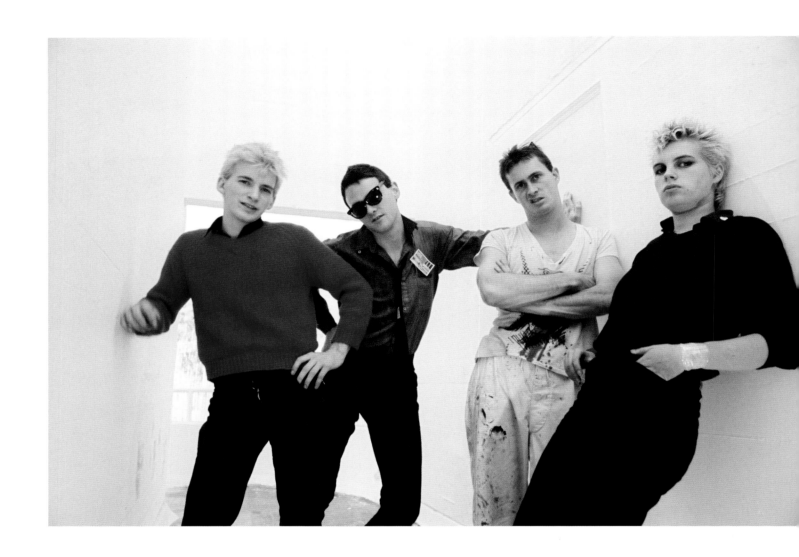

PRECEDING PAGE AND ABOVE The Avengers, from left to right: Jimmy Wilsey, Greg Ingraham, Danny Furious (Dan O'Brien), and Penelope Houston, 1977.

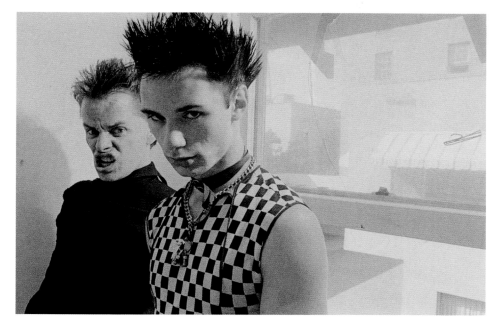

LEFT AND BELOW The Screamers in Los Angeles, late seventies. Tomata du Plenty and Tommy Gear were the core of the LA punk experimental band the Screamers. I don't think there are any proper recordings of them, but there are clips and demos of them around—sort of Suicide meets the Sex Pistols with other diverse elements. We were friends with Tomata from his drag days in New York. I had met him even before I met Debbie. He was part of the New York early glam-trash experience. The Screamers were him reinventing himself. Tomata (David Harrigan) died in 2000.

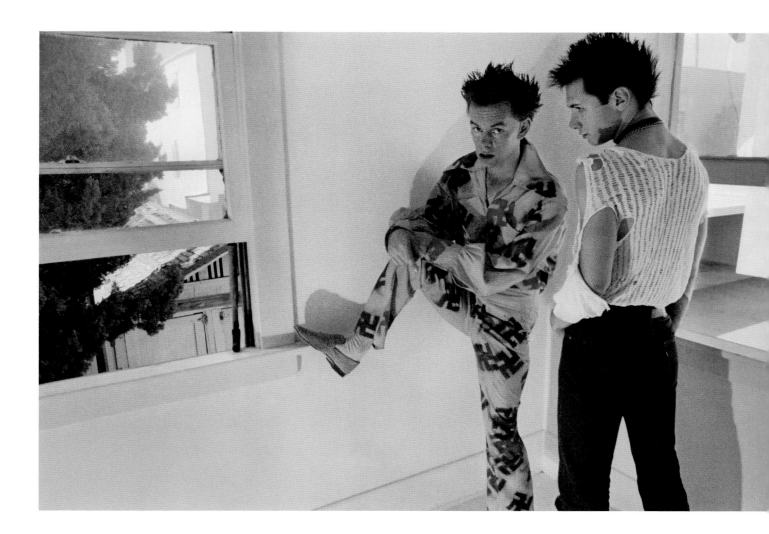

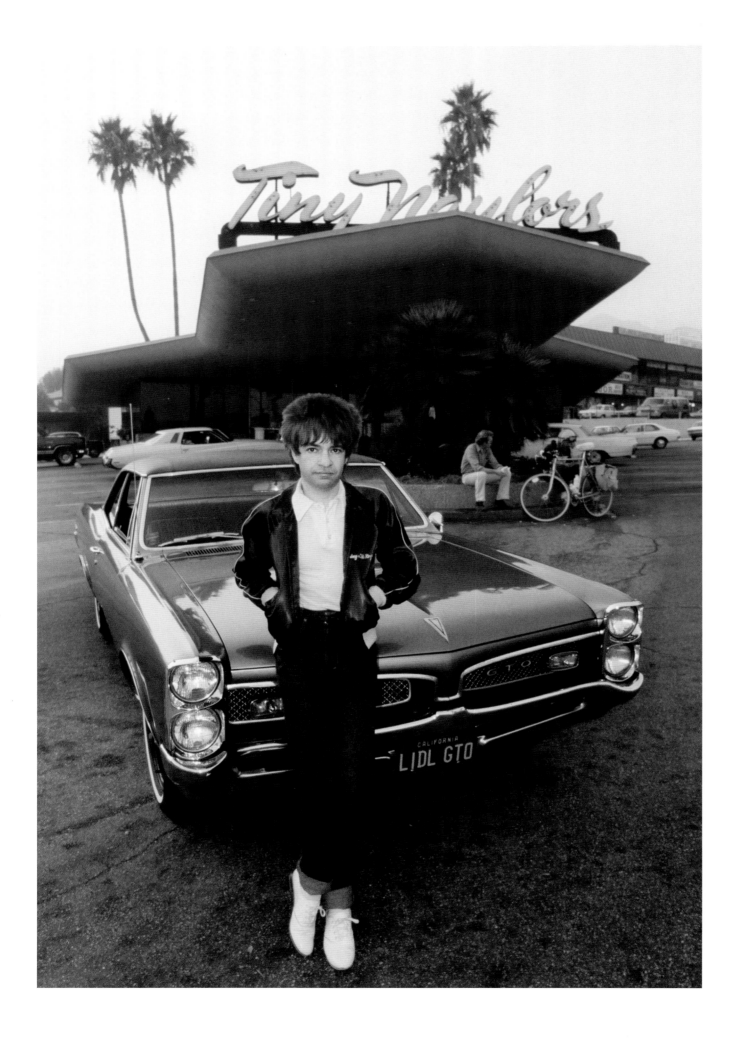

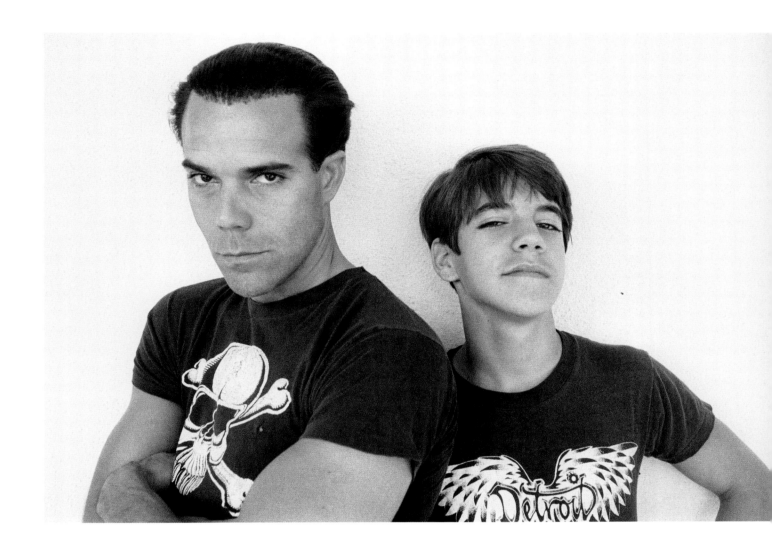

OPPOSITE Rodney Bingenheimer, in front of the now-demolished Tiny Naylor's drive-in in Los Angeles, with his famous Pontiac GTO, late seventies. Rodney was instrumental in introducing Blondie's music to America. He was one of the first radio DJs in the country to embrace new wave and punk music. He has a long-standing radio show on KROQ in L.A. His associations with pop culture are vast.

ABOVE Actor John (aka Blackie Dammett) and son Anthony Kiedis at the Tropicana in Los Angeles, late seventies. Someone from our extended group knew Blackie from the local scene, and one day he showed up with Anthony, who he introduced as his son. They looked really cool together so I shot a roll of film of them against one of the walls outside the motel rooms. Anthony was fourteen here. He would later go on to found the Red Hot Chili Peppers.

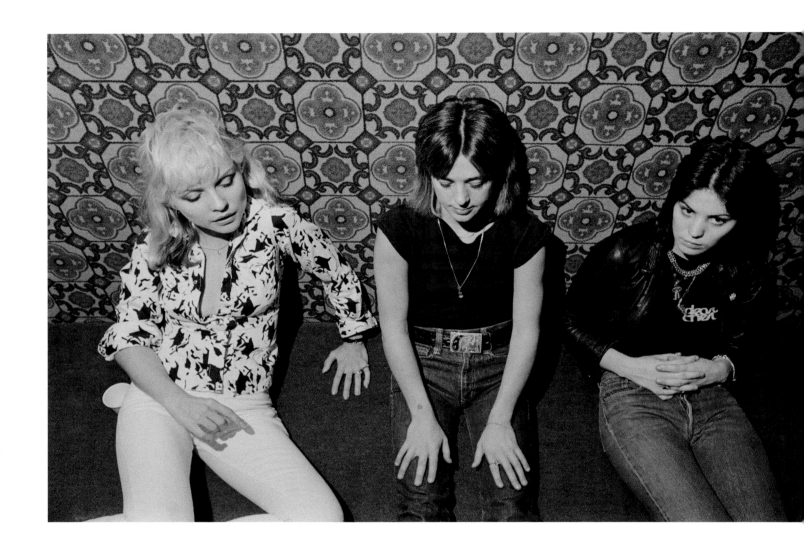

Debbie, Suzi Quatro, and Joan Jett
in a studio in Los Angeles, where Suzi
was recording with producer Mike
Chapman. This may have been our
first meeting with Mike. Suzi was a
hero of Joan's but was much more
restrained and moderate, if you
compared her lifestyle to that of the
Runaways. I thought this made some
distance between them. Suzi, of
course, was one of the first female
hard-rock instrumentalists.

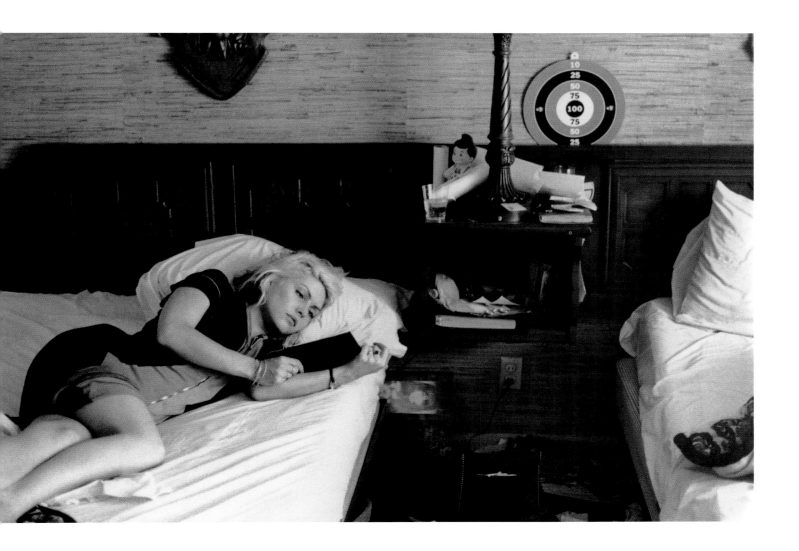

Debbie in a hotel, California, late seventies.
This looks like a room that we must have
been in for some time. The Bob's Big Boy
figure suggests California.

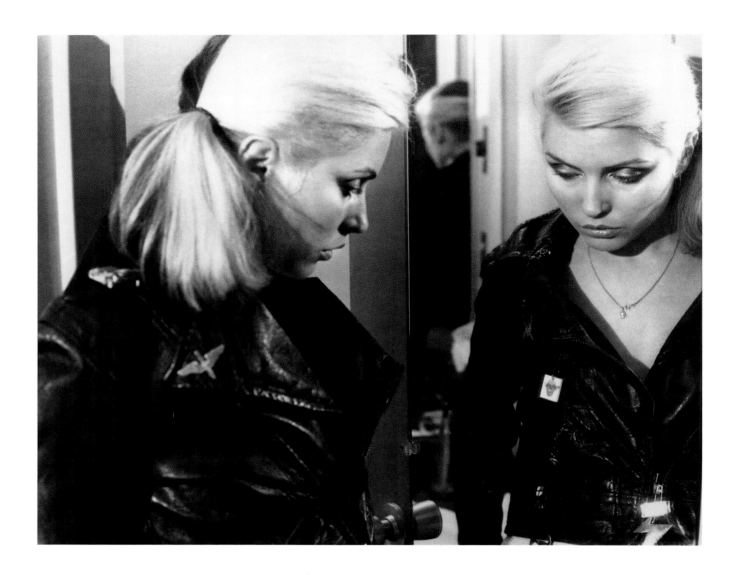

Debbie in a vintage motorcycle jacket,
c. 1976. In the late seventies, you
weren't able to go into a boutique
and purchase any one of a hundred
variants of the classic motorcycle
jacket. This particular jacket was
bought at a shop on Santa Monica
Boulevard in Los Angeles, when that
street was only populated by a handful
of such stores. It probably dates
back to the late forties or early fifties
and would cost a great deal today. I
recall debating if we should spend
the few hundred dollars that it must
have cost then. She probably still has it.

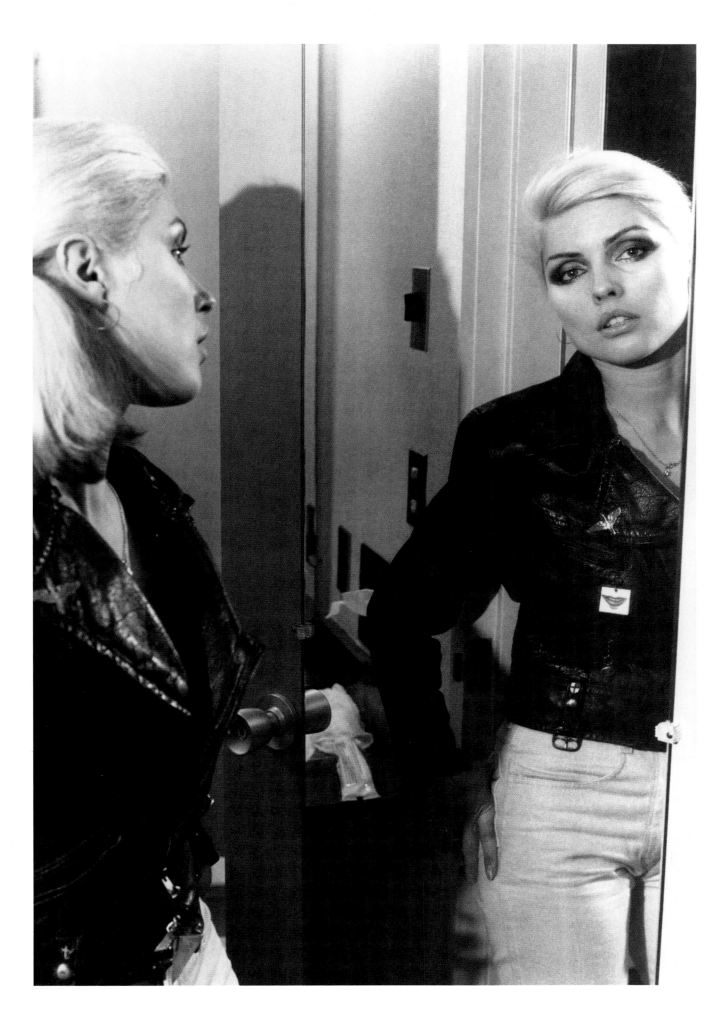

Yet another anonymous hotel room.
On one occasion, we were staying
at the Fontainebleau hotel in Miami
long before it was fixed up. It was still
pretty funky, this was maybe 1977–78.
The room I was in was freezing, the
air-conditioning cranked. I opened
the big French-style window doors.
Outside was super hot and humid and
the room was instantly covered in
condensation. The moisture covered
everything including the ancient
giant TV set that I had been watching.
Smoke began pouring from the TV,
it made a few crackling sounds and
died with a loud "pop."

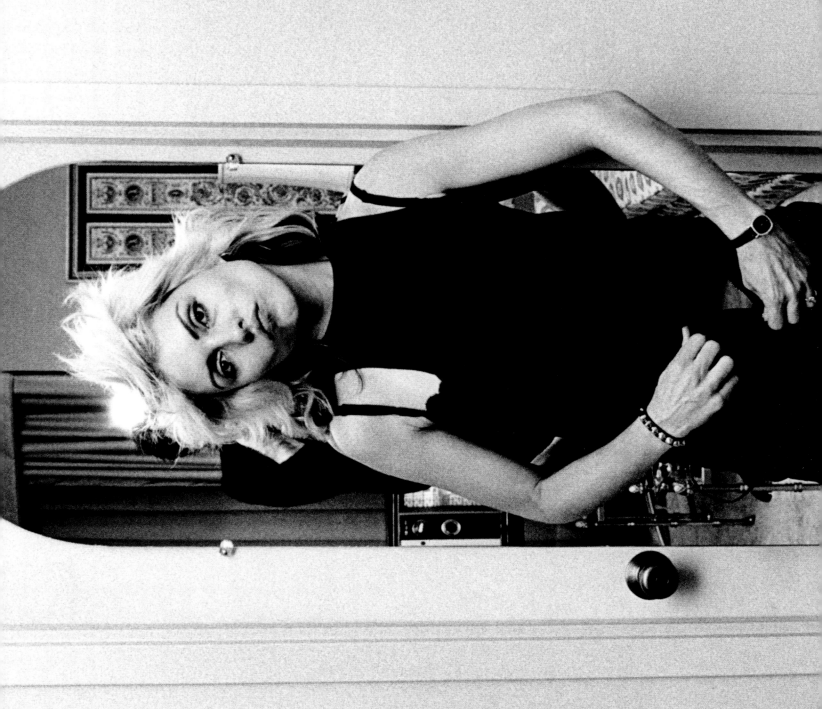

Debbie in a *Plastic Letters* outtake, Los Angeles, c. 1977. The photos for the second Blondie album, *Plastic Letters,* were shot by Phillip Dixon. There was a first session shot at and around the Tropicana in Los Angeles. In these images, Debbie is dressed in a pillowcase, which has been wrapped with red duct tape. We spent a day shooting and everyone left liking the Polaroids and concept. When the photos got to Chrysalis Records, there was a big outcry that the images were "too punk" and Dixon was hastily flown to New York for a brief second session, which produced the shot of the band around a prop New York police car. [The story I got was that the police car was supplied by the NYPD, and that it was a special, smaller version of the actual thing they hired out for film and video.]

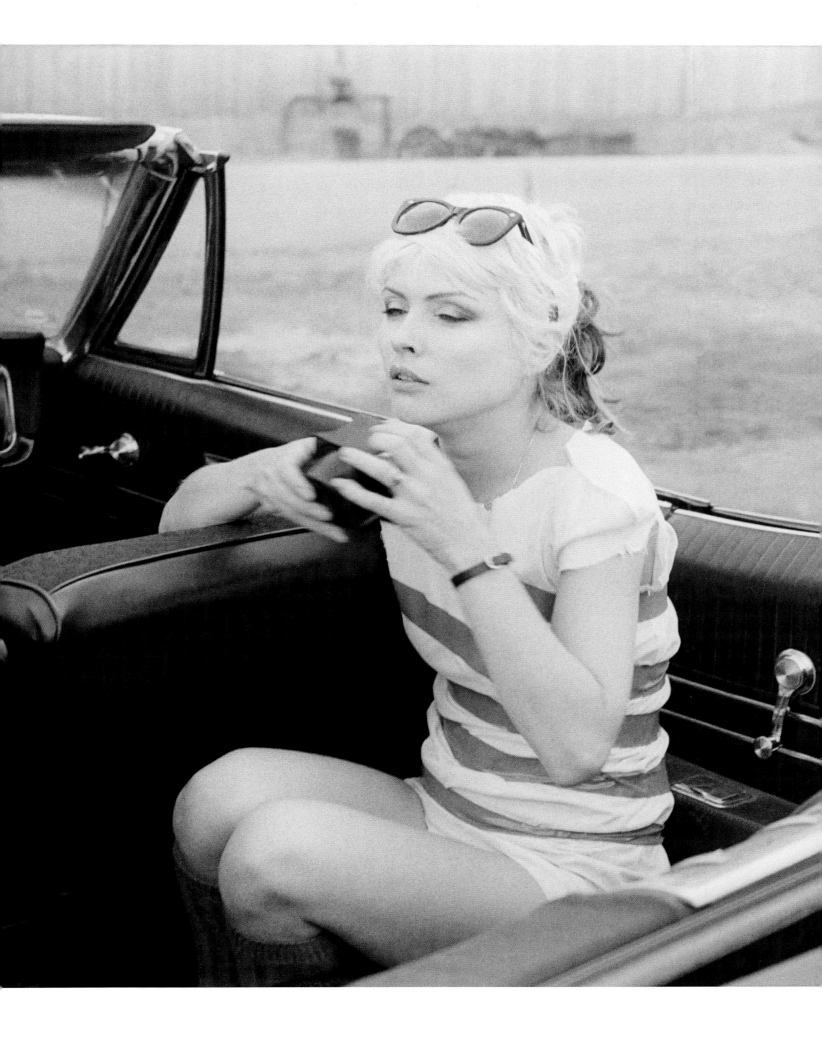

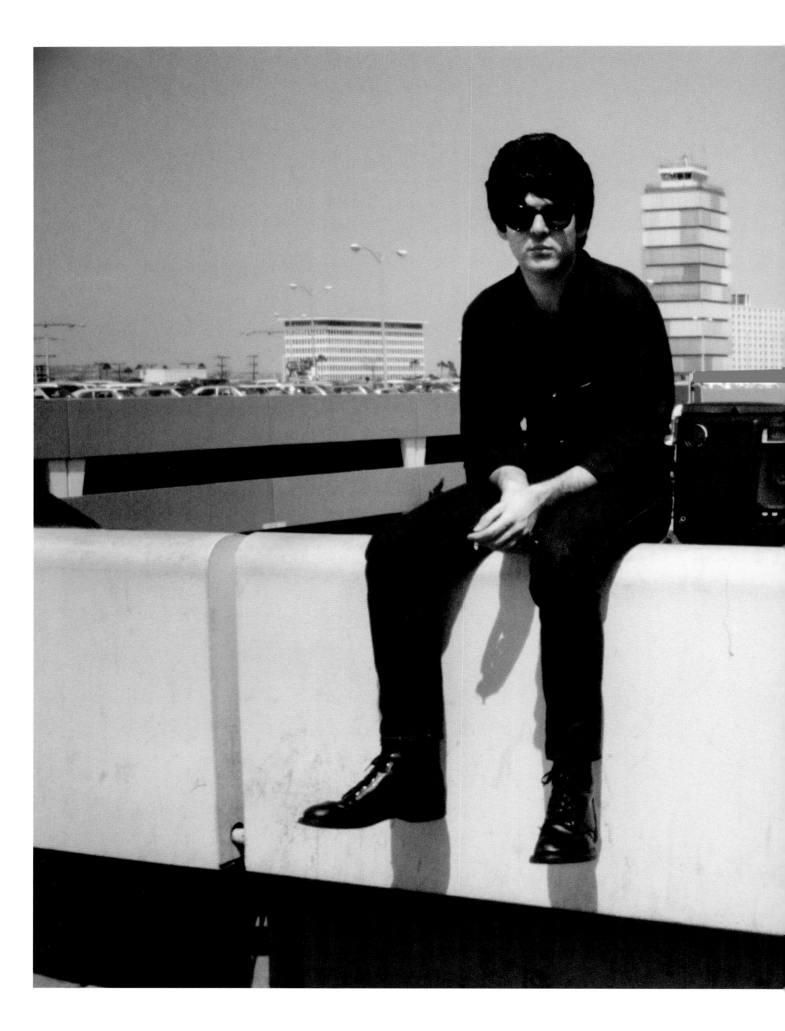

PRECEDING SPREAD Clem on a Los Angeles wall, c. 1978. In 1978, Sony released their first boom box, the CF-520. Here, Clem is sitting next to two CF-570s that we got in Tokyo and dragged all around the world. I would use mine as an amplifier when I was working on tapes in various hotel rooms, plugging all kinds of outboard audio devices into it. It lasted for years, and I think it was finally killed in an accident—a flood or something.

OPPOSITE Debbie boarding a private jet, c. 1978. To this day, Debbie carries around her own bags. I always tell her, "Michael Jackson never carried his bags." It falls on deaf ears.

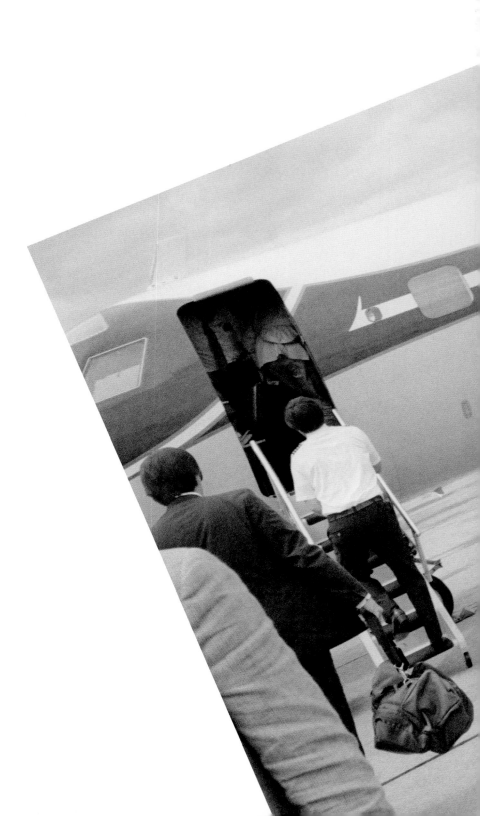

BEYOND US

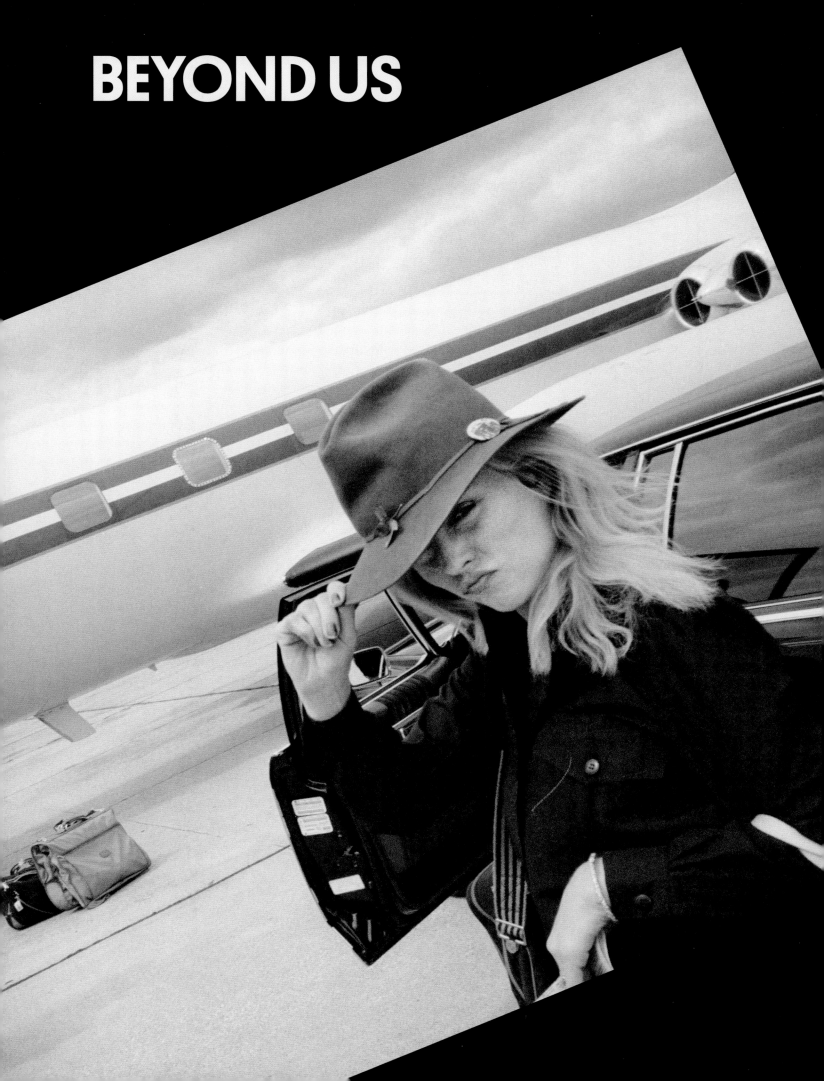

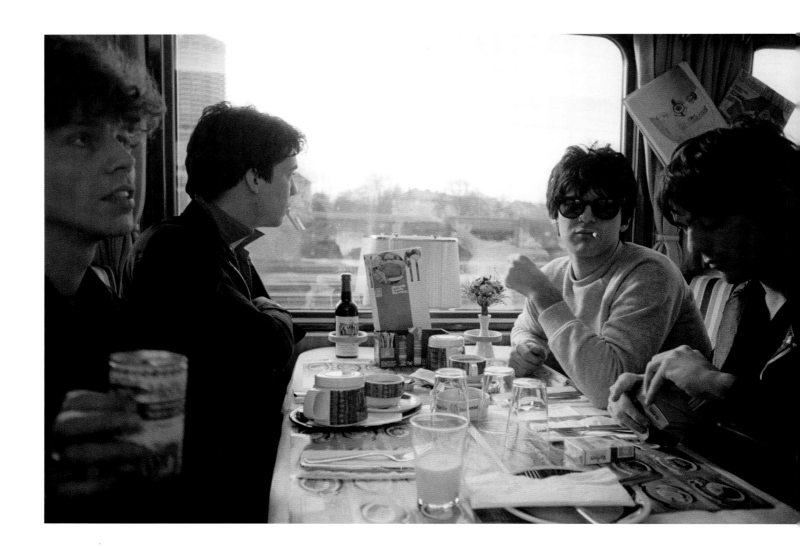

ABOVE From left to right: Nigel Harrison, Jimmy Destri, Clem Burke, and Frank Infante, the lineup at the height of Blondie-mania on a train somewhere inland Germany, 1978. There was always a vague Beatle referencing going on with us—certainly Clem encouraged it—and this shot takes me back to that atmosphere, to the band we were, and the mental image we all had in our heads of the bands that we were fans of, coming together.

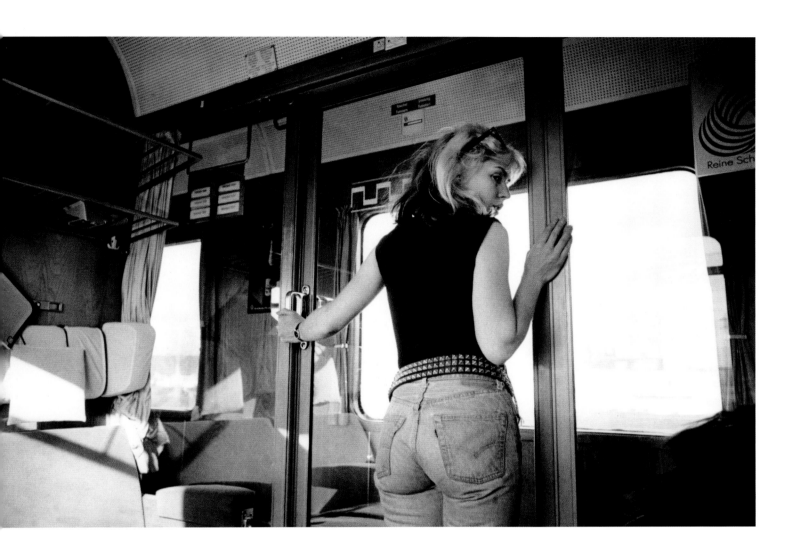

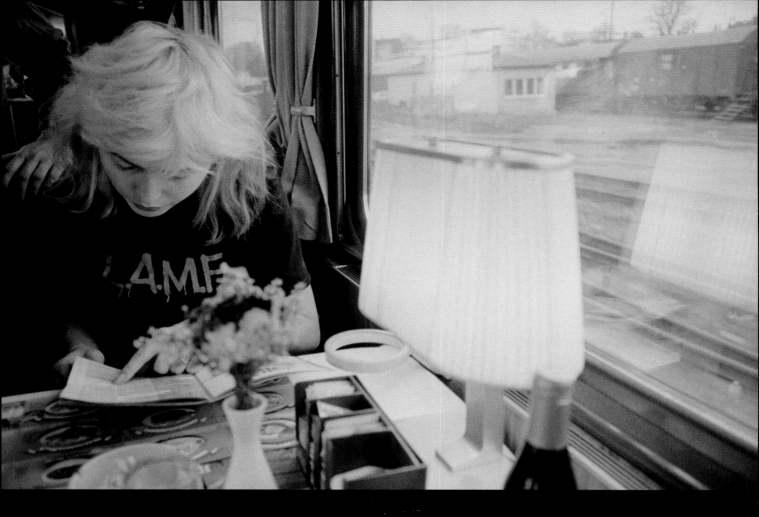

Debbie reading on a train in Europe, late seventies. Debbie is wearing a Heartbreakers/Johnny Thunders T-shirt with an L.A.M.F. logo. This was the title of the only Heartbreakers album. Maybe there's one person who doesn't know that this stands for "like a motherfucker." The term dates back to the fifties and may have been coined in Brooklyn, another part of New York, or maybe even elsewhere. My friends and I from Brooklyn had a folk-rock band that played on Sundays in Washington Square around 1966 when musicians would congregate there. This organization was named "The Millard Fillmore Memorial L.A.M.F. Band." "L.A.M.F." in this case meant the "latent admirers of Millard Fillmore." We thought this was hilarious.

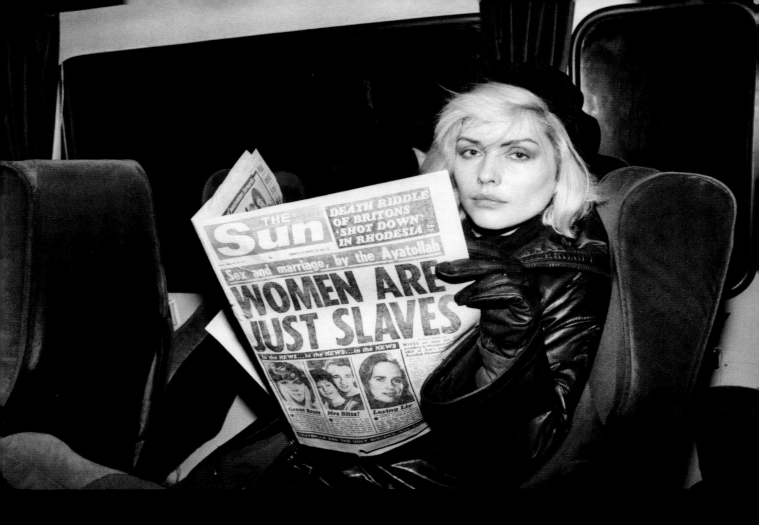

Debbie with *The Sun*. It's not as if UK
tabloid "newspapers" push the limits
of credibility any more than their Ameri-
can counterparts, but in a way, the Brit-
ish organs got there first. Here, Debbie
reads about sexism under the ayatollah

ABOVE Outdoor market outside of London. The bleakness of this scene really struck me—even at the time. This was shot when the cities of the West were still victim to the ravages of crap economies. The early punk scene in the UK did emerge from socioeconomic malaise, and the "dole" [the British welfare system] kept popping up as a lyrical theme in punk songs. I suspect that things had deteriorated even further by the eighties.

OPPOSITE Debbie in a jean jacket, c. 1978. This shot was used for the cover of one of the weekly music papers in the UK.

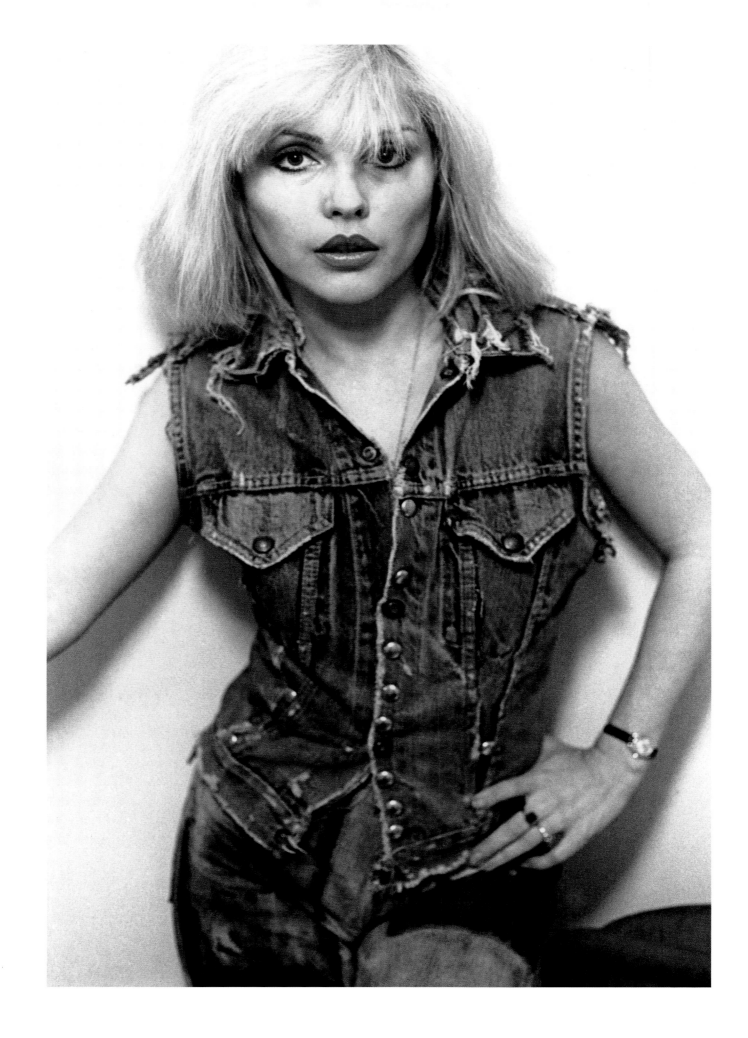

Clem on Kings Road in London next to a Television/Blondie poster, 1977. This was our first trip to the UK as a band. We were opening for Television, and Clem, in particular (as a real Anglophile), was well prepared for the British rock scene. Prior to this, opening for Iggy Pop on the Idiot tour had been very gratifying. Both Iggy and David Bowie were completely professional and emphasized to us their concern that the whole show—that is, both bands—be integrated and move smoothly. In later years, with the various bands that were our peers, there was a more competitive atmosphere surrounding various tours. I can't say we didn't contribute to it.

Kings Road was central to the emerging London punk scene and was a super-exciting milieu. At our first London show with Television, there was an outpouring of support for Blondie from various members of the London rock press. What we didn't know at the time was that good first reviews pretty much always meant that your second reviews would be, shall we say, less favorable.

It's also a little ironic that there's a Dr. Feelgood poster here. A bit of unknown music history is the big influence Dr. Feelgood had on the early New York music scene. Dr. Feelgood recorded their first album before anyone in New York had gotten into a studio and the record's minimalism was very popular with members of the New York inner circle. Feelgood did two shows with the Ramones in 1976 at the Bottom Line in Manhattan.

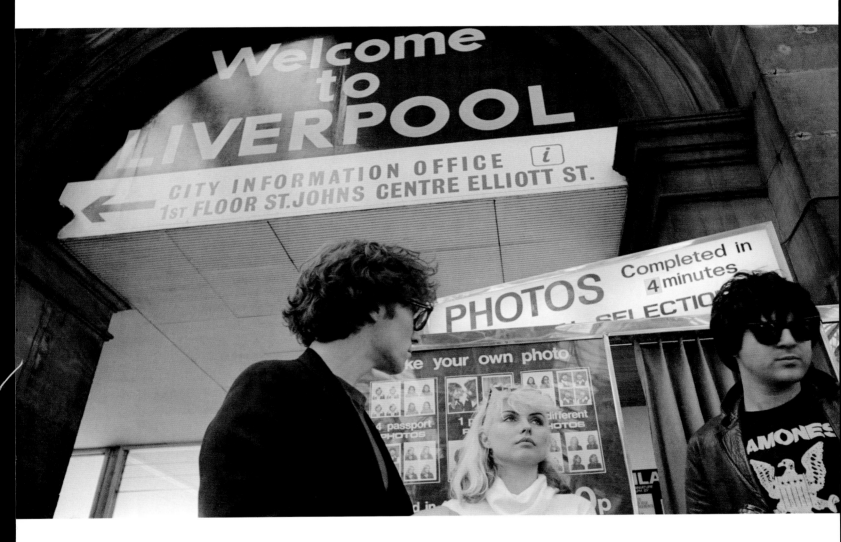

Gary, Debbie, and Clem at Lime Street Station in Liverpool. This may have been our first trip to Liverpool and the shot was probably taken in 1977. When I investigated, I saw that we didn't play a Liverpool show on the first UK tour with Television, so this must have been sightseeing. (I also noticed that on this tour we played six shows in six days in five UK cities; these days we try to keep it to three in a row.) Here is more of the interface between our reality and the external rock-and-roll plane that we were mentally hooked into. Here, we were aware of the rock history of the place: *A Hard Day's Night* scenes, the River Mersey music scene, etc. There are great historical levels in this shot as Clem is wearing what might be the first Ramones eagle T-shirt.

FOLLOWING SPREADS Clem at a train station and Debbie in a hotel room somewhere in Europe during this time.

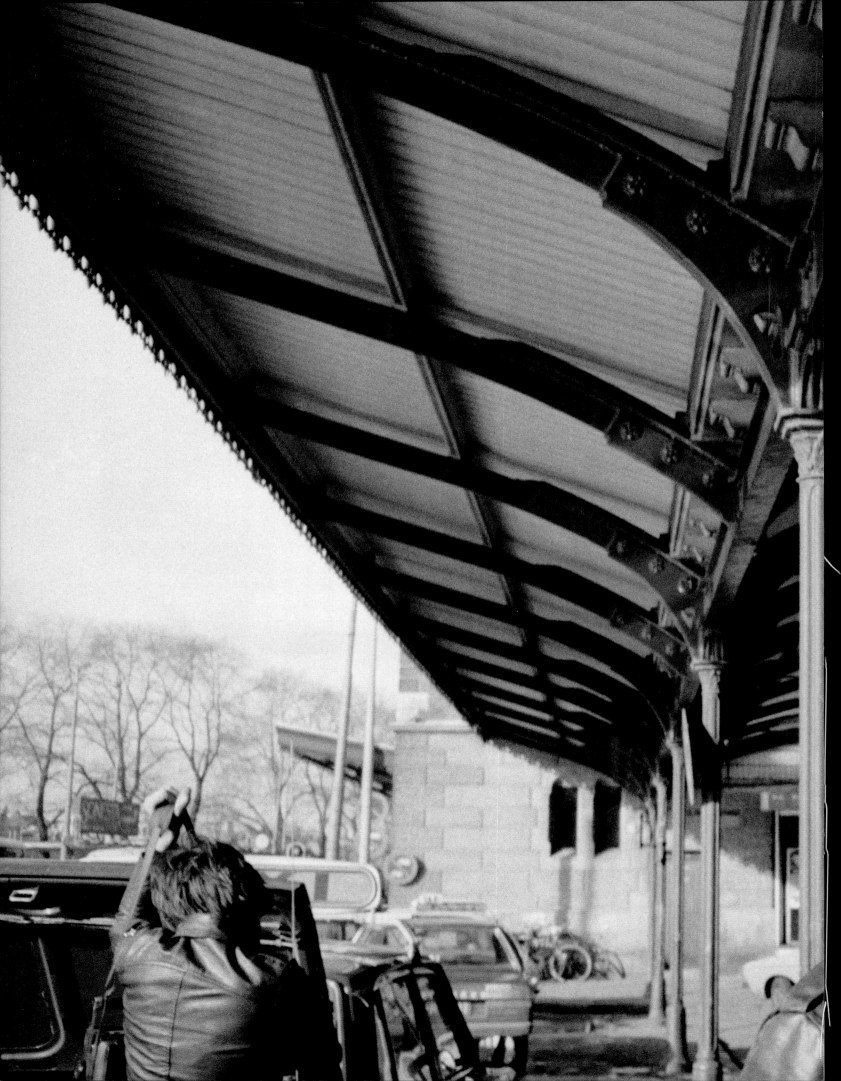

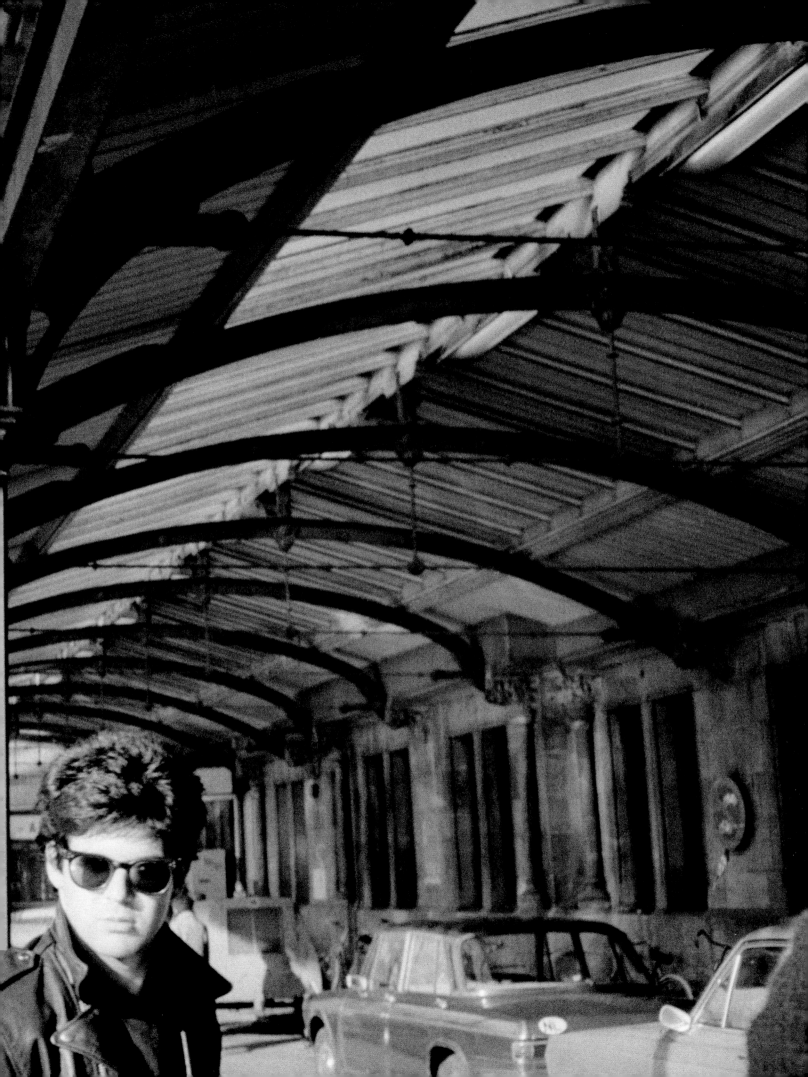

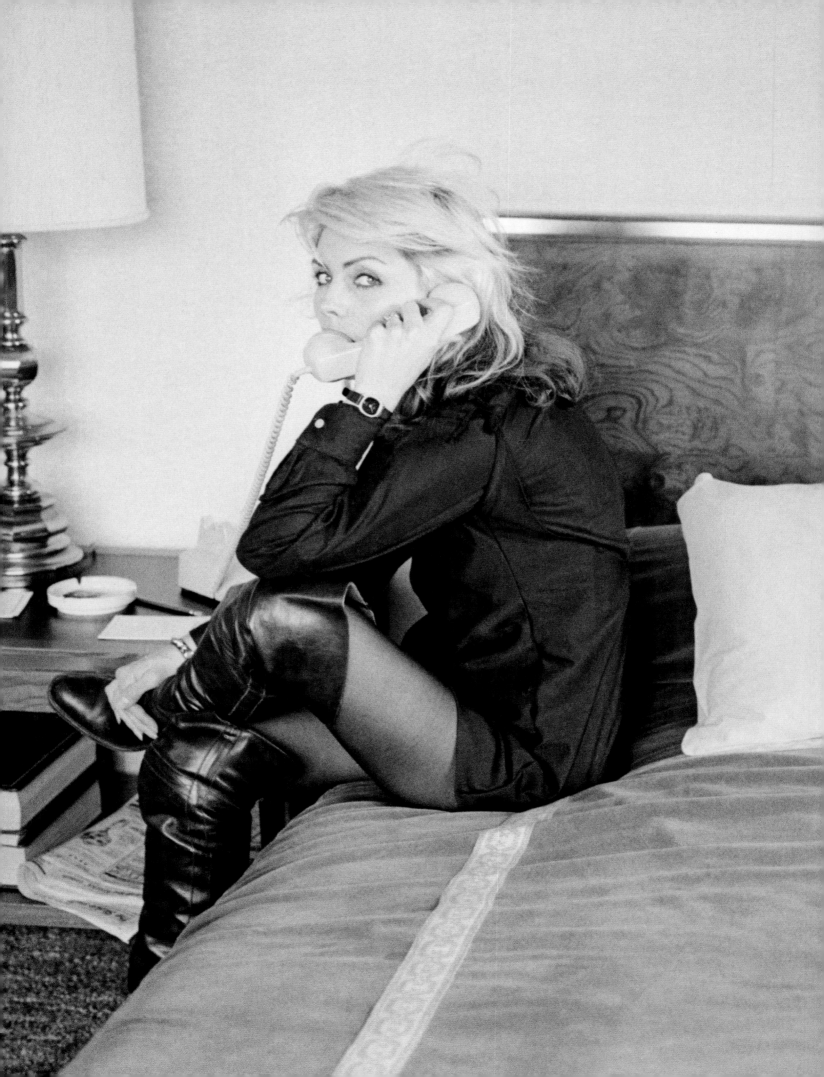

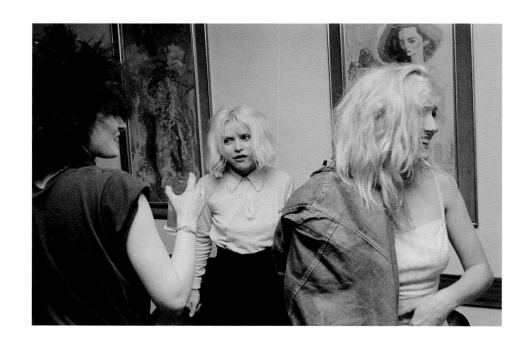

RIGHT Siouxsie, Debbie, and Viv in London.

BELOW Chrissie Hynde and Debbie.

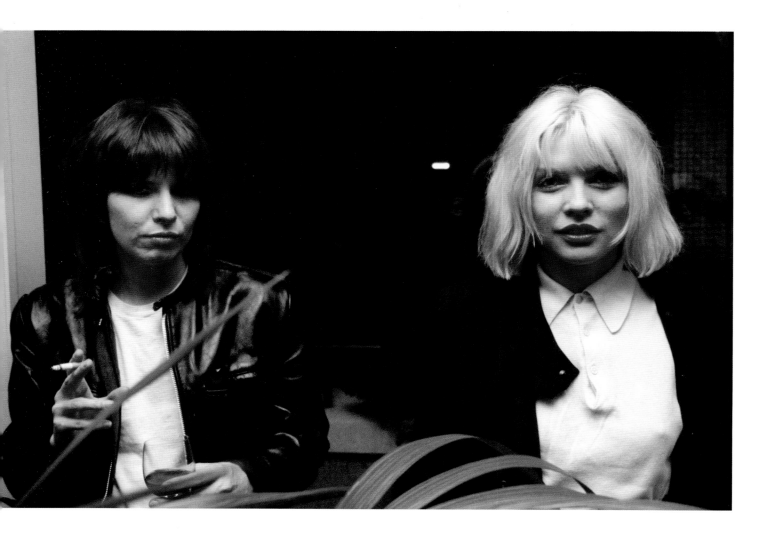

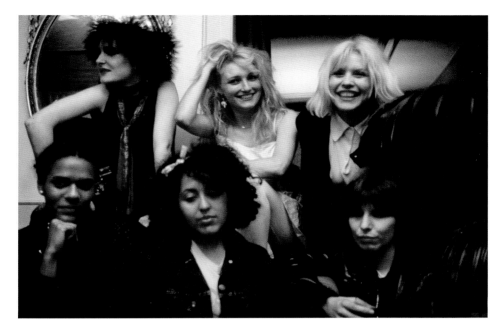

BELOW From left to right: Chrissie Hynde, Pauline Black (then of Selecter), Debbie, Poly Styrene (then of X-Ray Spex), Viv Albertine (then of the Slits), and Siouxsie Sioux of Siouxsie and the Banshees, 1980. One of the UK music papers set up a sort of summit with the top rock women of the day. Kate Bush was invited but didn't show up. There was an interview conducted, which was later published, but mostly I recall the girls socializing and having fun.

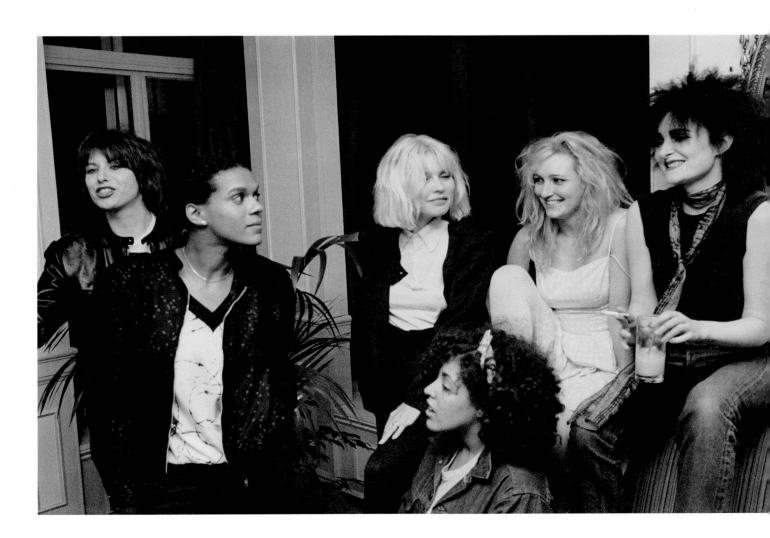

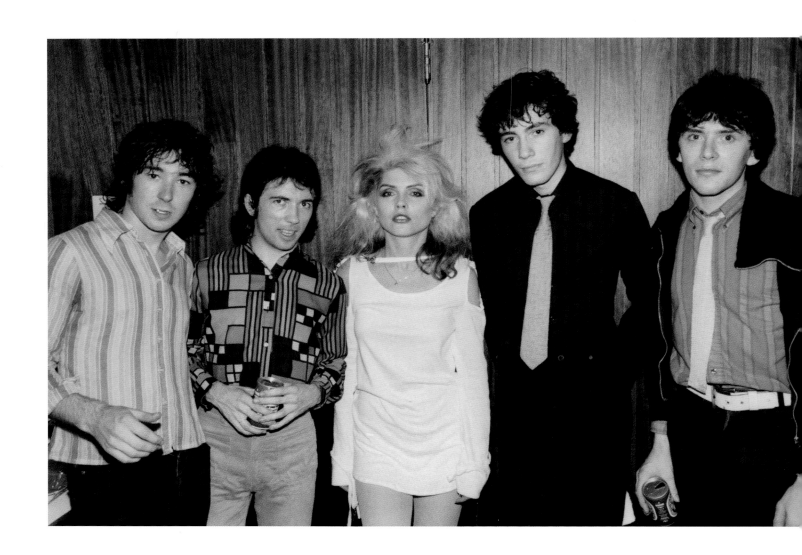

Blondie toured Europe with Buzzcocks
in 1978. From left to right: Steve Diggle,
Pete Shelley, Debbie, Howard Devoto,
and Danny Farrant.

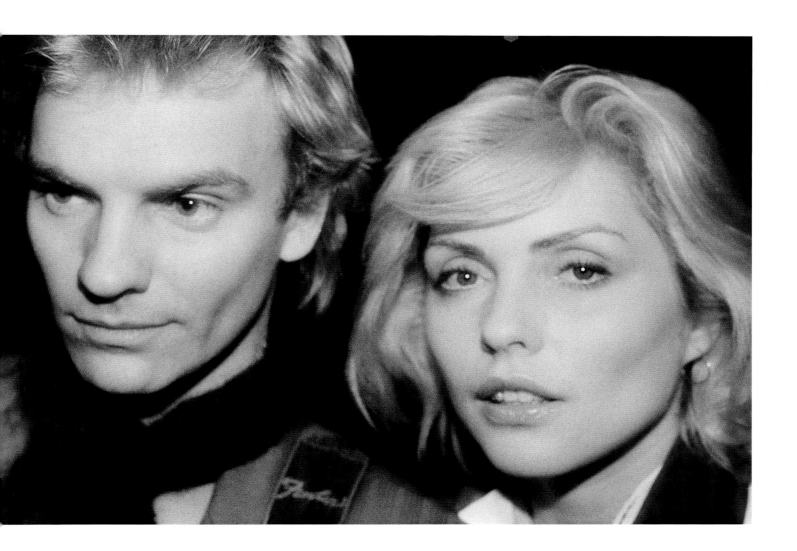

Sting and Debbie in the UK, 1979. We
only encountered the Police briefly on
a few occasions in the UK. This photo
is shot in infrared, which makes for the
glow. Cheekbone competition.

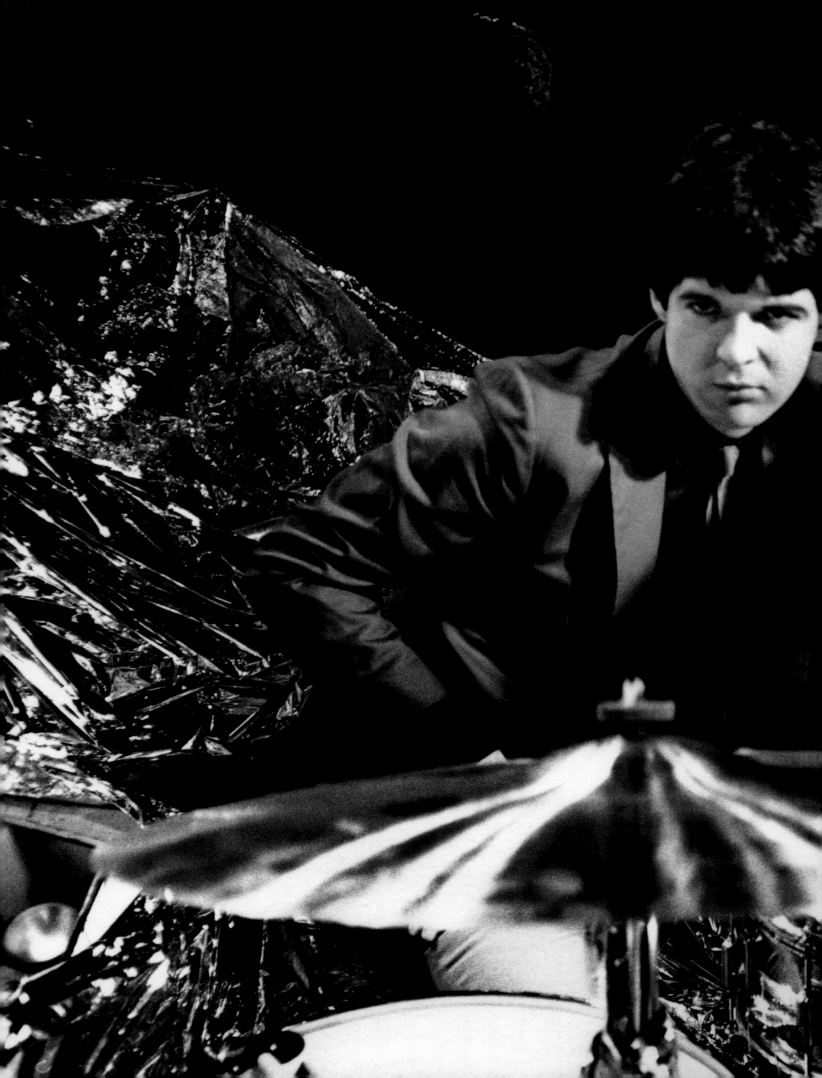

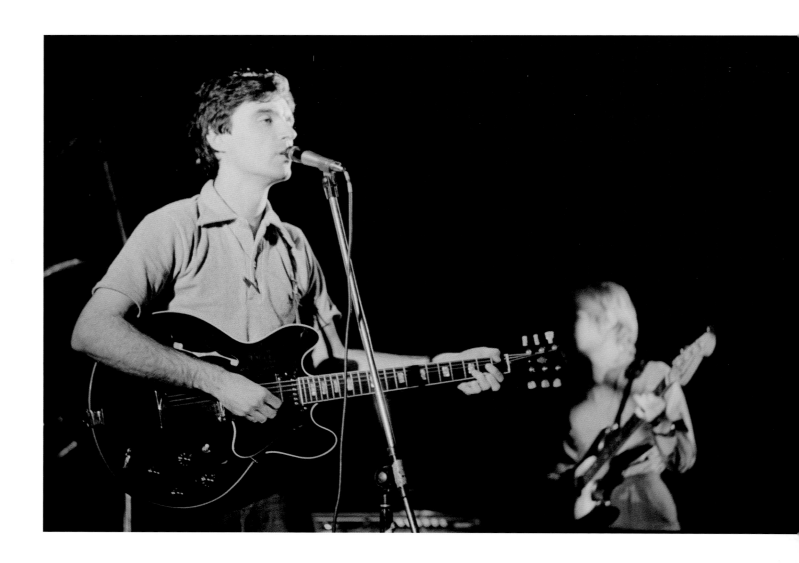

Talking Heads in Glasgow, Scotland, May 1977. Touring frequently put us in the same place as other bands. These photographs were taken at a Talking Heads and Ramones show at the University of Strathclyde in Glasgow, Scotland. The next night we played with Television at the Apollo. Apparently, some of the local press announced that CBGB had arrived in Glasgow. This was my first encounter with "white night" conditions: I remember emerging from the Ramones/Heads show late and it still being light out.

PRECEDING SPREAD Clem on drums, touring in Europe around this time.

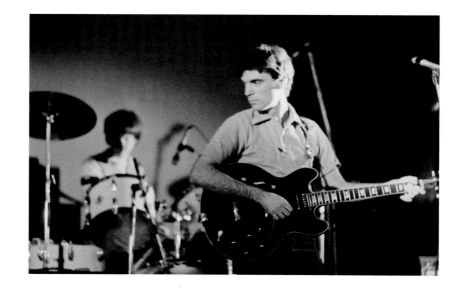

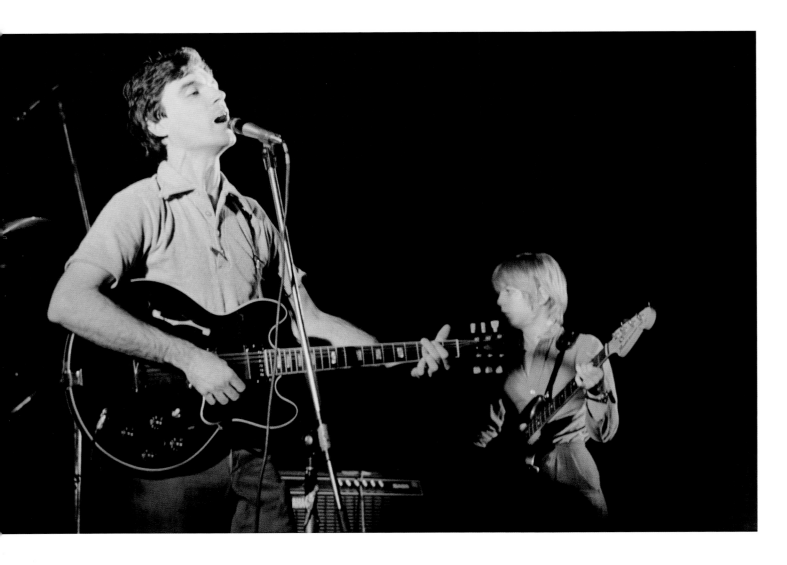

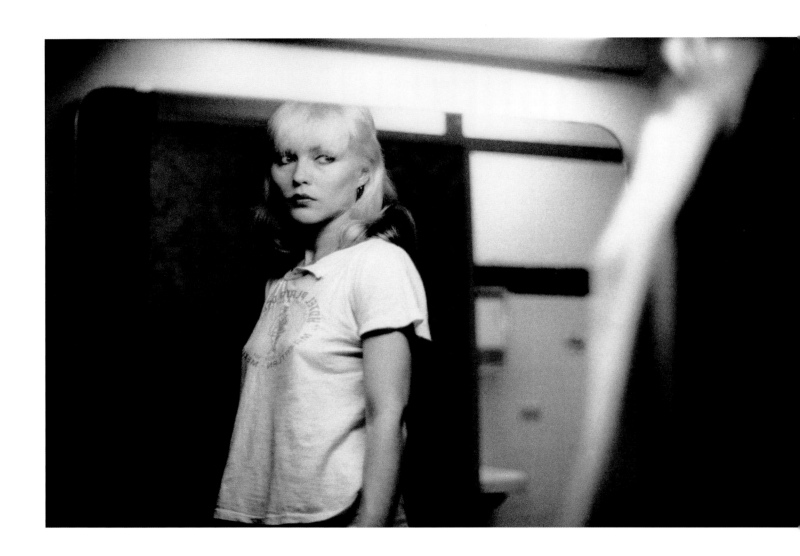

Debbie, in a hotel room during the
Australian leg of our first tour, c. 1977.

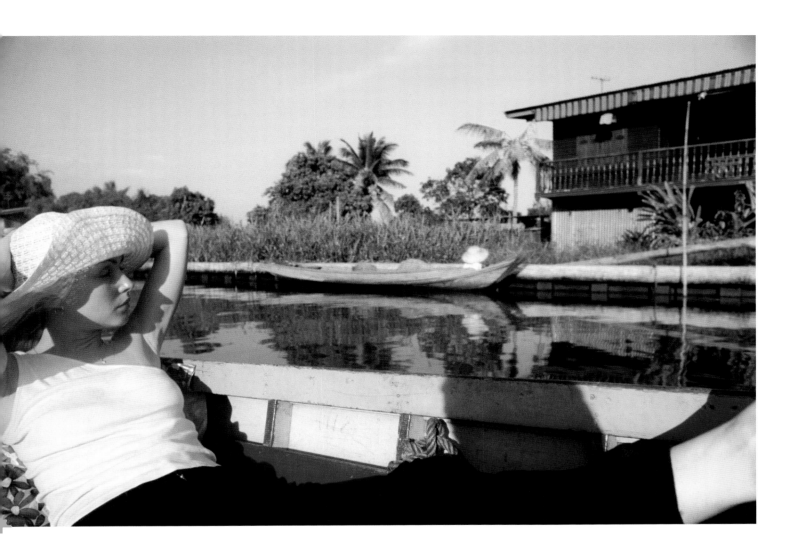

Debbie in Bangkok, Thailand, 1977. Bangkok, like western cities, has undergone a crazy transformation since the mid-seventies. When we went back in 2005, what had been a fairly bucolic cityscape with many areas of natural growth, parks, etc. was now well covered in concrete and filled with traffic. In 1977, we had encountered all manner of exotica as well as lepers begging.

Bordeaux, France, 1978. This shot is from our first European tour. When we arrived, there was some political posturing and confrontation going on between right- and left-wing groups. I'm not sure how we heard, but we got word that the local fascists and the local communists were preparing to have it out at our show, so it got cancelled.

FOLLOWING SPREAD Debbie with bubblegum, late seventies. These images were shot for one of the British music papers.

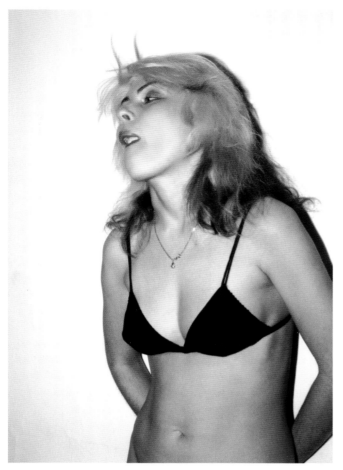
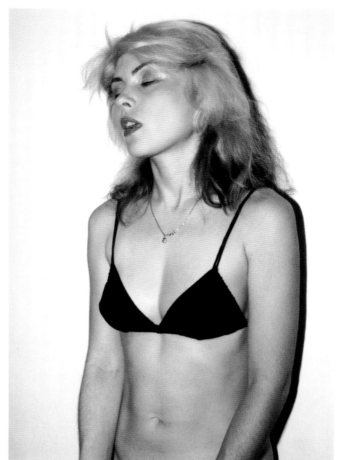
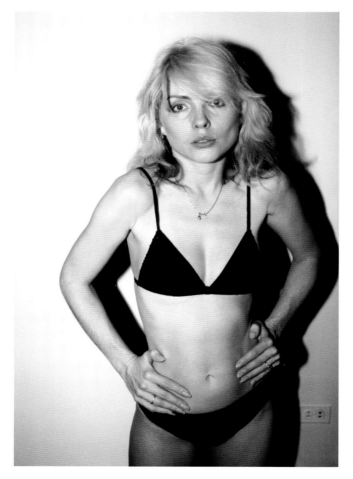
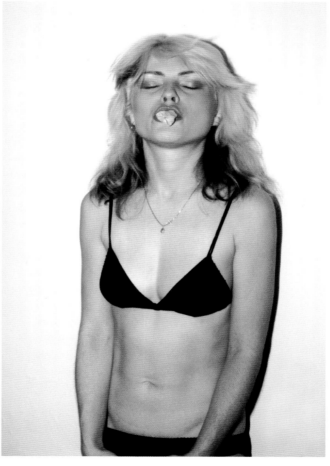

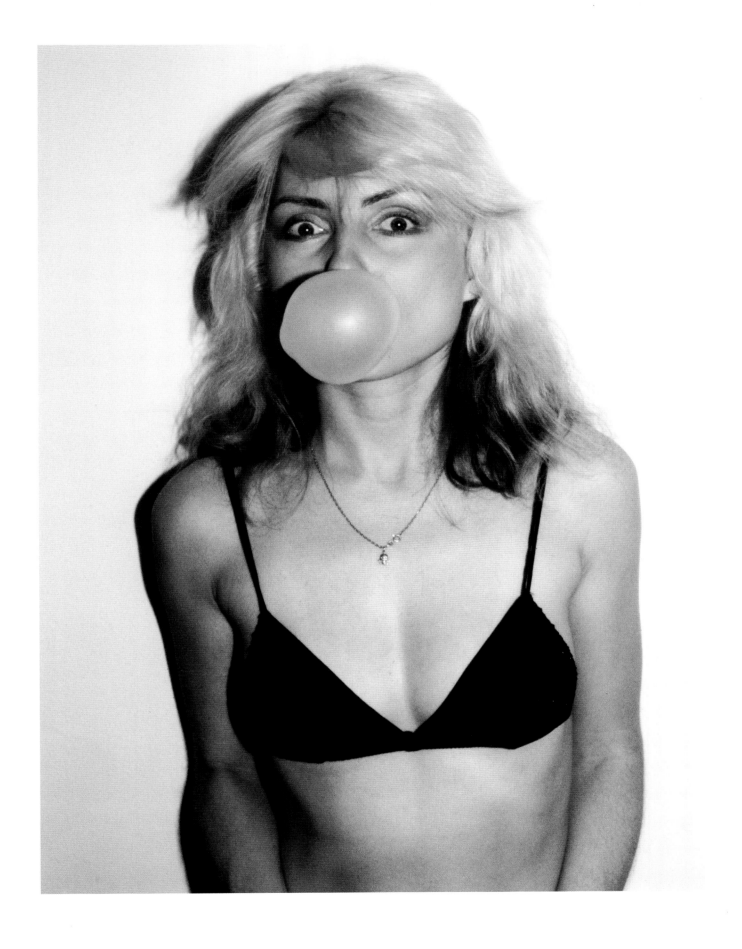

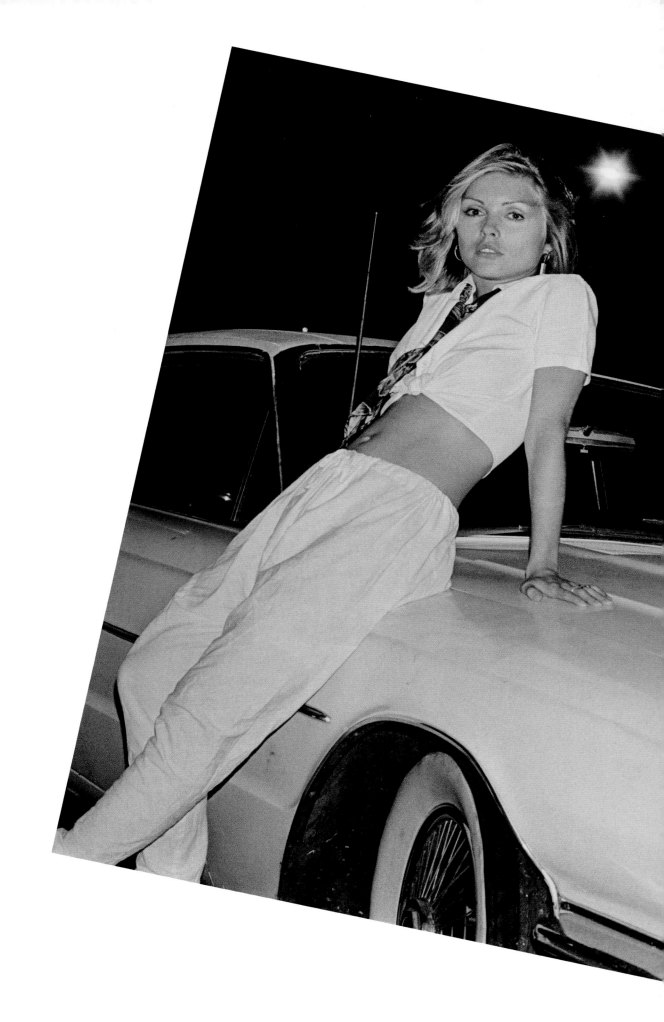

EVERYWHERE 80s

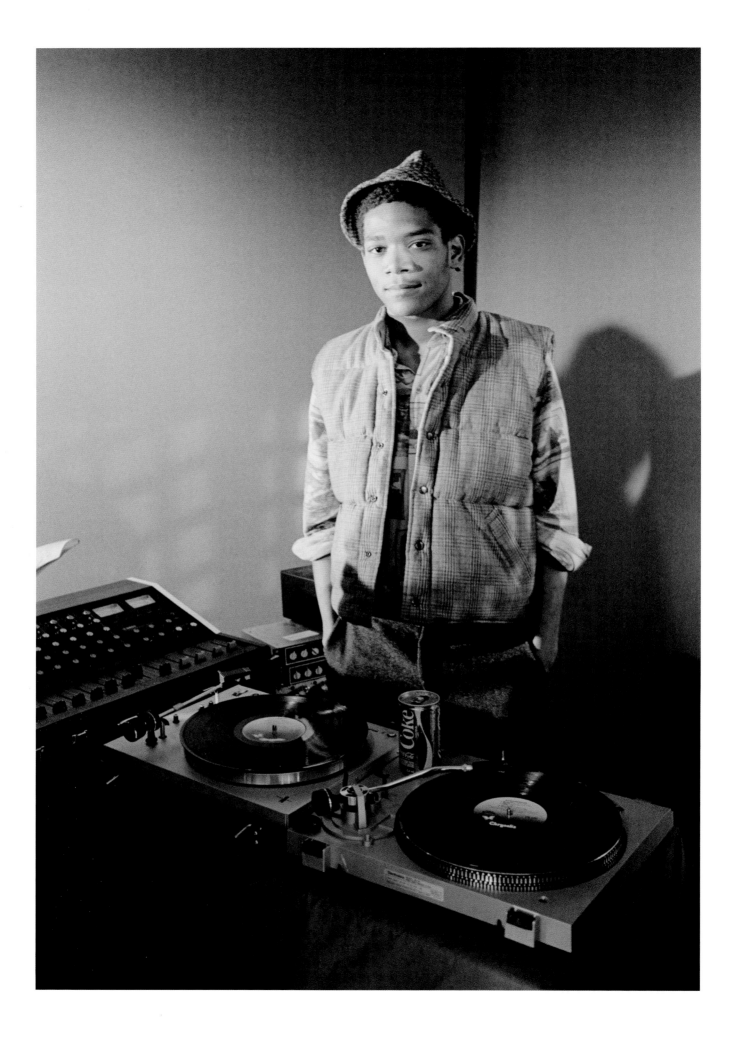

Jean-Michel Basquiat on the set of the "Rapture" video, New York, 1981. We knew Jean-Michel Basquiat from the early days of his street writing into the period of his celebrity and his end. I tried to help him with his drug issues by getting him into a methadone program, which he stuck with for a while. He was a moody guy, but really fast and bright. Jean was an extra on a few Blondie videos and, in this one, had the role of a DJ. He was really perturbed because the director didn't want him to write on the set behind him but instead wanted it to be a solid red color. A similar event occurred at a *TV Party* shoot when he wrote "mock penis envy" on a newly painted blank wall at the studio we worked in. The people who ran the TV studio were pissed. I bought the first work he did on a piece of canvas (he painted on cardboard before that) from him for two hundred bucks. He told various people how much he had ripped me off. I sold it in January of 1985 for ten grand while he was still alive. I wish I still had it.

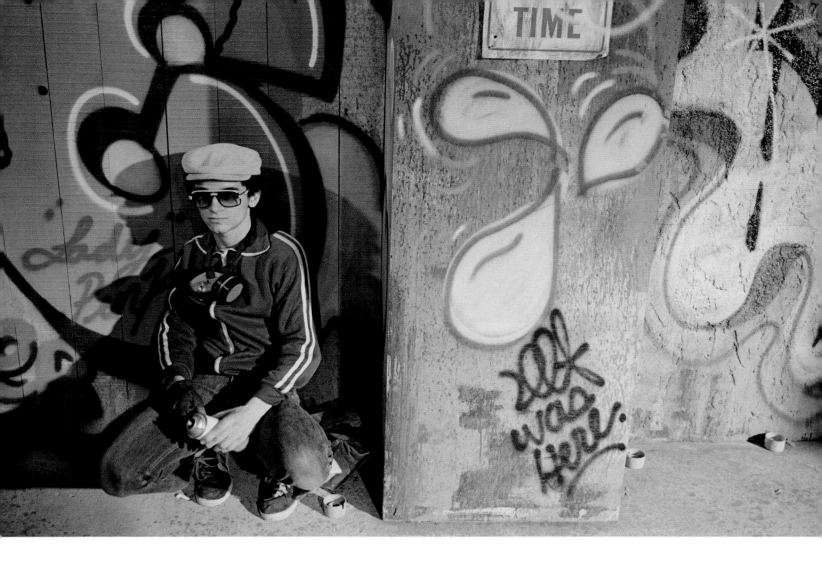

ABOVE Lee Quinones on the set of the "Rapture" video shoot in New York, 1981. Lee Quinones is one of the most respected street artists. His graffiti work and tags were featured in several of our videos. He was the star of *Wild Style*, made in 1983, which was really one of the first films about hip-hop and rap/street culture. This photo was taken on the set of the "Rapture" video in front of one of his pieces.

OPPOSITE William Barnes and Freddie Brathwaite on the set of the "Rapture" video, New York, 1981. Barnes plays a Baron Samedi-style voodoo character. Samedi is one of the spirits or "Loa," of voodoo lore. We asked him to recruit some real voodoo dancers, and he brought in three Haitian girls, who also appear in the video. At one point in the shoot, one of the girls began showing symptoms of possession. In voodoo or "vodoun," the celebrants are often "ridden" (possessed) by the Loa spirits for a short time during the ceremony. Barnes took her aside and either did or said something to make her come out of her trance state, then

the shoot continued. Fab Five Freddie, of course, was instrumental in leading us to the hip-hop scene. In 1977, he brought us to our first live rap event at a Police Athletic League in the Bronx. The passion and energy in the crowd and onstage was very moving for me. I was struck by this scene going on at the same time as our downtown rock scene, but being in its own universe. I was really buzzed by the power of rap music and, around that time, I spoke about it to various "higher-ups" in the music biz. Every one of these guys told me that rap was "a fad" that would go away. Forty years on, it's deeply embedded in popular culture.

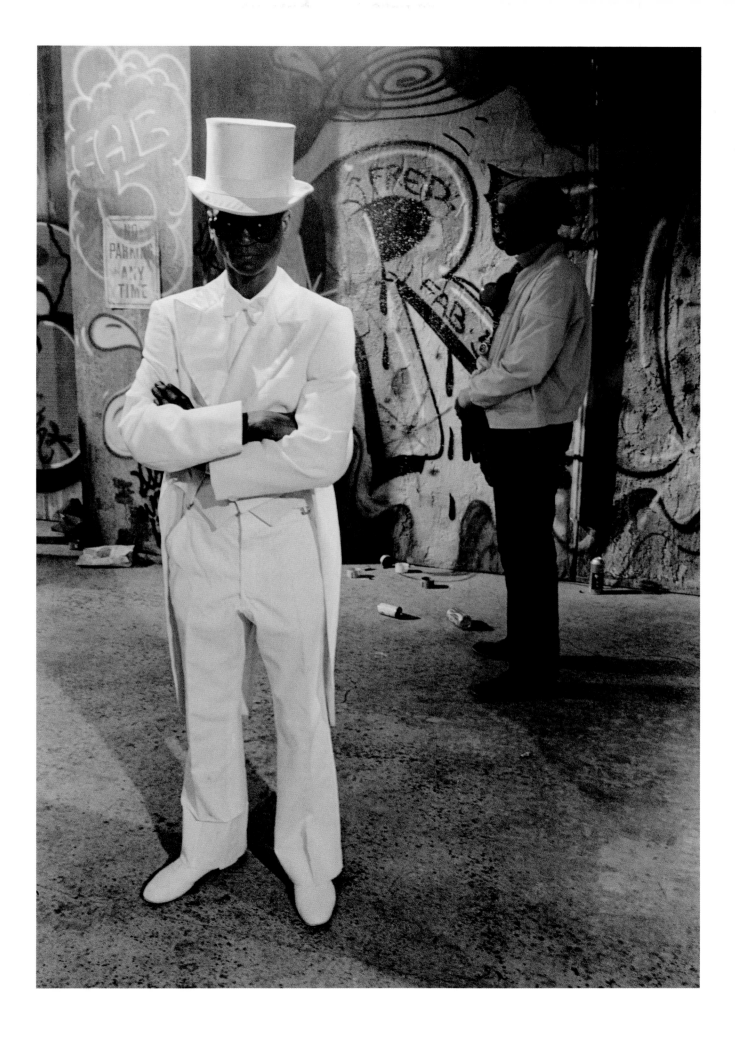

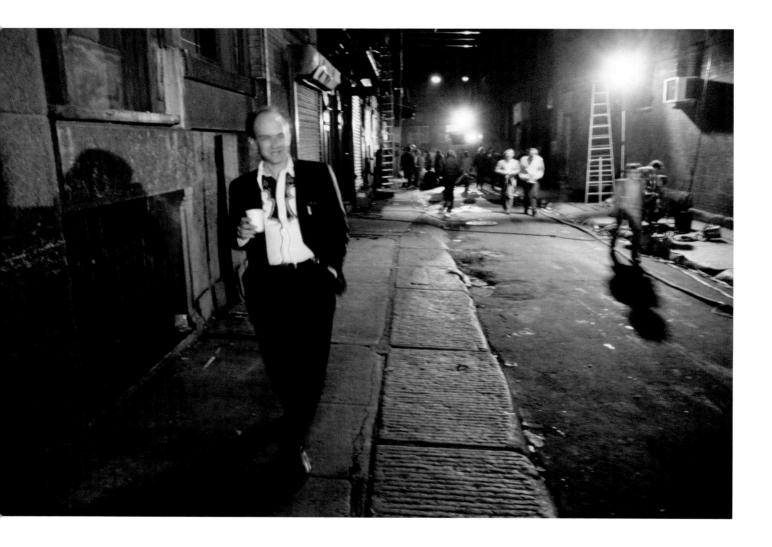

Steve Mass outside the Mudd Club, New York, 1980. This was taken during a shoot for Debbie's Murjani Jeans. Earlier on, Gloria Vanderbilt invented designer jeans and somehow we attempted to cash in on the trend. The commercial itself is bizarre and juxtaposes elements of the then very conservative fashion world with pieces of the downtown no-wave scene. I did a bunch of work with John Lurie and the Lounge Lizards and managed to get him to play on the track for the commercial. The twenty-nine-second TV spot is just Debbie walking down Cortlandt Alley next to the Mudd, then entering and briefly grooving with some of the crowd who was there at our request. Lurie even has a brief cameo as Debbie enters the club. Mudd was founded by Steve Mass, Anya, and art curator/dealer Diego Cortez. The club opened in October 1978 and was apparently named after Samuel Alexander Mudd, the doctor who set John Wilkes Booth's broken leg after the Lincoln assassination. (Mudd was pardoned by President Andrew Johnson and released from jail but his name stayed mud.) The Mudd Club was part of a long line of New York's semi-private clubs, private in the sense that they just weren't well known and would employ various dress codes in order to edit those who sought entrance.

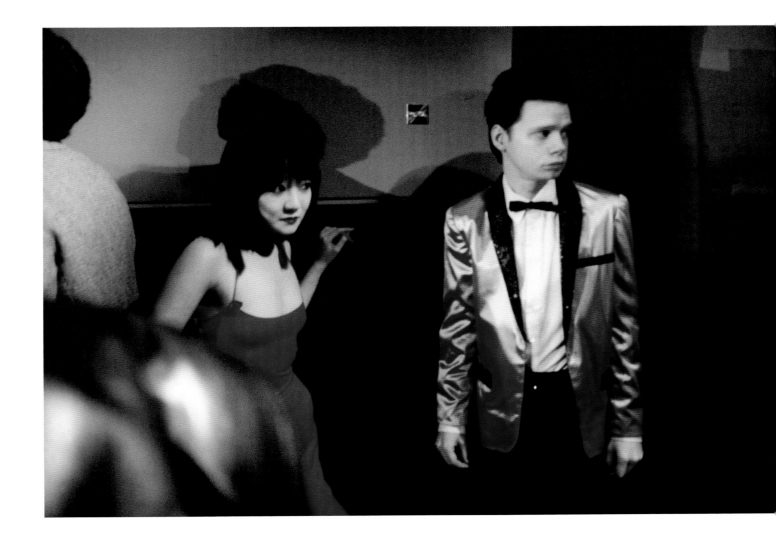

James Chance (aka James White, James Black) and Anya Phillips at the Mudd Club, New York, c. 1980. Anya was a tremendous contributor to James' band situations. They were together for many of the last years of her life. James was a game-changing musician. He pre-dated and foreshadowed Prince, Bruno Mars, and many current stylists. His role as the central figure or bandleader (a la James Brown) in a punk band was innovative. The musicians in his various groups changed frequently and Debbie and I did a few shows with him. I remember instances of his getting into fights with audience members over his oftimes confrontational stance during shows. Musically, he explored free jazz, funk, and punk rock styles, and easily tied them together. I released one of his many records, *Sax Maniac,* on my Animal label in 1981 and he later played on the Blondie *No Exit* record. I played with James very recently (early 2013) and he is more accomplished than ever, a very schooled musician.

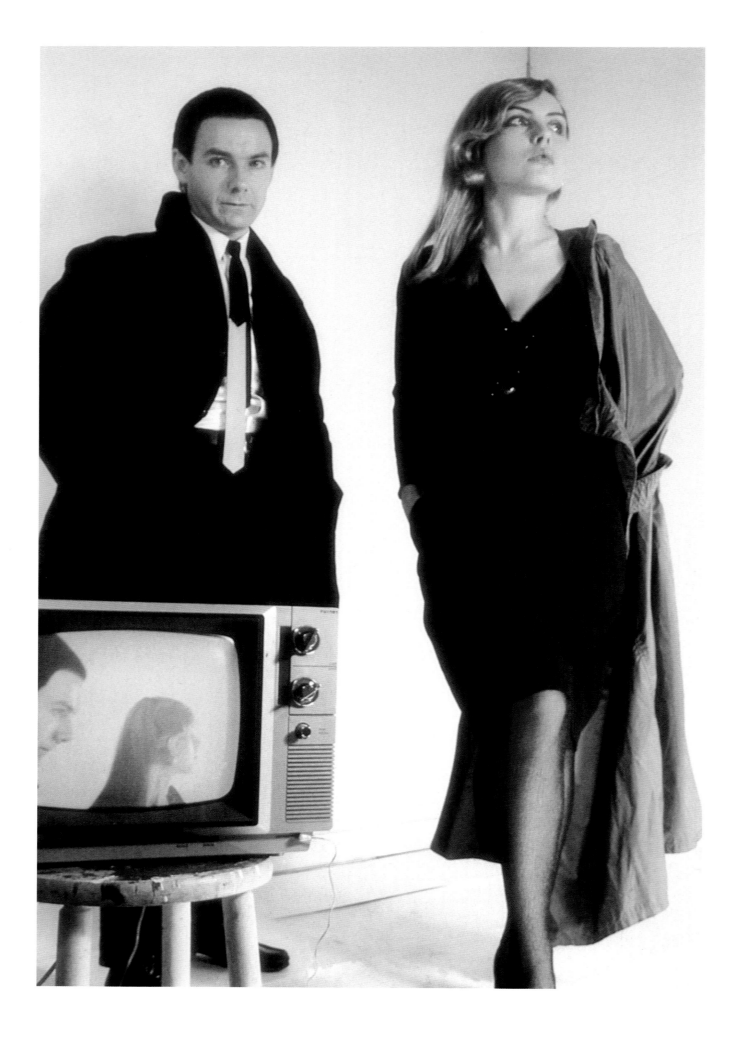

OPPOSITE Robert Fripp and Debbie with TV, album shoot, New York, c. 1980. I think Robert Fripp first approached us, showing up at a show. This began a long friendship. Robert was one of our heroes and his playing on the "Fade Away and Radiate" track on *Parallel Lines* elevates the song to a fantastic place. We did various shows in London and New York with Robert sitting in on guitar. Around the time we met him, we played with the idea of remaking Jean-Luc Godard's seminal art sci-fi film noir *Alphaville*—the plan was that it would star Fripp as lead Lemmy Caution and Debbie as Natacha von Braun, and be directed by Amos Poe. It never got very much beyond the discussion phase, but we did get to meet Godard when we bought the so-called rights from him for a thousand bucks. We subsequently found out that he didn't really have controlling rights to the film, but Amos still has the "contract" that he signed, which is probably worth more than a grand. Here Robert and Debbie did test shots. Here also are Xeroxes we made on Stephen Sprouse's copier, who lived in the same building as we did on 58th Street.

FOLLOWING SPREAD Robert Fripp, *Exposure* graphics, 1978–79. At some point, while we were all on 58th Street, Steve Sprouse rented a color Xerox machine. Having access to this thing was a huge deal, and I wound up making hundreds of copies of slides, comic book covers, Halloween costumes, and other ephemera. I must have copied some of the shots I took of Robert Fripp and Debbie, and when Robert saw them, he enlisted me to do his first solo album cover graphics. Fripp, in front of a shot of his right eye, is on the front cover of *Exposure*; the actual graphic for the cover was airbrushed [it was before Photoshop], and so the horizontal lines across the face were not there. A solo shot of Robert on a monitor is on the back cover.

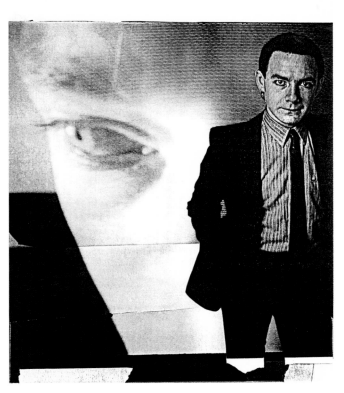
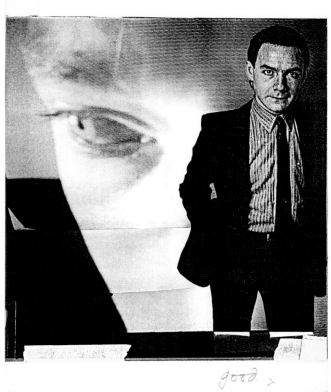
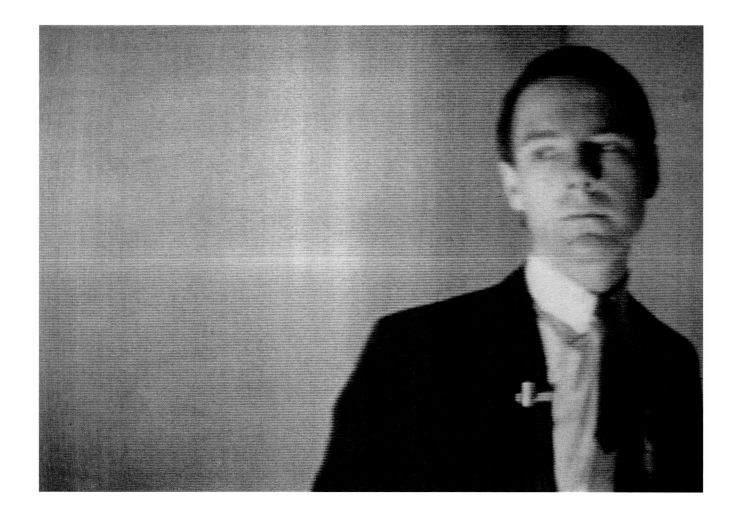

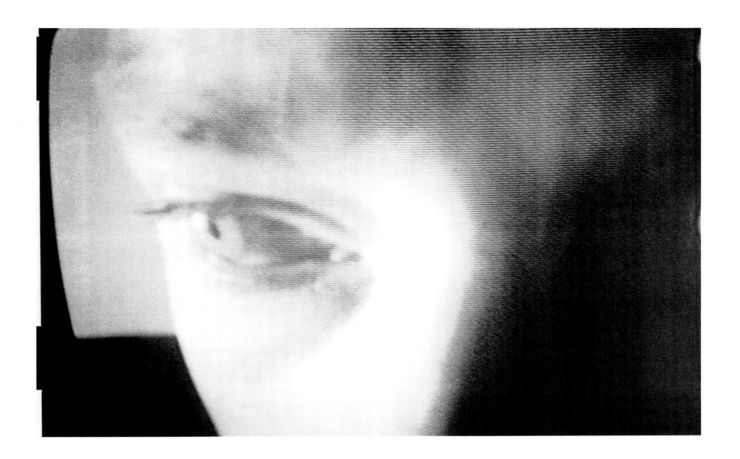

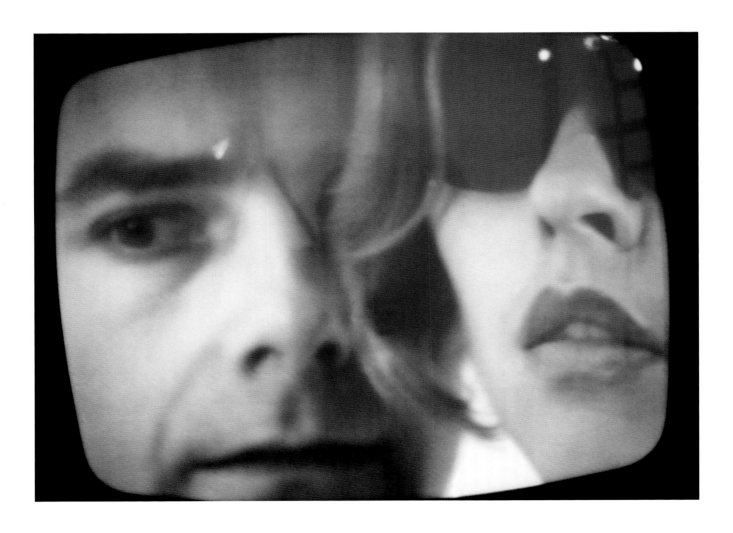

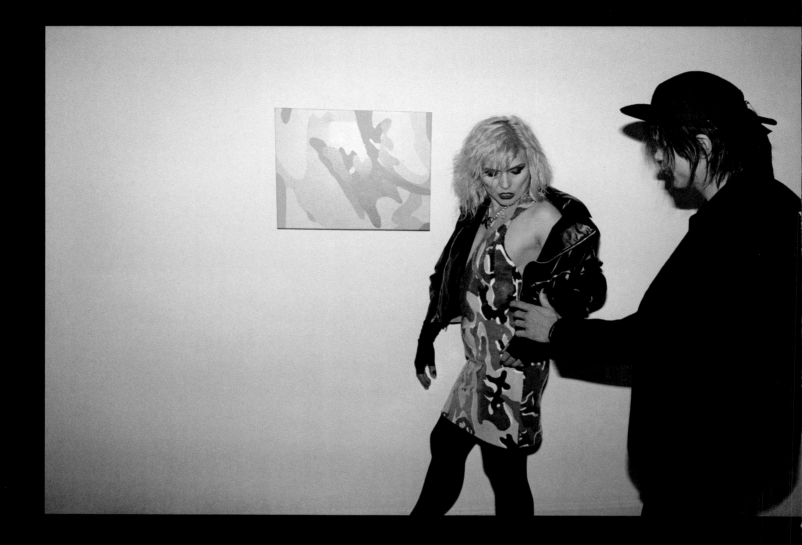

Debbie with Stephen Sprouse, late eighties. We had a long association with Steve, whom we initially met when he came to live on an upper floor of our Bowery loft. The loft was three floors and had originally been rented by Anne Wehrer, who was friends with Iggy Pop and worked on an early autobiography of his called *I Need More*. Anne was somehow acquainted with one Benton Quinn, whom we knew from the scene. When she left the loft, Benton inherited it and asked us to come live there when we were excommunicated from the

105 Thompson Street apartment. Later, Steve lived in the same building we did on 58th Street. Steve was furiously ahead of his time, embracing the punk anti-aesthetic—punk being anti convention as couture twenty-five years or more before everyone else.

Steve was a favorite of Andy Warhol, who encouraged and collaborated with him on various projects. These shots were taken after Steve had just taken over the Warhol Factory space on Union Square and Broadway when Andy moved to a bigger building

(there were four Warhol Factory locations over the years). Steve opened a boutique in SoHo when the neighborhood was at the beginning of its gentrification and commercialization. The Sprouse store was unsuccessful. Had it opened a few years later, it would have been huge. Steve died in 2004. Had he survived, he would have been a mainstream success.

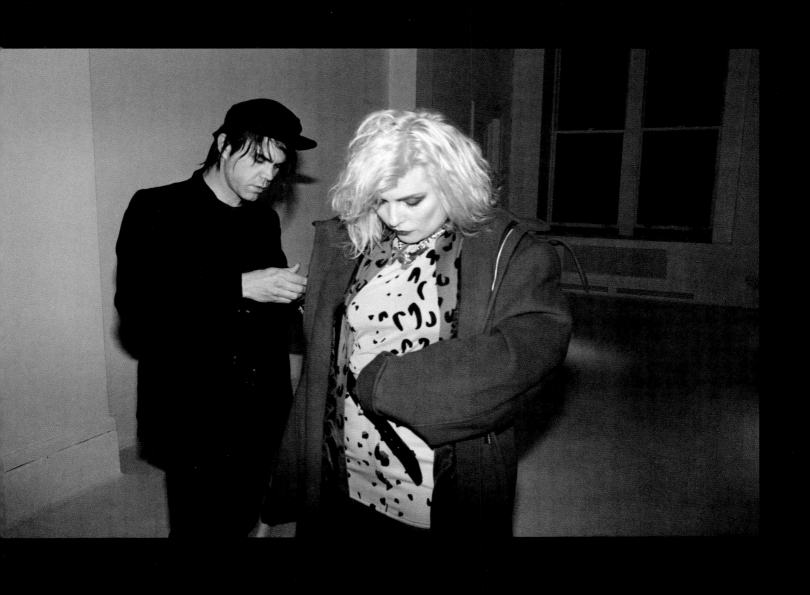

OPPOSITE Debbie on the Bowery in a Stephen Sprouse dress, one of his very early creations, mid-seventies. Even then I was aware of the contrast between the environment and the attempt at glamour that was going on here. This shot was taken in the Bowery loft. The loft was the scene of numerous impromptu gatherings. One winter night, a group of us were there when someone arrived with the announcement that "There is a frozen bum downstairs!" There was a rush down the stairs and, indeed, there was some poor guy lying dead and blue in the snow. Someone said he thought he had seen him earlier walking around in the snow without shoes. Everyone in the group got quiet and dispersed. An ambulance showed up and collected the body.

FOLLOWING SPREAD Debbie at a photo shoot in our apartment on 58th Street, New York, early eighties. The one-shoulder black dress was among the first trademark pieces that Stephen Sprouse made for her.

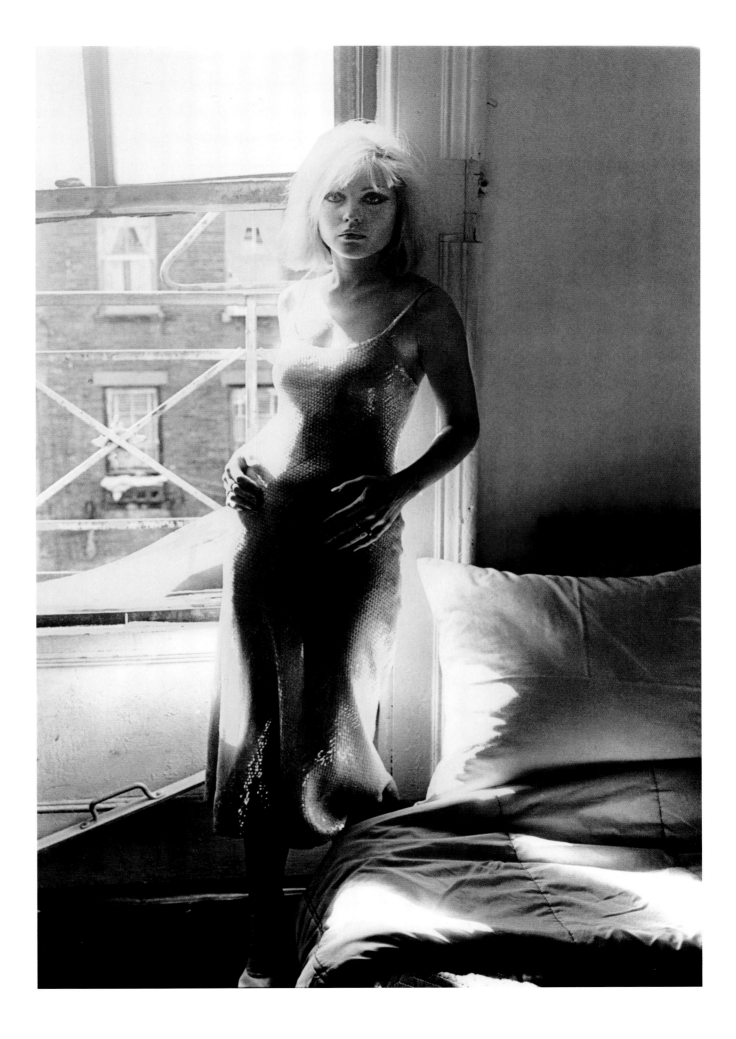

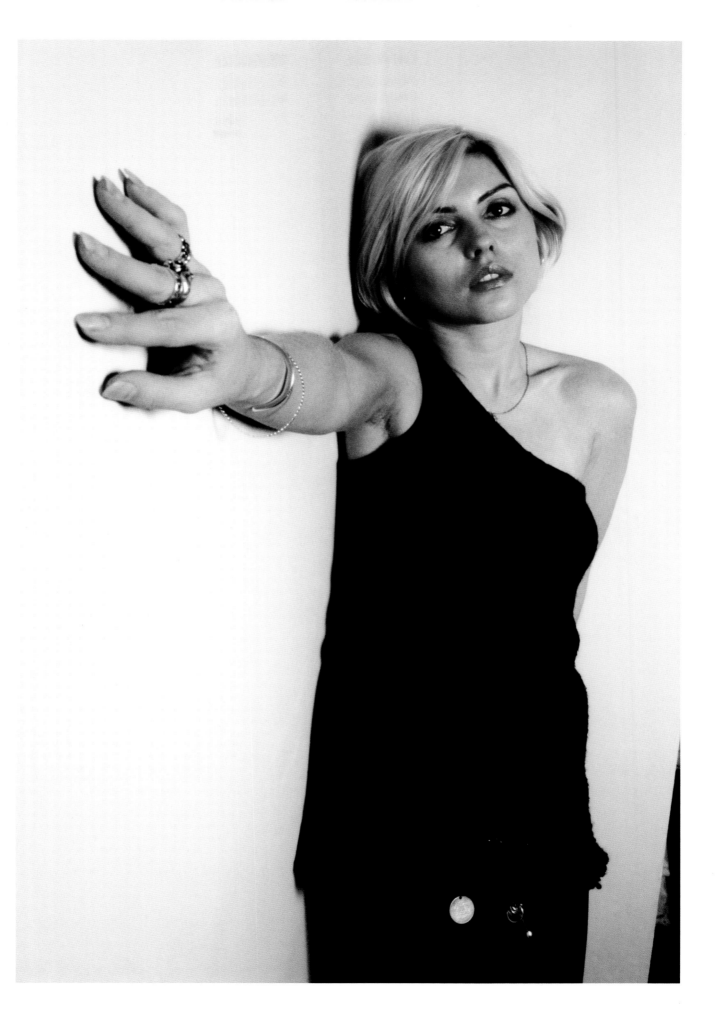

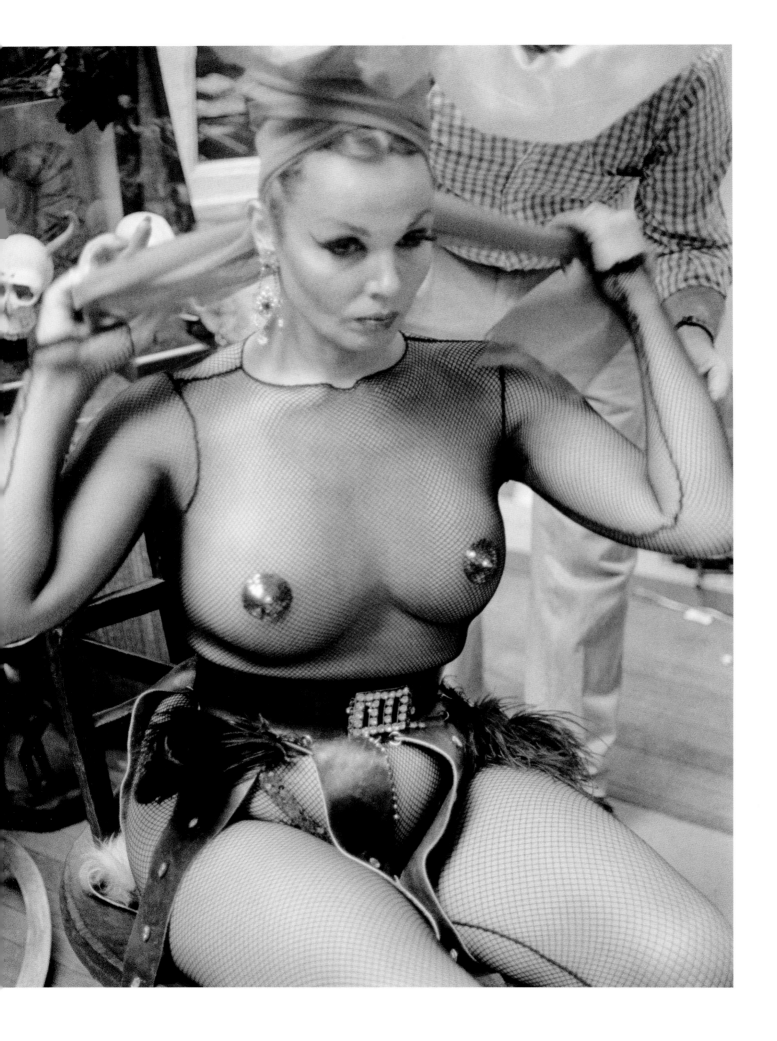

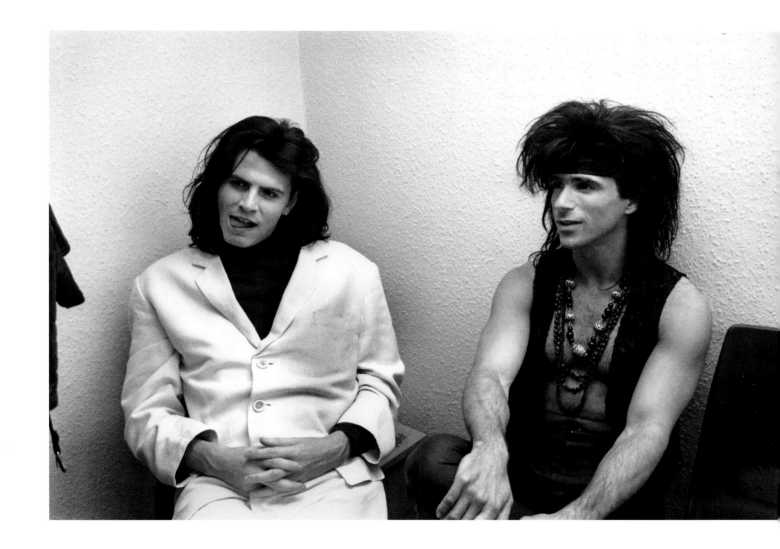

OPPOSITE International Chrysis was born Billy Schumacher in Brooklyn and began a gender swap at age twelve. She was a friend of Salvador Dali and singer Pete Burns who named a band after her. Here, she was in my Greenwich Street loft during a record cover shoot I did for our old friend Paul Zone (pictured in the following spread in a Stephen Sprouse suit). Chrysis died in 1990.

ABOVE Duran Duran members John Taylor and Warren Cuccurullo, during one of Debbie's solo tours in Europe in the eighties. This was shot at some concert we were both playing at.

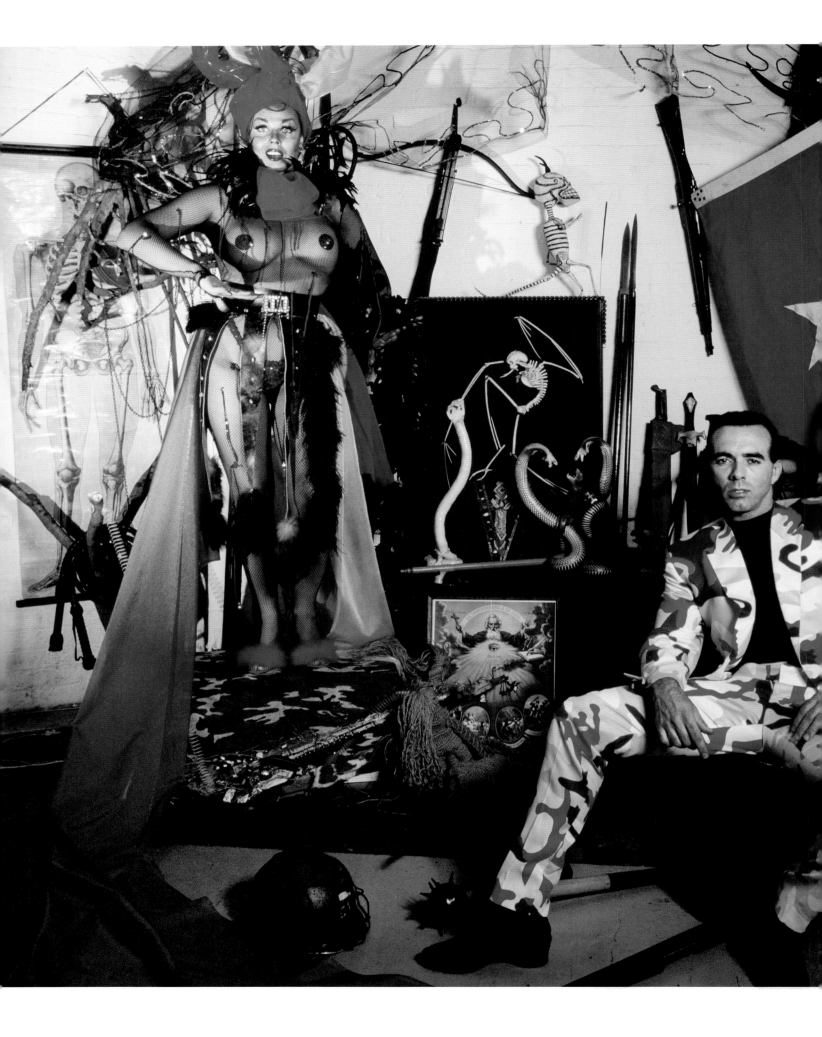

International Chrysis and Paul Zone in my Greenwich Street loft, c. 1988. This was shot as a cover for a single release: "Cuba"/"Try My Love" by Paul's group, Man 2 Man. In the late eighties, after the band had stopped working, I moved into a great loft in a building on Greenwich Street, which was owned by our friend Kerry Riordan (thanks, Kerry). The loft was an awesome space—a basement and first floor. I spent all of the nineties there. When Blondie re-formed, we did two albums, *No Exit* and *The Curse of Blondie,* in the basement. The loft was central to many adventures, and I am occasionally approached by someone with a story about being there that I don't remember at all. The subterranean basement studio was nearly soundproof. Iggy and I were shooting a German Luger in the basement, and he shot a hole through one of my gold records. I got him to sign it—I still have it—"This hole made by I. Pop."

When I moved in, Tribeca hadn't been named yet, and it was still full of artists, bikers, drug dealers, and other assorted art-freak types. I remember starting to see women pushing baby carriages and thinking what an odd place to decide to raise little kids. Little did I know . . .

In about 1996, I met my wife, Barbara, at a Penny Arcade show. Barb was an actor and did a lot of underground theater. Burning Man was one of the first things that Barbara and I talked about when we met, and we both went for the first time in 2000. I don't go to Burning Man every year; we've only gone eight times so far. I'd like to go every year but it's hard. I recommend everyone get there at least once.

In 2001, we were just back from the desert, where we'd been for a week. I walked the dog in the early morning, and when I got back to the loft, I heard a really loud plane engine passing overhead, followed by a muffled boom. I thought it was a jet breaking the sound barrier. Within minutes the phone rang: "Turn on the TV!" I don't remember who called. A plane had crashed into one of the twin towers of the World Trade Center. The loft was in a direct line, ten blocks uptown, from the towers. The dust only reached about six or seven blocks, but the whole area smelled oddly for a long time. I remember the site burning, smoking, for what seemed like a

couple of months. For about a month afterward, there were media tents pitched all around the neighborhood. The National Guard was posted on Canal Street, and for about a month, we had to show ID to get back on the block.

The objects in the shot are all things that I had in the loft. I often heard people refer to the loft as "museum-like," but it might be construed as borderline hoarding as well. After 9/11, the final gentrification of Tribeca began in earnest, and my rent went up by five times as Kerry attempted to keep up with the ever-rising costs of maintaining the building. Barbara and I moved upstate.

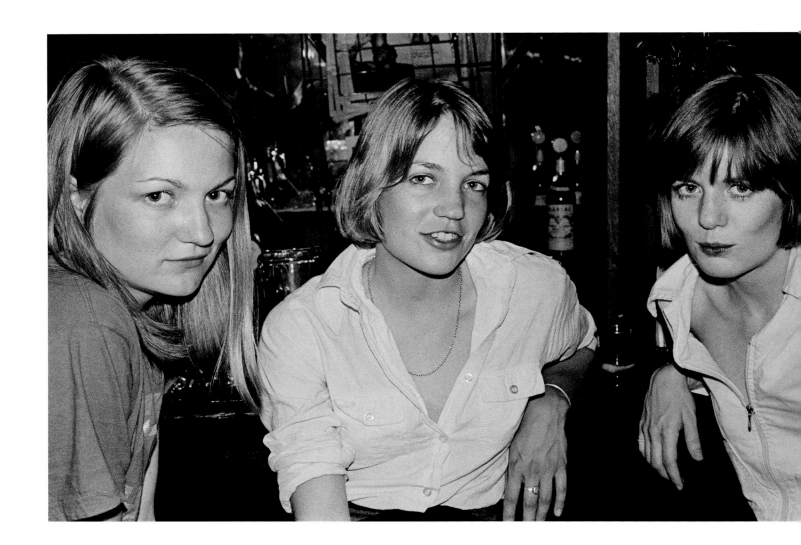

The Weymouth sisters, 1976, from left
to right: Laura Weymouth, Lani
Weymouth, and Tina Weymouth.
They would later form the Tom Tom
Club in 1981, a collective of musicians
founded by husband-and-wife team
Tina Weymouth and Chris Frantz,
named after the dancehall in the
Bahamas where they rehearsed for
the first time while on hiatus from the
Talking Heads in 1980. I am amused
by the girls' conservative *Hannah
and Her Sisters* look in this shot.
They certainly are a contrast to their
contemporary punked-out peers.

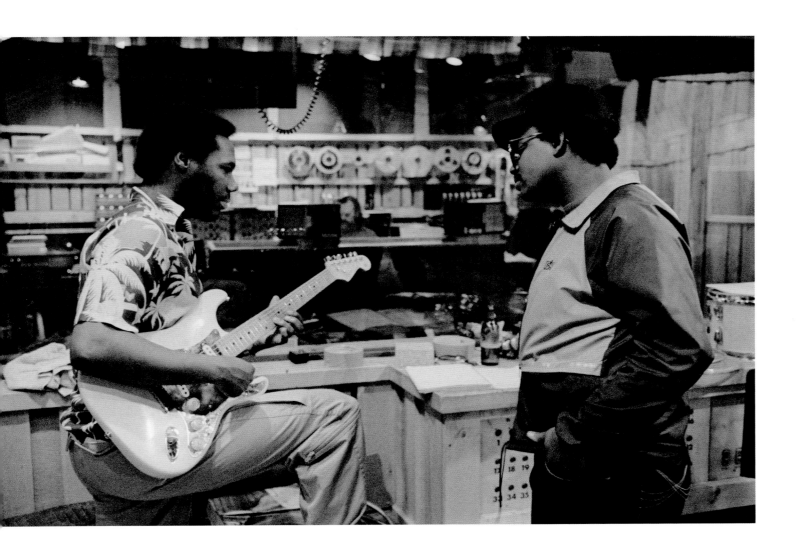

Nile Rodgers and Bernard Edwards in the studio, c. 1981. Nile and Bernard confer about something during the production of Debbie's first solo album, *KooKoo*. We loved the band Chic and approached Nile to work on something together. We wound up being the first in a long line of people outside of Chic that Nile (and Bernard) worked with. Bernard died in 1996. His playing was part of the foundation that has evolved into modern hip-hop—and pop in general. Nile and Chic's influence can't be easily conveyed in a few lines. Nile's career is unprece-

exquisitely relevant for such an extended period of time, most recently with the huge Daft Punk hit that he co-wrote, "Get Lucky," featuring Pharrell Williams. *KooKoo* is adventurous but maybe a little tentative since both we and the Chic band were just starting out on solo careers. I still find it hard to either categorize or "slot" this album into a genre.

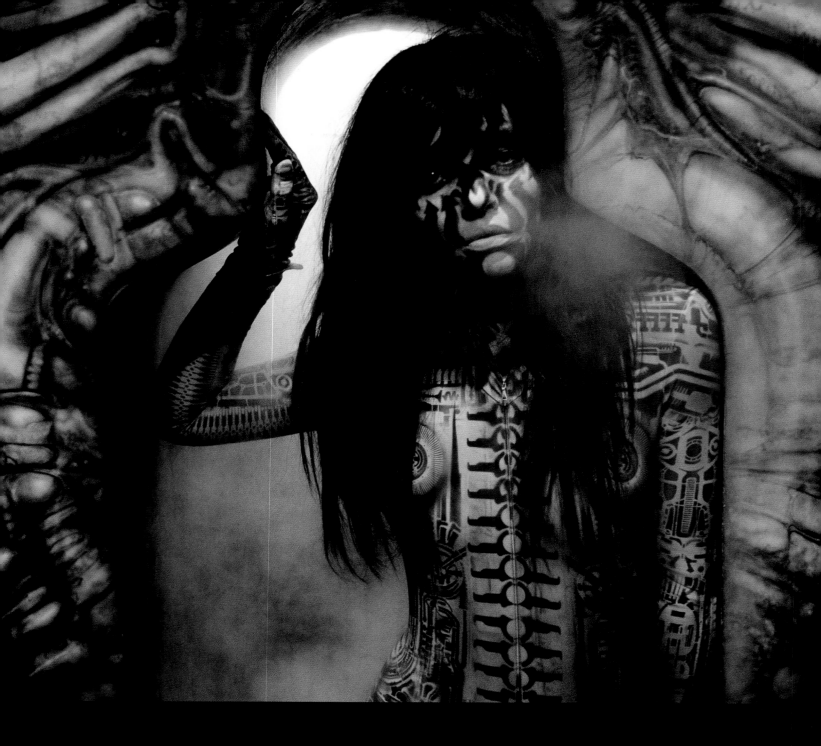

Debbie styled by H. R. Giger, Zurich, 1981. We went to see a show of Giger's art from *Alien* in a gallery on 57th Street near our 58th Street apartment. By some odd chance, Giger was there, on his way back home to Zurich after winning the Academy Award for his work on the film. We hit it off and invited him back to our apartment. We all stayed in touch, and when we worked on the *KooKoo* project, someone got the idea to ask him to do the cover art. He agreed and we eventually wound up staying with him at his studio/living space in Zurich. Giger helped develop the *KooKoo* title, which is

a reference to acupuncture: He was thinking of the punk device of safety pins and the needles through Debbie's head on the cover as being related to that. I don't know if people generally make the connection, and the music is much more R & B based anyway.

We stayed with him for about two weeks and shot a couple of videos with him. This was one of my first forays into using a Hasselblad and I shot a lot of pictures. Giger made costumes for Debbie and used some of his existing large works as backdrops. He made various new constructions and back-

drops for the video shoots, too. Giger takes his place in a line of magicians/artistes including Austin Spare, Aleister Crowley, Rosaleen Norton, Vali Myers, and Alan Moore. His environment reflected his sensibility: His Oscar sits on a shelf next to skulls and a shrunken head. His work ethic was profound in approach; he was meticulous and deeply committed to whatever he was dealing with. I saw him working on a book and attempting to adjust really small color variants in the printing before it went to press.

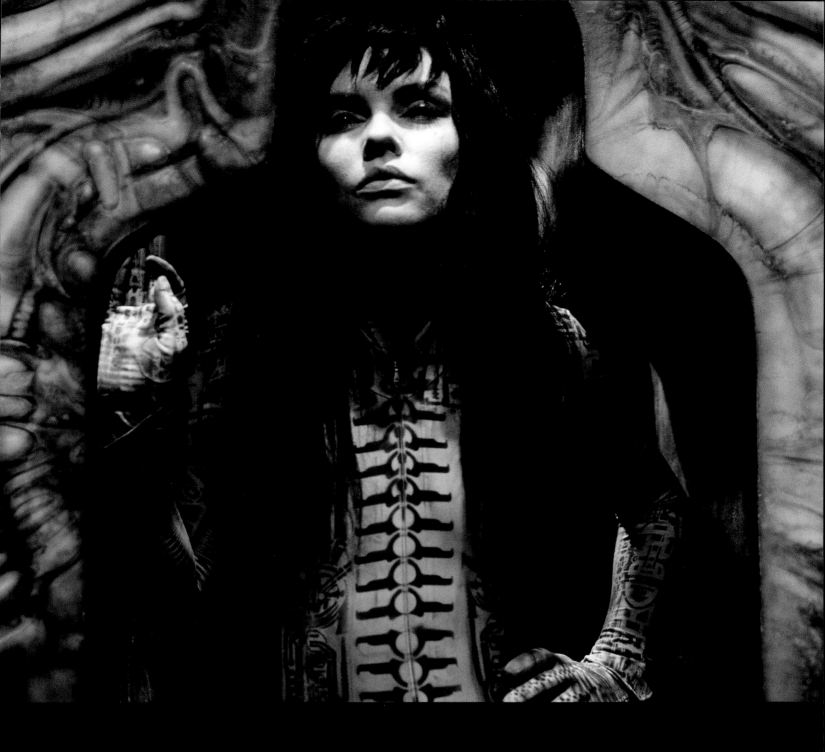

I still am amazed that Giger doesn't have a piece at the Museum of Modern Art in New York. He has influenced several generations of artists. Americans all incorrectly pronounce his name "G-eye-ger"; it's pronounced "G-ee-ger.

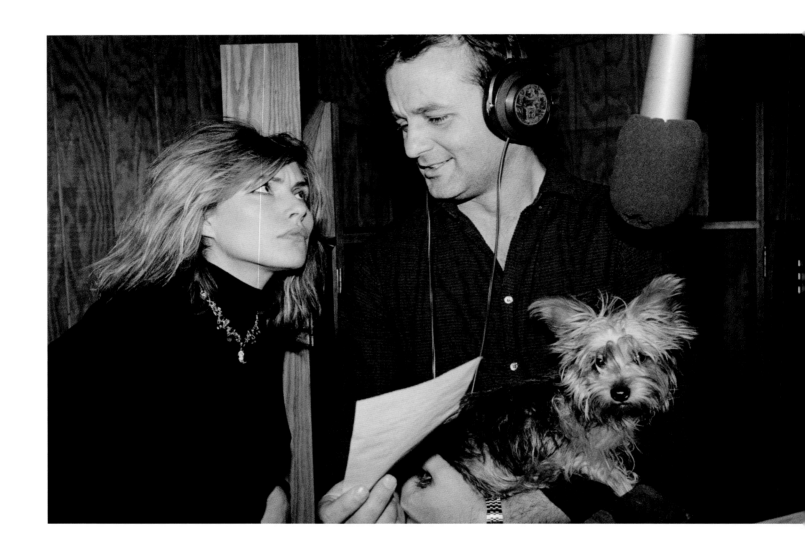

Debbie and Bill Murray recording for *Polyester*, New York, 1981. We worked on the musical score for John Waters' film *Polyester*. We had done *Saturday Night Live* around this time and I had seen Bill Murray doing his lounge singer act. I suggested that John use Bill's voice on the score. At first John was resistant, saying, "I'll just be known for having the guy from *Saturday Night Live* singing in my movie." Eventually, he came around. On the day of the session, Bill was on the A to Z bar tour in New York, an event wherein participants drank in different bars, the caveat being that each bar, in turn, had to have a name that started with the next letter of the alphabet. Bill arrived somewhere around letter Q or R, did his vocal, then left to rejoin the tour.

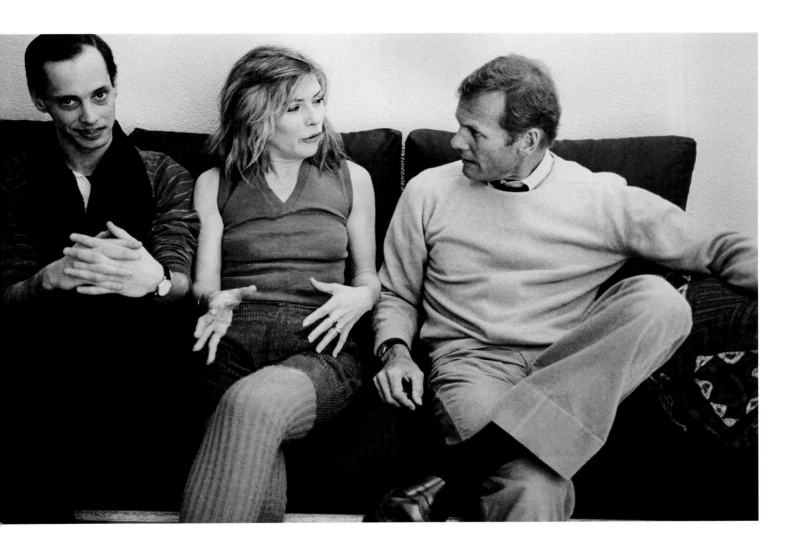

John Waters, Debbie, and Tab Hunter during the *Polyester* soundtrack work in New York. John is John—not much to say there. Well . . . recently, in 2012, he hitchhiked across the US, getting picked up by random travelers. It took him eight days. He is planning to write a book about his experiences. Tab Hunter was a really big film star and singer in the mid-to-late fifties and sixties. When I was a kid, I saw *They Came to Cordura*, which starred Tab and Gary Cooper, many times.

Somehow, *They Came* was a little smarter than your average western of the time; it had a psychological component even though it might be construed as heavy-handed by today's standards.

OPPOSITE Unknown time and location, US. This is a shot from the hotel-room window in some empty town center, maybe in the Midwest. I don't remember where exactly it was taken.

FOLLOWING SPREAD Debbie in showgirl mode in a *Top of the Pops* appearance in the UK during her later solo period.

Blondie and Beyond

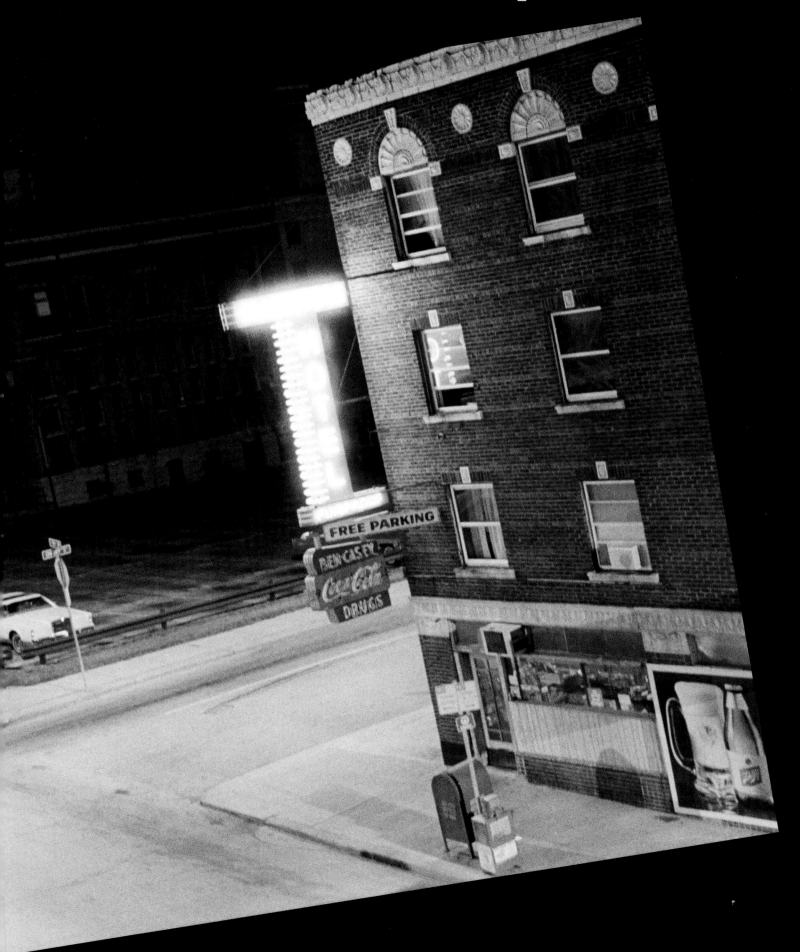

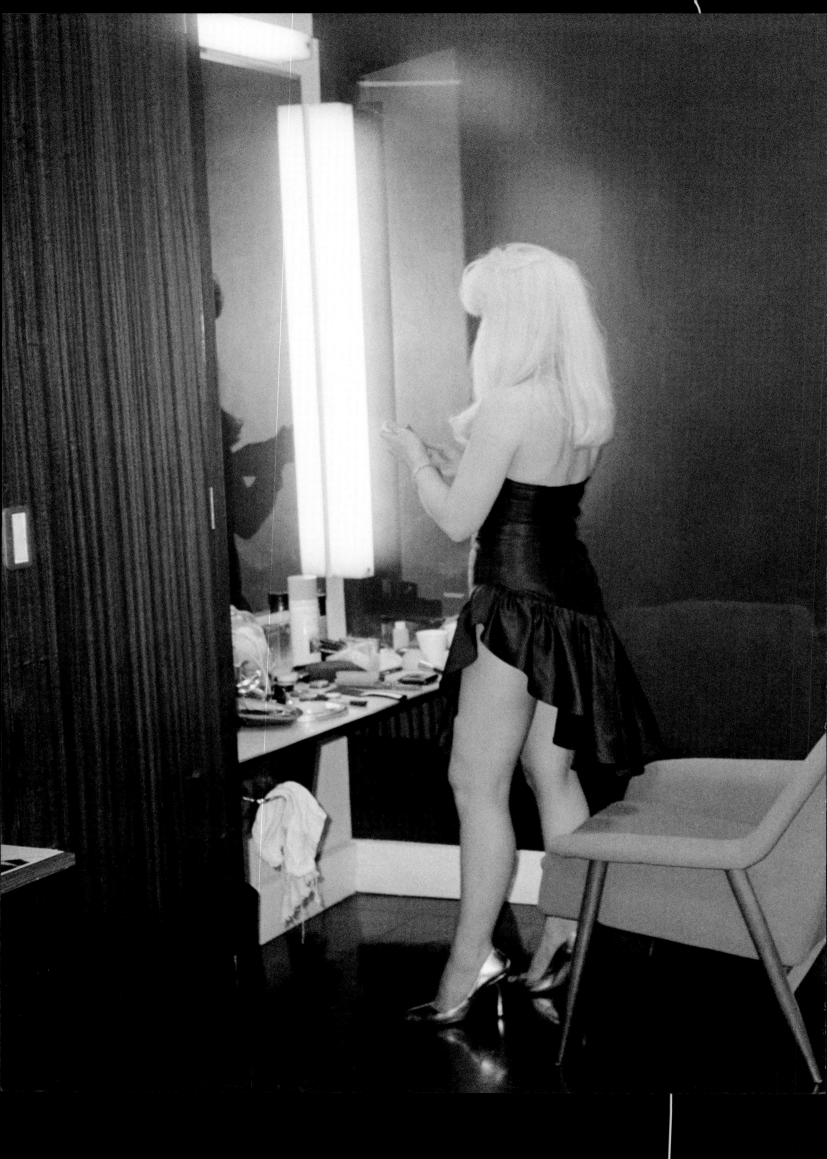

Debbie bungee jumping topless in New Zealand, 1990. She kept her pants on, though. I wouldn't do it and Jimmy Clark, a big macho guy who was the drummer for this Debbie solo tour, got to the top and just came back down without jumping. The guys who ran the thing offered to give Debbie a "tandem" jump, whereby one of them would hold her while the cord was stretched and they both took off from a standing position. She declined, and a few weeks later we noticed in the news that someone had been killed doing this same stunt.

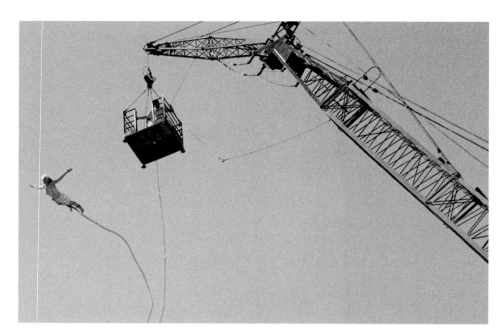

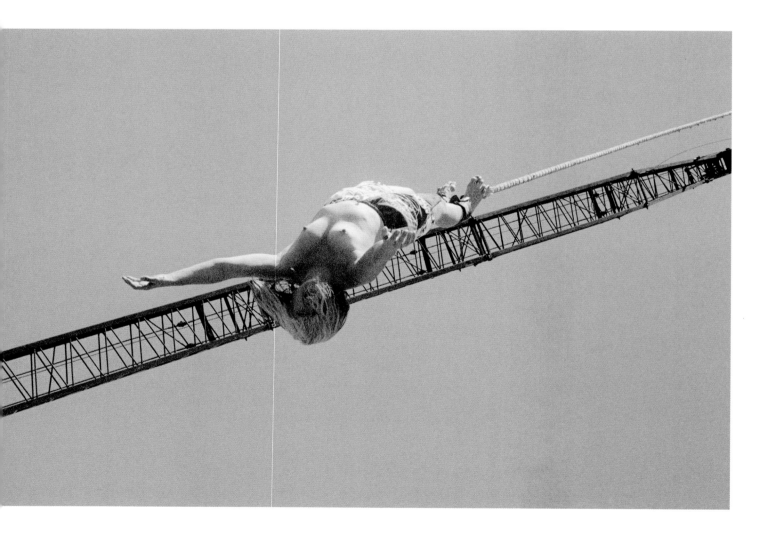

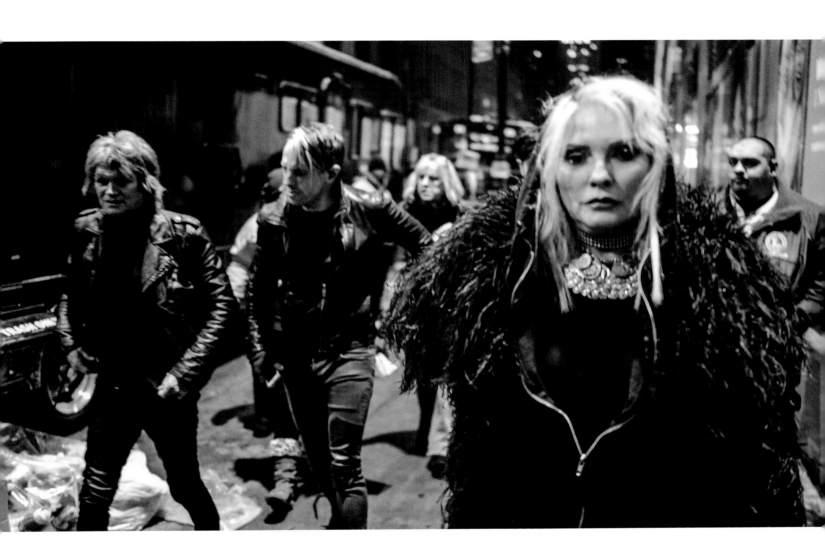

Members of the current Blondie lineup, from left to right: Leigh Foxx, Tommy Kessler, and Debbie heading to the stage in New York City at a Super Bowl event, 2013. Debbie maintains her ability to hypnotize an audience today. The band now is my favorite incarnation of Blondie.

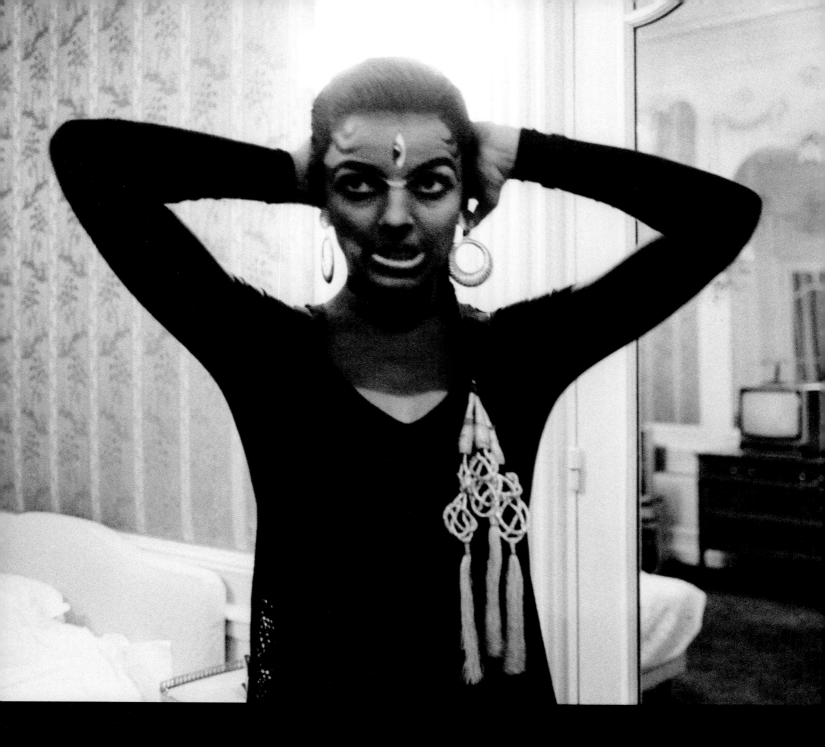

Nina Hagen showed up at a hotel in
Paris, coming from a photo shoot she
did dressed as Kali, who is the consort
of Shiva, the goddess of time and
change . . . appropriate for Nina, who
is extremely powerful in her feminine
aspect. Nina is great; from time to time,
I still come upon the odd track that
she produced for some small label or
another. I played a show with her, just
the two of us on guitar at the Tunnel,
a New York nightclub in 1995,

Stiv Bators, the lead singer of the Dead Boys, was another really nice person. I was closer to him in the last years of his life, and this photo was taken on the roof of his Paris flat, probably just a few weeks before his death in June 1990. The famous story, as I heard it, goes like this: Johnny Thunders was staying at this same Paris apartment with Stiv and Stiv's longtime girlfriend, Carol Ayache. Dee Dee Ramone showed up, perhaps unannounced, and asked to stay. Dee Dee and Johnny were involved in some sort of feud over something or other, and things went from bad to worse, climaxing with Dee Dee's pouring a bottle of bleach on Johnny's suitcase full of clothes then smashing his famous Les Paul TV model guitar.

I was really lucky to be close to William S. Burroughs. We met him in the late seventies, through the writer Victor Bockris, a friend of his. When I had that long-ass illness in the eighties, there was a period when I didn't leave Manhattan for several years. The first out-of-town trip I took was to see Bill in Lawrence, Kansas, where he had set up headquarters. When we initially met, he spent more time in New York at the famous "Bunker," which was an old men's locker room that had been converted into austere living quarters on the Bowery, just a block or so from

where we lived. I guess as time went on, every time Bill left the building there would be some fan handing him a manuscript to read, so he retreated to Kansas.

Bill loved firearms, and shooting with him was a sort of rite of passage into his domain. He is pictured, right, with his famous half-severed finger. Burroughs cut off his finger out of love for Jack Anderson and sent it to Arnold Gingrich at *Esquire* for publication. Gingrich sent Burroughs a note back reading, "I greet you at the beginnings

of a wonderful career, when do I get the corpse?" but I never heard this firsthand. His anarchic stance in literature was crucial to the development of many subcultures, including Beats, hippies, and punks. He is a massive figure of the twentieth century.

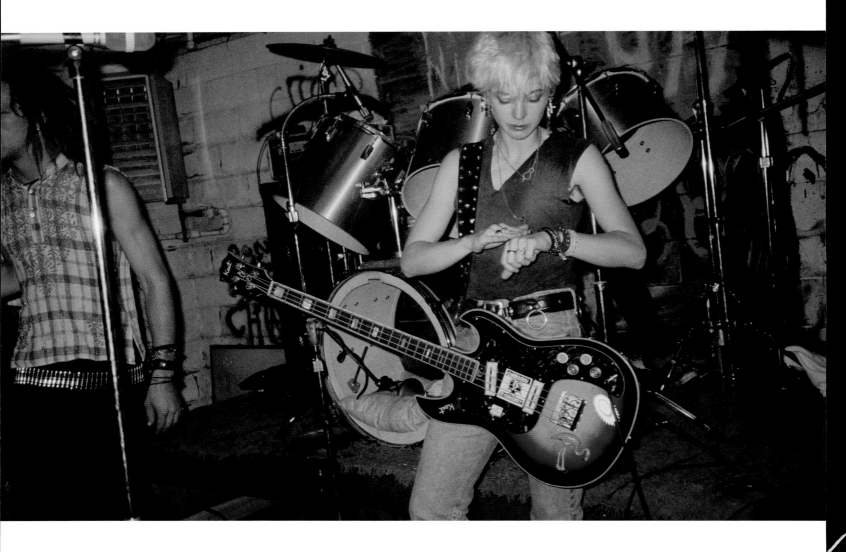

Greta Brinkman at the Outhouse in Lawrence, Kansas. When I was staying with Bill Burroughs in Lawrence, we went to a couple of shows at the local punk club called the Outhouse, which was located way out in the middle of nowhere on the edge of a cornfield. The Outhouse was literally a bunker, a low concrete building with electricity coming in from somewhere. It had a very outsider, do-it-yourself environment that I was immediately attracted to. It did feel like an image from Bill's *The Wild Boys*. At one of the shows, there was a band I liked called Unseen Force. Members included the couple Greta Brinkman and Dewey Rowell. Dewey went on to be in Gwar, a band that is sort of indescribably epic in its awesomeness. Greta, a terrific musician, went on to play bass during Debbie's Debravation tour, and later with Moby and many others.

Wall at the Outhouse, Lawrence, Kansas.
Punk comes full circle in the Midwest.

Saint Petersburg, Russia, c. early 1990s. In the early nineties, Debbie and I got invited to Saint Petersburg to do a small show. The whole situation was really odd, and we wound up in a very small club playing to a very few people. We did a short acoustic set and that was it. Afterwards, we were entertained by various guys in leather jackets for a week or so. There seemed to be a strong identification with the whole Russian Mafia/gangster deal but some of the aforementioned guys might have been the genuine article.

TOP Hollywood Cigarettes, Saint Petersburg, Russia, c. 1990s.

While in Saint Petersberg we got to visit the Kunstkamera, or "Chamber of Curiosities," created under the order of Peter the Great. Opened in 1728, it is allegedly the first museum in Russia and a collection of just the weirdest stuff imaginable. For two dollars I got a photo pass and took pictures of fetuses in jars, hands and disembodied heads, skulls, and various mummified human malformations. Apparently, old Peter was sort of the Warhol of his time, insofar as being the center of a whole scene that included artists, writers, and more generally, the "beautiful people" of his day.

I don't know exactly where my affection for dark things derives from. When I was a kid, I was very passionate about horror movies—like *Dracula* and *Frankenstein*. Growing up in Brooklyn, one of my great influences was a TV show hosted by a fellow named Zacherley. He looked like a character from Charles Addams, whom I was also very fond of. *Zacherley's Shock Theater*, *Famous Monsters of Filmland* magazine, and other things like this were likely responsible for a whole generation turning to the dark side in matters of taste and personal style.

In the West, there is a tendency to be culturally nervous about death. Halloween touches on our acceptance and celebration of our end. I recently saw a story about an Ohio man being buried sitting on his Harley and I thought of the Madagascar ceremony of "Famadihana" wherein one's dead relatives are dug up every year to join in the partying. Our fascination and fear of death probably comes from our linear sense of time and seeing it as an end rather than as part of a circle/cycle.

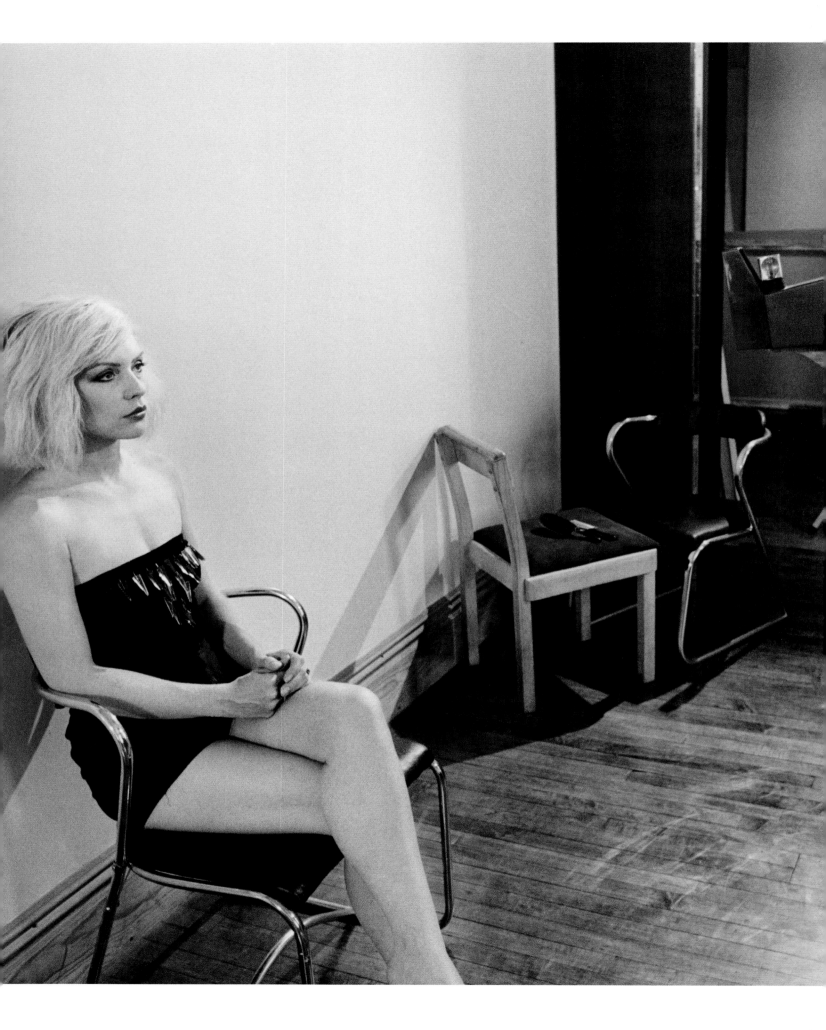

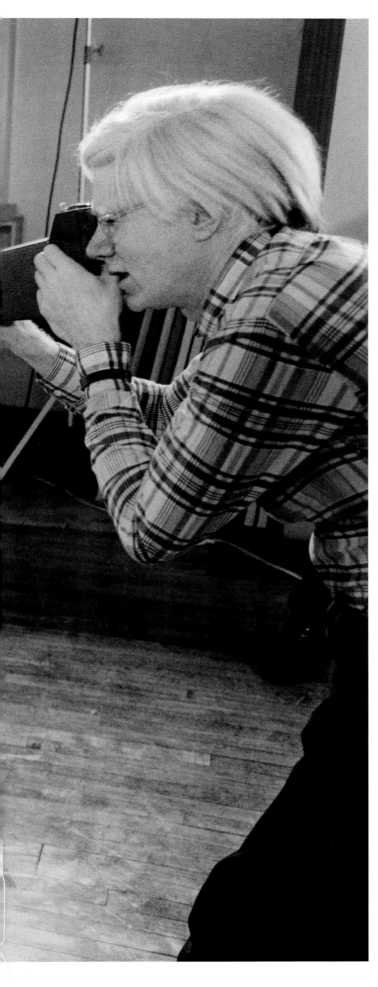

These were taken in the early eighties, maybe in 1980 or '81. We were close to Andy during the period of the third Factory. The first Factory was on East 47th Street, the second on Union Square West. I'd only been to the first one once or twice, while I was a frequent visitor to this one, which was on Union Square North. There was a statue of Andy below this location; I'm sure he would have loved it. Andy was happy to do Debbie's portrait. In *The Andy Warhol Diaries* he says that if he was to have plastic surgery, he would want to come out looking like Debbie. One of my favorite aspects of the Andy portrait phenomena was the fact that he used the cheapest Polaroid camera. The Polaroid "Big Shot" was an unwieldy and unpopular thing, mainly due to the fact that it was focused by moving it back and forth in relation to the subject. Thrift shops were full of Big Shot cameras, and we bought several for Andy at different times. They would cost about twenty dollars each and the irony of his producing expensive paintings with them probably wasn't lost on anyone, least of all him.

Walter Steding, who worked at the Factory, told us that he saw Andy personally painting Debbie's picture. Andy Warhol was a singular event. When he arrived at a party or an event, it might as well have been the pope walking in; suddenly, everyone in the room was somehow more justified in being wherever it was; his just sitting in the corner gave an odd credibility to any situation.

My first in-the-flesh encounter with Andy was at an event at Carnegie Hall on September 24, 1965. This concert, Sing-In For Peace, was part of the burgeoning peace movement and tied to the folk music scene that provided the early soundtrack. Therefore, it was a really big deal when Joan Baez almost apologetically announced that she was going to "sing a rock-and-roll song." Even though the audience was full of folky purists (this was two months after the controversy surrounding electric music at the Newport Folk Festival), they all reacted well with cheers and applause as she sang a few bars of "Stop! In The Name of Love," dedicating it to LBJ, an appeal to end the Vietnam conflict.

At the end of the concert, as the crowd was filing out, there was this moment that stuck with me for all this time. The sea of people parted, and there, in the midst of it all, was Andy looking like something from twenty years in the future. Silver hair and brown leather jacket accompanied by a statuesque model type who was dressed in a baggy football jersey. Needless to say, no one looked like this at that time.

By 1967, my friends and I were entranced by the first Velvet Underground album. My friend Joey Freeman worked for Andy at the first Factory. One evening, Joey appeared at my house in Brooklyn, and announced that the band set to open for the Velvets had cancelled and asked us if we'd like to do it. We got on the subway with our guitars and traveled to a place on the Upper West Side called the Gymnasium. It was an actual gym. Maureen Tucker let us use her drums, even turn the bass drum off its side, and we used the Velvets' amps. We played our little blues-rock set, and afterward, someone came over and said, "Oh, Andy thinks you're terrific." The Velvets came on and were awesome. We had been daunted by the echo-y acoustics of the place, but they used the natural reverb to their advantage. There were maybe forty people at this event. After that, there was frequently an element of Andy in things I dealt with: someone connected to him, some event he was involved with, some of his art, references to him, etc.

On December 3, 1984, Andy had his first day of work at the fourth and last "Factory," which was an old Con Edison building located on Madison Avenue, between 32nd and 33rd Streets. This place was huge, and I hung out there occasionally and did some interviews for Andy's TV endeavors. I interviewed Burroughs there for *Andy Warhol's 15 Minutes*, his TV show that I also did a theme for. I was interviewing the Ramones there one weekend in 1987. I remember Johnny asking where Andy was and being told that he wasn't feeling well. I think that was the same weekend that he died of complications after a gallbladder operation.

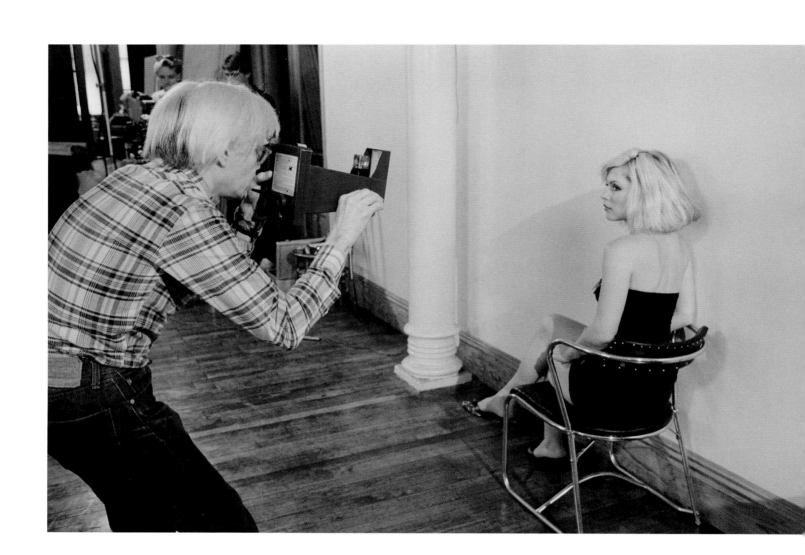

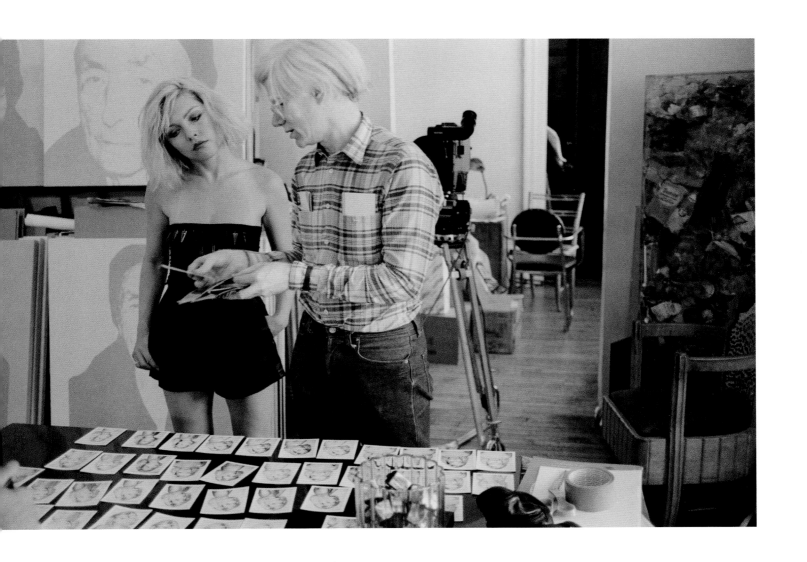

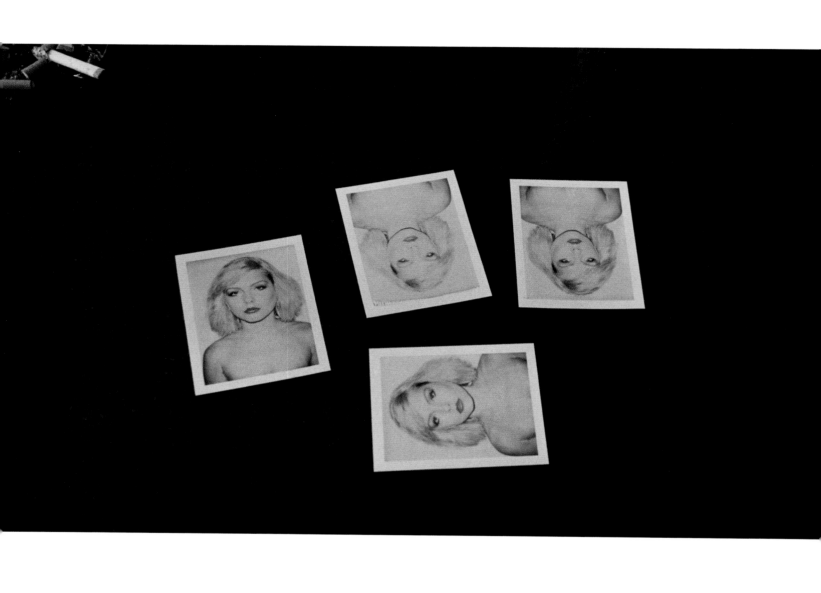

Afterword
Clean Slate
Shepard Fairey

"Cool" is not easily defined, so it's hard to say what the word meant to me in 1979 when I was nine years old. All I remember is that, for me, its epitome was Blondie's "Heart of Glass." I'm not sure what made the song cool, but I knew it when the feeling hit because it was unlike anything I'd felt before. I knew nothing about the culture that inspired Blondie or the scene from which they emerged, but I knew they stood out from everything else on pop radio.

Even if "cool" had a definition, it would inherently outgrow the label before it stuck. Definitions become relevant by virtue of their longevity, and cool is only cool when it pays no heed to shelf life. Cool is fluid, in the moment, stylish, and not self-conscious. The more I got to know about Blondie, the more I realized my gut feeling was right: They were cool, punk, adventurous, artsy, and all sorts of other characteristics that separate the creators from the spectators. Most people know that the creative core of Blondie was, and is, songwriter/guitarist Chris Stein and lyricist/vocalist Debbie Harry. What many people don't know is that Chris is not just a musician; he also studied photography and fine art at New York's prestigious School of Visual Arts.

Blondie always had a strong aesthetic sensibility, thanks in large part to Chris Stein. As a photographer, Chris constantly documented the people and things he found inspiring—from his own band to street scenes, other musicians, artists, and writers. My notion of "punk" is a philosophy of fearless creativity and open-mindedness with no interest in conformist structures. When I look at the images in this book, they remind me of how punk it is just to be true to oneself. Blondie was totally punk by saying "anything goes," and their influences, from sixties girl groups to disco, funk, hip-hop, and reggae, highlight their disregard for any sort of static caricature or orthodoxy that fits some working definition of punk.

Chris was photographing things that had authentic value mainly to him and possibly a small group of others at the time. However, if you look at the cultural weight and value of these subjects now, Chris would have been the ultimate stockbroker of cultural currency—yet he was guided by intuition, not calculation. There is an undeniable cool factor to all of these photos; not a single one of them feels contrived.

As a friend and admired peer of most of his subjects, Chris was able to capture natural moments that would have been off-limits to other photographers. How many people could get intimate portraits of Debbie Harry, the Ramones, Richard Hell, Iggy Pop, David Bowie, Joan Jett, Devo, The B-52's, the Screamers, Rodney Bingenheimer, Chrissie Hynde, Siouxsie Sioux, Buzzcocks, Talking Heads, Jean-Michel Basquiat, Lee Quinones, Andy Warhol, John Waters, and William S. Burroughs? That list, and therefore this book, looks like a catalog of most of my biggest heroes. Chris's photos are an extension of his unique view inside that world and that time, and to see them all together makes me feel like a lucky kid who's just been handed an all-access pass.

Chris and I have become friends in the last few years, and I feel very fortunate to hear his stories and even illustrate from one of his fantastic Joan Jett photos. When he asked if I'd be willing to contribute to the design of this book, I was honored, humbled, and a bit stumped. I thought of most "punk" books and how their design followed aesthetic clichés that Blondie never bought into. Blondie was always on the move, and I thought the design of this book should reflect their clean-slate, ever-evolving pursuit and shaping of avant-garde culture. Chris's images speak loudly and deserve better than to compete with distracting design gimmicks typically used to camouflage weak content. I wanted to keep the design of this book sharp, clean, and neutral. Chris's photos speak for themselves, and with their history in his own words, we are reminded what punk looked like when it could look like anything beyond definition.

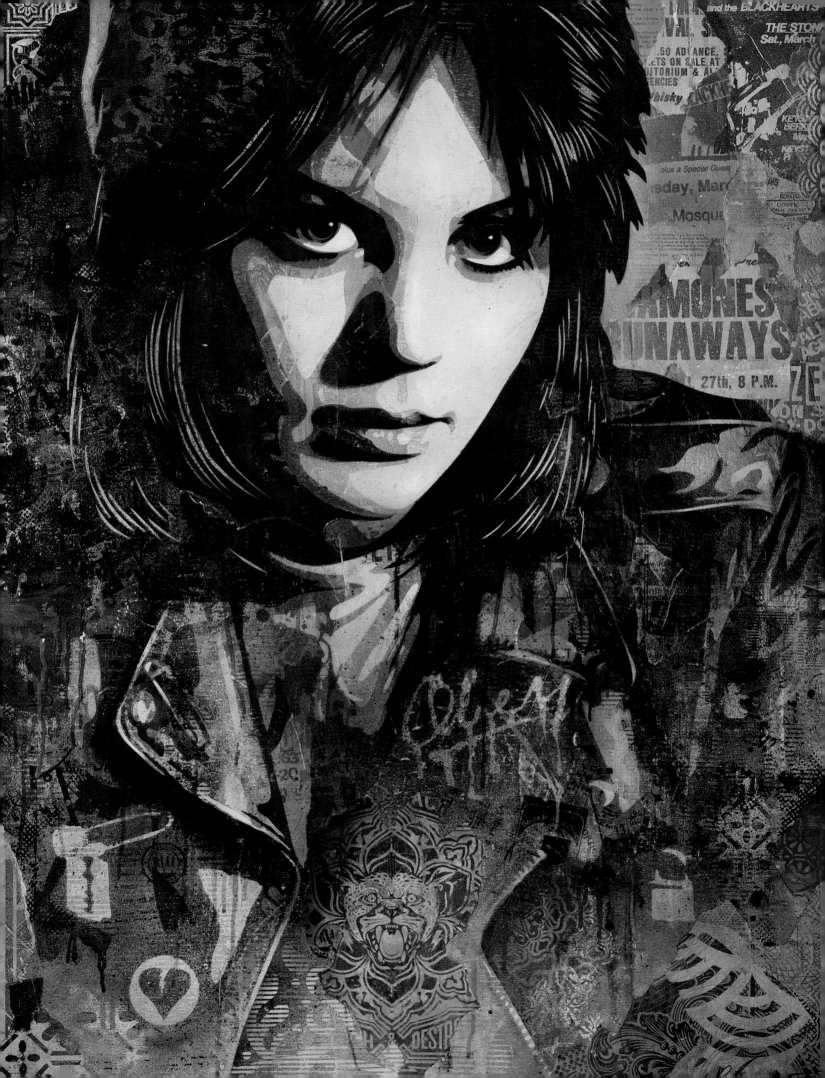

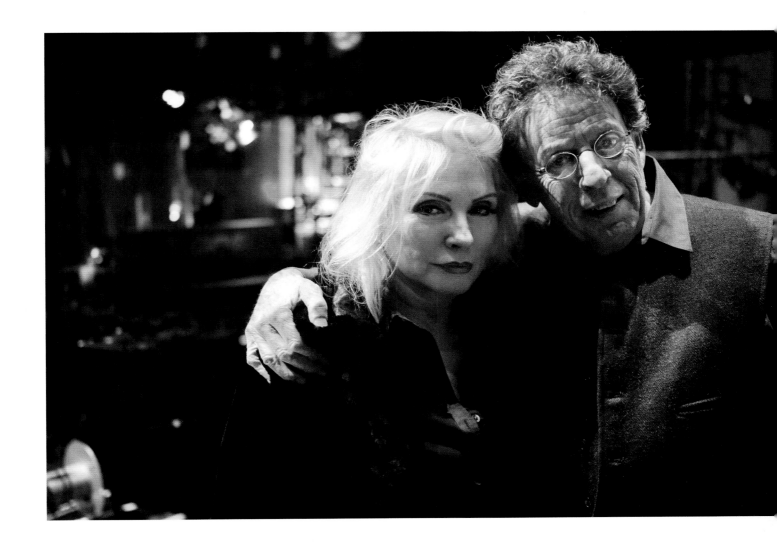

ABOVE Debbie and Philip Glass at Lou Reed's memorial service, New York, 2013. During the time I have been working on this book, we have lost Lou, Marty Thau, Bob Casale and Alan Myers of Devo, Dave Brockie (aka Oderus Urungus) of Gwar, and other friends. There are many mentions of friends lost within these pages and I often wonder what things would be like if they were still around, what they would be up to.

OPPOSITE My photo of Joan Jett, conceptualized by the artist Shepard Fairey, 2013.

Dedication and Acknowledgments

I'd like to dedicate this to Barbara Sicuranza, with all my love. She helps with a large amount of the band's and my stuff and is always a support. I'd also like to thank Leah Whisler, who's been great as editor on this project; her cohorts Loren Olsen and Anthony Petrillose; Shepard Fairey, who is just all-around Mister Honorable; Marc Gerald, who helped get the book deal going (quickly); Josh Flaherty, who helps with all manner of day-to-day nonsense as well as the "big stuff"; Allen Kovac; Linda Carbone; Glenn for contributing without the least hesitation; Debbie, who is always there; and Akira and Vali (STOP IT! but I love you).

Charles Miers, Colin Hough-Trapp, Maria Pia Gramaglia, and Kayleigh Jankowski at Rizzoli; Richard Edelman at Woodstock Graphics Studio and Terri C. Smith for all their work with the images themselves; Monika Tashman; Barry L. Kramer and Susan Homer for help with the type; Johan Kugelberg for his support; and, of course Cleon Peterson at Studio Number One and Armin Vit and Bryony Gomez-Palacio at UnderConsideration LLC for their beautiful work with the design.

Everyone else—friends, photographic subjects, and musical acquaintances—thanks for your support. Finally, to the fan base, none of this would be possible without you.

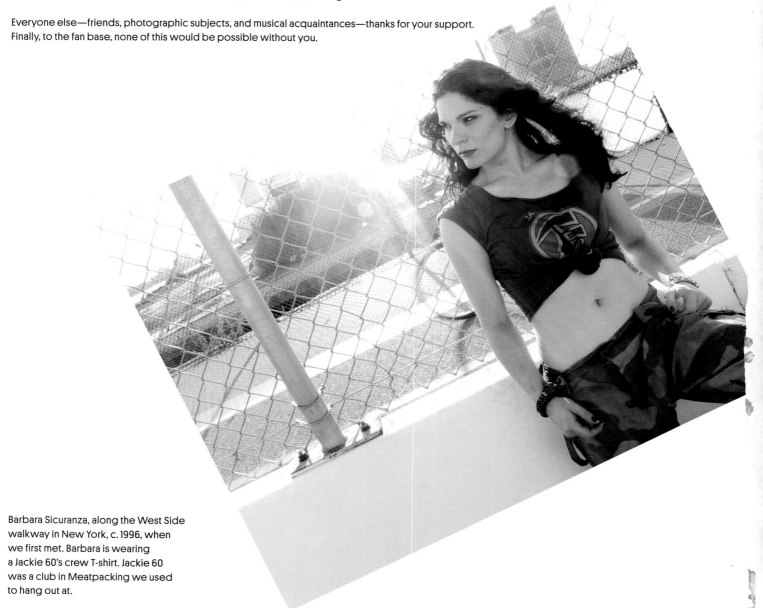

Barbara Sicuranza, along the West Side walkway in New York, c. 1996, when we first met. Barbara is wearing a Jackie 60's crew T-shirt. Jackie 60 was a club in Meatpacking we used to hang out at.